A Gift to the College

The Mr. and Mrs. Adolph Weil Jr.
Collection of Master Prints

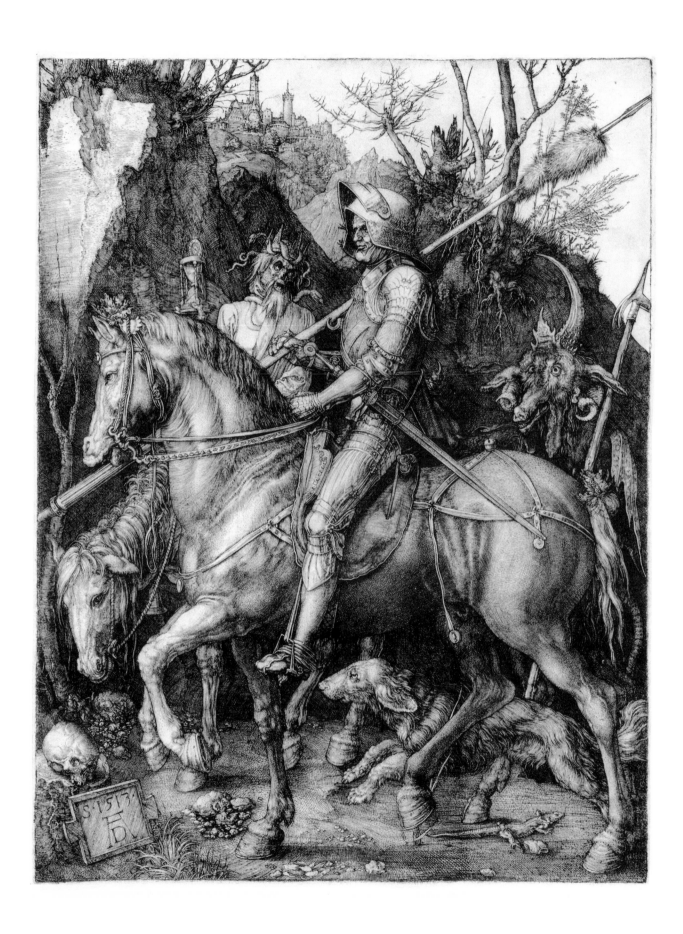

A GIFT TO THE COLLEGE

The Mr. and Mrs. Adolph Weil Jr. Collection of Master Prints

ESSAYS BY

Timothy Rub

Egbert Haverkamp-Begemann

CATALOGUE BY

Kelly Pask

CONTRIBUTIONS BY

Juliette M. Bianco

Jane L. Carroll

Katherine W. Hart

Kelly Pask

David R. Smith

Hood Museum of Art
Dartmouth College

Abaris Books

1998

Co-published and distributed by Abaris Books,
70 New Canaan Avenue, Norwalk, CT, 06850

This exhibition was organized by the
Hood Museum of Art, Dartmouth College.
The exhibition and catalogue have been
generously supported by The Marie-Louise
and Samuel R. Rosenthal Fund and The
George O. Southwick 1957 Memorial Fund.

A Gift to the College:
The Mr. and Mrs. Adolph Weil Jr.
Collection of Master Prints
Hood Museum of Art, Dartmouth College
Hanover, New Hampshire
October 17 – December 20, 1998

Design and typography: Glenn Suokko.

All photography by Jeffrey Nintzel,
with the exception of photograph of Mr. Weil
on page 12, which is by Jon Gilbert Fox, and
cat. nos. 99 and 240.

Printing: Hull Printing.

Typeset in Bembo.

Printed on Monadnock Dulcet.

Library of Congress
Cataloging-in-Publication Data

A gift to the College: the Mr. and Mrs.
Adolph Weil Jr. collection of master prints/
essays by Timothy Rub and Egbert
Haverkamp-Begemann; catalogue by Kelly
Pask; and contributions by Juliette M. Bianco
... [et al.].
p. cm.

Catalogue of an exhibition held at the
Hood Museum of Art, Dartmouth College,
Hanover, N.H., Oct. 17–Dec. 20, 1998.

Includes bibliographical references.
ISBN 0-944722-20-2 (hard)
ISBN 0-944722-21-0 (soft)

1. Prints, European—Exhibitions.
2. Weil, Adolph—Art collections—Exhibitions.
3. Weil, Adolph, Mrs. —Art collections—
Exhibitions.
4. Prints—Private collections—
New Hampshire—
Hanover—Exhibitions.
5. Prints—New Hampshire—Hanover—
Exhibitions.
6. Hood Museum of Art—Exhibitions.
I. Rub, Timothy.
II. Haverkamp-Begemann, Egbert.
III. Pask, Kelly.
IV. Bianco, Juliette M.
V. Hood Museum of Art.

NE57.W44G54 1998
769.94'0747423—dc21
98-36752

cover:
Rembrandt van Rijn
Faust, c. 1652
cat. no. 249

endleafs:
Jacques Callot
The Stag Hunt, c. 1619
cat. no. 6 (detail)

frontispiece:
Albrecht Dürer
Knight, Death and the Devil, 1513
cat. no. 98

TABLE OF CONTENTS

Dedicated to the memory of Adolph Weil Jr.

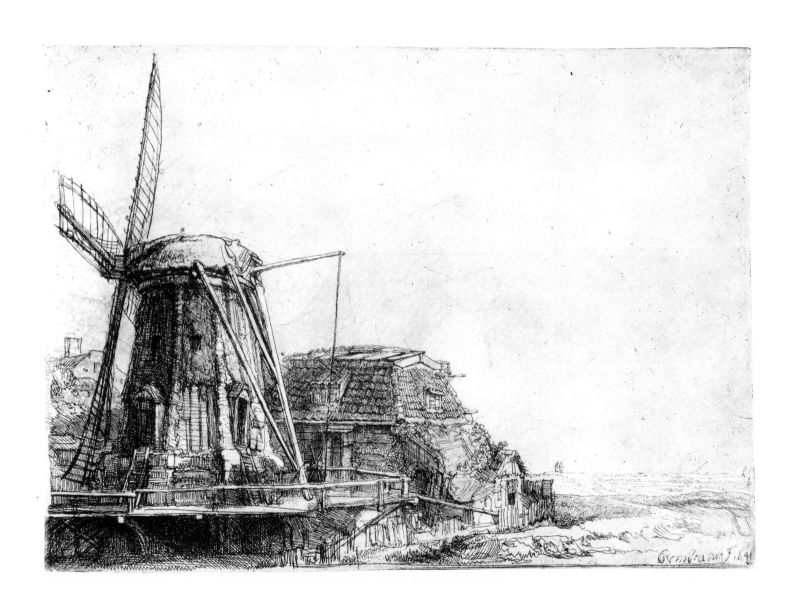

Rembrandt van Rijn, *The Windmill*, 1641, cat. no. 247

PREFACE AND ACKNOWLEDGMENTS

As those familiar with such matters can attest, museum collections develop in various and, at times, unpredictable ways. On the one hand, there can be long periods of incremental growth, with individual works of art acquired by gift or by purchase, and, on the other, those rare moments when institutions are, quite literally, transformed by donations of extraordinary scope and consequence.

Dartmouth College is fortunate to have received many such benefactions. Indeed, the range and quality of its fine arts and ethnographic collections—both housed since 1985 in the Hood Museum of Art—serve as an index of the significance of these gifts. Among the most important have been the donation of one hundred works of art, including paintings by Ben Shahn and Thomas Eakins, made by Abby Aldrich Rockefeller in 1935; the collection of Native American art and artifacts assembled by Frank and Clara Churchill that came to the College in 1946; the very large groups of European and American prints and drawings donated by Dr. F. H. Hirschland and Mrs. Hersey Egginton in memory of her son, Everett Egginton, Class of 1921 in, respectively, 1948 and 1954; and, more recently, the very large collection, numbering well over one thousand pieces, of Melanesian art assembled by Harry A. Franklin and given to the museum by his daughter Valerie in 1991.

This catalogue and the exhibition that it accompanies are intended to document another such gift—or, more accurately, a series of gifts—comprised largely of European prints dating from the late fifteenth to the early nineteenth centuries made to the Hood Museum of Art by Mr. Adolph Weil Jr. and, after his death in 1995, by his wife, Jean. Although by no means the largest donation ever received by the museum, it is, when considered in terms of the quality of the works included in the gift and their impact on the collection, without doubt one of the most significant.

It is a great pleasure to be able to recognize in this manner the generosity of Mr. and Mrs. Weil and to honor the memory of a distinguished member of Dartmouth College's Class of 1935 and a long-time supporter of the museum. Adolph Weil Jr. was a gentleman of the highest caliber and a consummate connoisseur of prints. His unfailing generosity, modesty, and good humor made all exchanges with him a great pleasure. He was a good friend and is sorely missed by all who knew him. We are delighted to have this opportunity to share his and

Jean's wonderful gift—which includes notable works by Dürer, Rembrandt, Lucas van Leyden, Canaletto, Goya, and many other artists who made seminal contributions to the history of printmaking—with the academic community and our public audiences.

Entitled *A Gift to the College: The Mr. and Mrs. Adolph Weil Jr. Collection of Master Prints*, this publication provides a comprehensive catalogue of all the prints donated to the Hood Museum of Art by the Weils over the past decade. The exhibition that it accompanies offers, by necessity, a selective survey of the collection and includes some 110 works in all.

It remains to offer my heartfelt thanks to the many people who assisted us with this important project. I would first like to acknowledge the generous support of Jean Weil, who has helped in many ways and graciously agreed to lend two important promised gifts, Dürer's *Saint Jerome in his Study* and Rembrandt's *The Three Trees*, for presentation in the exhibition. I am grateful, as well, for the assistance of her son, Adolph Weil III, who made time in his very busy schedule to deal with the innumerable questions that arose during our work on cataloguing the collection and making preparations for the exhibition.

We owe a debt of gratitude to the distinguished scholar of Dutch art, Egbert Haverkamp-Begemann, who kindly agreed to author an essay for this publication and whose knowledge of Rembrandt proved to be an invaluable resource during the preparation of the exhibition and catalogue. I would like to thank, as well, the other contributors to the catalogue: David Smith, Professor of Art History, University of New Hampshire; Jane Carroll, Visiting Assistant Professor of Art History, Dartmouth College; Juliette Bianco, the museum's Exhibitions Manager; Katherine Hart, the Barbara C. and Harvey P. Hood 1918 Curator of Academic Programming; and Kelly Pask, formerly the museum's Assistant Curator, who also undertook the complex task of cataloguing the collection. We are also indebted to independent scholar Judy Crosby Ivy for her assistance in determining the various states of the plates in David Lucas's and John Constable's *English Landscape*. Finally, I would like to express my gratitude to Glenn Suokko, who provided the elegant design of this catalogue and oversaw its production while working on a very tight schedule, and to Anthony Kaufmann of Abaris Books, the publisher of *The Illustrated Bartsch* series on European Master print artists, who as co-publisher made many valuable contributions to this process.

Credit is also due to Ms. Pask and her husband, Richard Rand, the museum's Curator of European Art, who carried out much of the organizational work during the early stages of this project before Dr. Rand assumed a new position at the Clark Art Institute this past fall. Many other members of the museum's staff deserve to be acknowledged for the contributions they made to the success of this project: Exhibitions Assistant Katherine Josephs, Interim Exhibitions Manager Sarah Bockus, Curatorial Fellow Amy Ingrid Schlegel, Research Curator Diane Miliotes, Curator of American Art Barbara MacAdam, Registrar Kellen Haak,

Associate Registrar Kathleen O'Malley, Assistant Registrar Cynthia Gilliland, Data Manager Deborah Haynes, and Exhibitions Curator Evelyn Marcus and the members of her staff, Nicolas Nobili and Julia Korkus. Finally, I would like express my deep appreciation to Katherine Hart, who agreed to assume responsibility for this project at a time when her schedule was already very full and oversaw every aspect of its production with patience, great skill, and an inexhaustible fund of good humor.

The presentation of *A Gift to the College: The Mr. and Mrs. Adolph Weil Jr. Collection of Master Prints* at the Hood Museum of Art and the publication of the exhibition catalogue are made possible in part through the support of the Marie-Louise and Samuel R. Rosenthal Fund and the George O. Southwick 1957 Memorial Fund.

TIMOTHY RUB
Director

Adolph Weil Jr., photographed in the Hood Museum of Art, June 1990

A Gift to the College

"Collect what pleases and interests you," Frank Weitenkampf—then Curator of Prints at the New York Public Library—recommended in his 1932 book entitled *The Quest of the Print*, "but base your choice on solid reasons, not on passing fancy. The range of possibilities at command is wonderfully wide and varied. One may select for purely aesthetic reasons. . . . One may be attracted by the suggestive summariness of the etching, by the formal line of the engraving on copper, by the luscious richness of the mezzotint, by the pliant response of the lithograph to the artist's touch, by the remarkable resources of the wood block. . . . But there will ever be the added attraction of the thousand-and-one points of interest yielded by the subject matter of the print."[1] Weitenkampf's advice to the aspiring print collector aptly characterizes the approach that Adolph Weil Jr. took in assembling what became over the course of nearly thirty years one of the most important private collections of Old Master and nineteenth-century prints in this country.

If Mr. Weil took great delight in acquiring works by those artists who held a special appeal to him by virtue of their mastery of the medium of printmaking—especially Rembrandt and Dürer—or their interpretation of a given subject, it is clear that he took equal pleasure in sharing his collection with others. This catalogue and the exhibition it accompanies are intended to provide a record of Mr. Weil's activities as a collector and to acknowledge the extraordinary series of gifts that he, up to the time of his death in 1995, and subsequently his wife, Jean, have made to the Hood Museum of Art.

Adolph Weil Jr., or "Bucks" as he was known to his many friends and acquaintances, was a graduate of Dartmouth College's Class of 1935—the members of which, following his example, have taken a strong interest in developing the museum's collection of Old Master prints. A leading citizen and active philanthropist in his native city of Montgomery, Alabama, he maintained a lifelong attachment to Dartmouth. It was here that his love of the visual arts, first encouraged by his parents, broadened and took deeper root through the instruction that he received from members of the Classics and Art History departments, most notably Churchill P. Lathrop, who for several decades also served as the director of the College's art galleries.

Mr. Weil's interest in Dartmouth was certainly strengthened by the opening of the Hood Museum of Art in 1985. Much had changed during

the five decades since his graduation—the permanent collection, for example, had grown dramatically through the efforts of Lathrop and his successors. And with the completion of this new facility the college reaffirmed the importance of the visual arts in a liberal arts curriculum and of the museum as an integral part of the academic community. Responding to an invitation from President David T. McLaughlin in 1986 to join the Board of Overseers of the Hopkins Center and Hood Museum of Art, Mr. Weil served on the board for six years and in this capacity made many significant contributions to the work of the museum. Among these were gifts that supported the purchase of an important group of preparatory drawings for the mural *The Epic of American Civilization*, painted by the great Mexican artist José Clemente Orozco in the Reserve Corridor of Dartmouth's Baker Library from 1932 to 1934, and the establishment of a new endowment fund for acquisitions.

It was, however, as a collector that Bucks Weil was to make his greatest impact on Dartmouth. Over the ten years that he was most closely affiliated with the museum he graciously lent important prints for presentation at the Hood Museum of Art. Among the exhibitions that were organized specifically from Mr. Weil's collection were *A Humanist Vision: The Adolph Weil, Jr. Collection of Rembrandt Prints* in 1988; *Fatal Consequences: Callot, Goya, and the Horrors of War* in 1990; and *Two Views of Italy: Master Prints by Canaletto and Piranesi* in 1995, which paired Canaletto's remarkable etchings of Venice and its environs from the late 1730s and early 1740s with one of the great treasures of the Dartmouth collection: Giovanni Battista Piranesi's nearly contemporary series of etchings of views of his adopted city to which he gave the title *Le Magnificenze di Roma*. While Mr. Weil's willingness to lend these works was motivated by a spirit of generosity and the wish that others should take pleasure in the prints that gave him so much enjoyment, it is also true that he, recalling his own student days at Dartmouth, took a special interest in their potential use for teaching and research.

Inspired, perhaps, by the benefit that the academic community derived from the use of works from his collection and by the museum's commitment to the development of its permanent collection, in 1986 Mr. Weil made the first of several benefactions to the college, donating a fine late portrait by the American expatriate artist James McNeill Whistler and a drawing in charcoal by the Costa Rican artist Francisco Zúñiga. These donations were followed in 1989 by the gift of Richard Earlom's aquatints after landscape drawings by Claude Lorrain (cat. no. 100), and in 1991 by several major gifts: a fine woodcut by Lucas Cranach the Elder entitled *The Penitence of Saint Jerome* dating to 1509 (cat. no. 84, ill. p. 90); Jacques Callot's two series of etchings, known respectively as the "Large" and "Small" *Miseries of War* (cat. nos. 28–52), both produced in the mid-1630s at the end of this artist's long and distinguished career; the powerful and still disquieting series of eighty prints by Francisco Goya entitled *The Disasters of War* (cat. nos. 102–81); and several sheets by

M. C. Escher (cat. no. 101) and Camille Pissarro (cat. nos. 225, ill. p. 78, and 226). The following year Mr. Weil made several additional donations to the museum: a number of engravings by the English artist William Blake and the series of mezzotints entitled *English Landscape*, of 1830–32 (cat. nos. 200–21), which resulted from the fruitful collaboration between the painter John Constable and the young printmaker David Lucas.

These successive benefactions, which in number totaled 134 works of art, did much to strengthen the permanent collection. They were augmented in 1997 by a truly remarkable donation to the college from Mrs. Jean K. Weil in memory of her late husband: 121 additional Old Master and nineteenth-century European prints from the collection he had assembled.[2] This gift, it can be said without risk of exaggeration, is one of the most important that has ever been received by the museum. While notable for its size alone, this donation is also distinguished by the exceptional quality of the impressions that it includes and—with prints by Mantegna, Dürer, Lucas van Leyden, Canaletto, and, above all, Rembrandt—its significance for the study of the history of printmaking.

Among the earliest works in the collection are two engravings from the 1470s by Andrea Mantegna, an artist who made seminal contributions to the development of printmaking in Italy in the late fifteenth century: the left half of his celebrated *Battle of the Sea Gods* (cat. no. 222, ill. p. 44) and *The Risen Christ Between Saints Andrew and Longinus* (cat. no. 223, ill. p. 109). Despite his obvious mastery of the technique of copper plate engraving, Mantegna made relatively few prints, probably only seven in all. Yet the skill that he displayed in this difficult medium, both in terms of his ability to model figures so convincingly in three dimensions and his concentrated power of expression (which is exemplified by the pathos and monumentality of *The Risen Christ Between Saints Andrew and Longinus*) have rightly secured Mantegna's enduring reputation as an artist whose achievements as a printmaker are of the very first rank.

The next artist, proceeding in chronological order, whose work held a special appeal for Mr. Weil was Albrecht Dürer, the leading figure of the High Renaissance in Germany. For Dürer, the son of a Nuremberg goldsmith, printmaking was an important and largely independent form of pictorial expression and the principal means by which his fame spread throughout northern Europe and even to Italy, where Giorgio Vasari later noted that "for their novelty and beauty, [Dürer's prints] were sought by everyone."[3] The donation made to the college by Mrs. Weil contains a number of important examples of his work including, in proof impressions, the ambitious set of twelve woodcuts known as *The Large Passion* (fig. 1, cat. nos. 85–96) that the artist began in 1497 and completed in 1511, and two of his best-known engravings: *Knight, Death and the Devil*, of 1513 (cat. no. 98, catalogue frontispiece), and, as a promised gift, the classic image of the humanist scholar, *Saint Jerome in his Study* (cat. no. 99, ill. p. 48), of the following year. Not as rich iconographically, but no less a tour de force of naturalism is a third engraving by Dürer in the

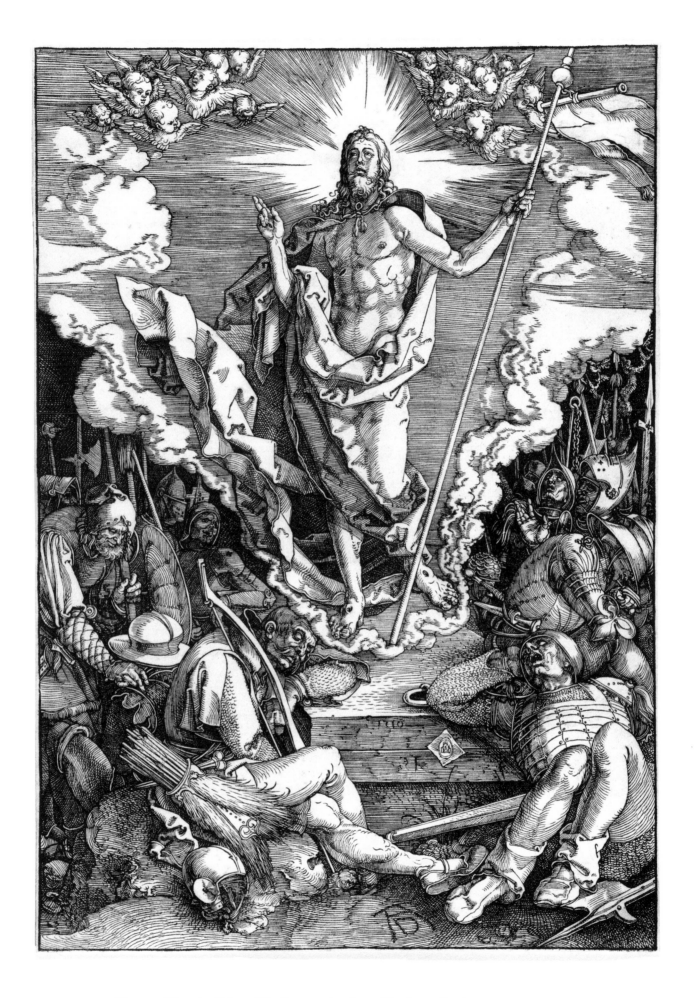

Fig. 1 Albrecht Dürer, *The Resurrection* from *The Large Passion,* 1510, cat. no. 96

collection, *The Large Horse* (cat. no. 97, ill. p. 93), dating to 1505, a composition that demonstrates the artist's mastery of foreshortened perspective and his uncanny ability to render deftly all the textures of the world in a pictorial language that is unique to this medium.

The development of printmaking in northern Europe after Dürer is represented in the collection by a group of eighteen prints by the Netherlandish artist Lucas van Leyden, who was himself a good friend of the older artist. Like Dürer, Lucas was both a gifted painter and printmaker, one who was equally at ease working in woodcut, engraving, or the nascent technique of etching. As Jane Carroll notes in her discussion in this catalogue of *Potiphar's Wife Accusing Joseph* (cat. no. 184, ill. p. 50), Lucas's manner of engraving was fundamentally different than Dürer's and essentially pictorial in character, relying to a far greater extent on tone than on line to structure his compositions. This distinction can be clearly seen in the complex, atmospheric landscapes in the series of engravings of *The Passion of Christ* that Lucas completed in 1521 (cat. nos. 186–99). These superb engravings, which brought the artist great acclaim during his brief career, also demonstrate Lucas's gift for devising narratives that greatly enriched the meaning of familiar biblical stories.

Widely acknowledged as one of the great printmakers in history and as an artist whose expressive range and technical command of the etching process have never been equalled, Rembrandt was also an active collector of prints by other artists, among them Lucas van Leyden, whose work he greatly admired and from which he clearly learned a great deal. Because the essay that Egbert Haverkamp-Begemann has contributed to this catalogue deals at length with Rembrandt's extraordinary achievements as a printmaker, I will simply note here that it was this artist that Adolph Weil Jr. collected in depth, appreciating his work above all others.[4] He was deeply moved not only by Rembrandt's consummate skill as an etcher, but also, and more importantly, by the keen intelligence and sympathy with which the artist rendered his subjects.

In this regard, the thirty prints by Rembrandt in the gift made by Mrs. Weil to the college represent an exceptional resource for the study of this artist's work and Baroque art in general. Among these are some of Rembrandt's most significant prints: fine impressions of his monumental treatments of biblical subjects such as *Christ Presented to the People* (in the fifth state: cat. no. 233, ill. p. 64), *Christ Crucified Between the Two Thieves: The Three Crosses* (in the fourth state: cat. no. 234, ill. p. 68), *Christ Preaching (La Petite Tombe)* (cat. no. 232, ill. p. 37), and *Abraham's Sacrifice* (cat. no. 230, ill. p. 26); a number of notable portraits and figure studies such as *Jan Lutma, Goldsmith* (in both the first and second states: cat. nos. 251 and 252, ills. p. 66 and 118), *Jan Cornelis Sylvius, Preacher* (fig. 2, cat. no. 253), *The Artist's Mother, Head and Bust: Three Quarters Right* (cat. no. 257, ill. p. 60)—one of Rembrandt's earliest etchings, *Faust* (cat. no. 249, ill. p. 34), and an unusually rich impression of the misleadingly titled *Negress Lying Down* (cat. no. 239, ill. p. 116); and several fine landscapes (an area in

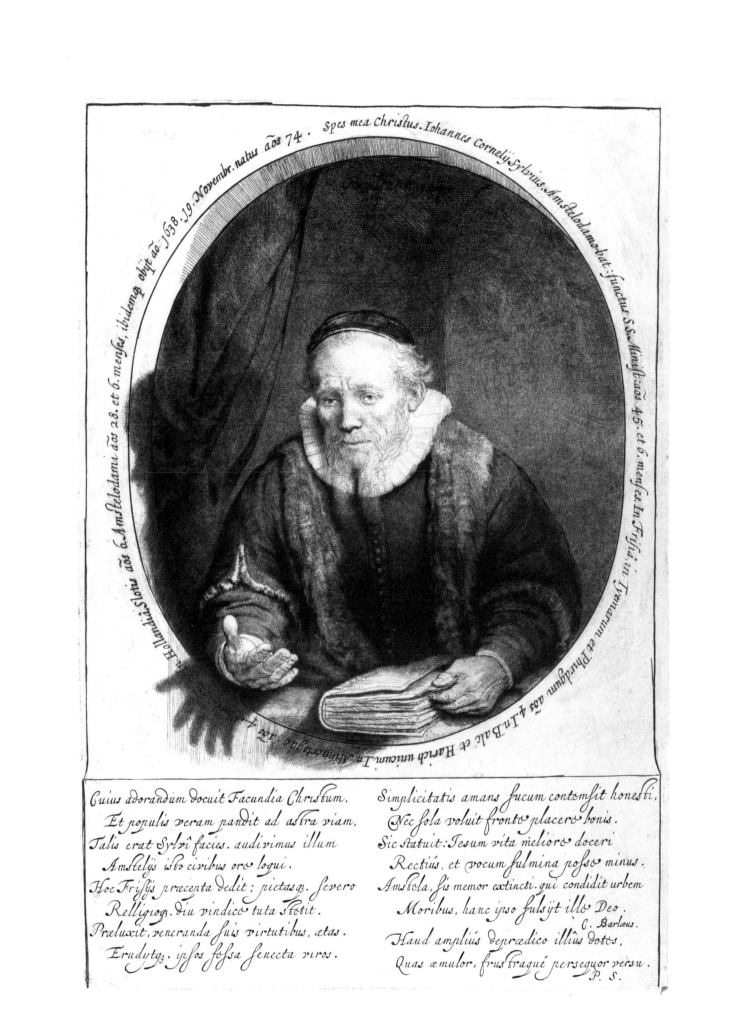

Fig. 2 Rembrandt van Rijn, *Jan Cornelis Sylvius, Preacher*, 1646, cat. no. 253

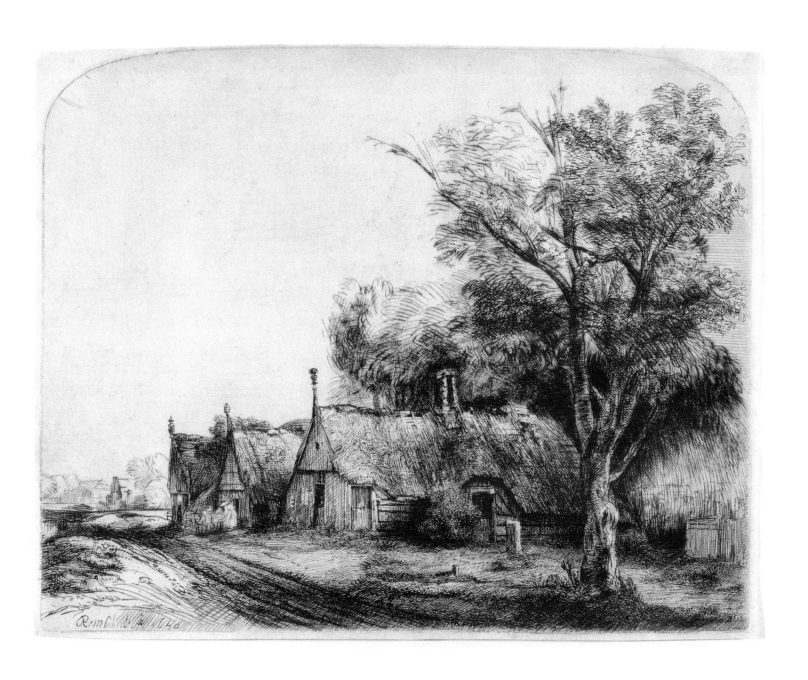

Fig. 3 Rembrandt van Rijn, *Landscape with Three Gabled Cottages Beside a Road*, 1650, cat. no. 242

which the Dartmouth collection had been very deficient), among them *The Goldweigher's Field* (cat. no. 248, ill. p. 41), *Landscape with Three Gabled Cottages Beside a Road* (fig. 3, cat. no. 242), and *The Windmill* (cat. no. 247, ill. p. 8), and, as a promised gift, the most magisterial of Rembrandt's landscapes, *The Three Trees* (cat. no. 240, ill. p. 62).

Two other works of this period deserve special mention. The first, Jusepe de Ribera's *The Martyrdom of Saint Bartholomew* (cat. no. 227, ill. p. 58), dates to 1624, just a few years before Rembrandt was to make his first etching. As Juliette Bianco observes in her discussion of the print in this catalogue, Ribera made only a few etchings over the course of his career and was known primarily as a painter; they were sufficient, however, to establish his fame as one of the finest printmakers of his day and are still regarded today as works of consummate skill. Indeed, this horrifying, yet exquisitely choreographed scene, in which we feel in equal measure both the physical suffering of the saint and his deep belief in the redemptive powers of his faith, offers ample evidence of Ribera's achievement and of the importance of printmaking as a creative activity for many of the leading artists of his time. The second, Jacques Callot's *The Stag Hunt* (cat. no. 6, ill. p. 54), dating to around 1619, serves both as a demonstration of this artist's virtuoso etching technique and as evidence of his great love of the theater and the enormous influence that this had on his work.

Although Mr. Weil focused much of his attention on the sixteenth and seventeenth centuries, he did not neglect the work of later artists. The Hood Museum of Art was particularly fortunate to receive as gifts from Mr. and Mrs. Weil two of the landmarks of eighteenth and nineteenth-century printmaking: the suite of thirty-one etchings depicting views—some real, others imaginary—of Venice and its environs created by the great Italian painter Canaletto in the late 1730s and early 1740s; and the eighty prints that Francisco Goya created between 1810 and 1820 in response to the invasion of Spain by the forces of Napoleon Bonaparte in May 1808 and its tragic consequences, a series to which he gave the title *The Disasters of War* (cat. nos. 102–81). The pairing could not provide a more striking contrast and has much to teach us about the potential of printmaking as a descriptive and expressive medium.

Titled by the artist *Vedute altre prese da i luoghi altre ideate (Views, Some Taken from Places, Others Invented)* and intended no doubt as mementos of the Grand Tour that was considered an essential part of a gentleman's education in the eighteenth century, Canaletto's superbly realized views of the city of Venice and the cities and towns in its orbit offer a comforting and harmonious vision of a world in which the past, so admirably reflected in the city's glorious architectural heritage, serves as a frame for the varied and lively activities of the present (fig. 4, cat. no. 54). The prints in Goya's famous series, created little more than a half-century later, present a hallucinatory and still hellish vision of a world gone mad and now bereft of any points of reference. There are no familiar back-

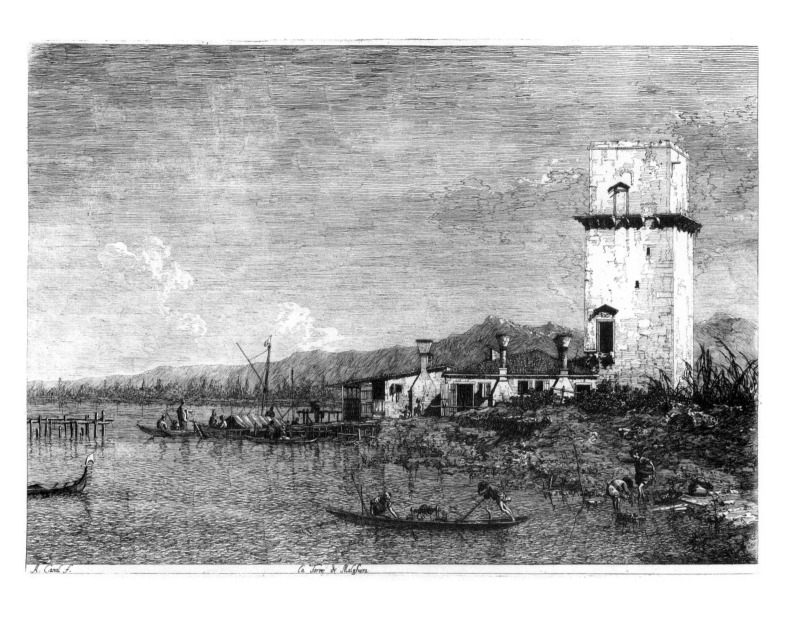

Fig. 4　Giovanni Antonio Canal, called Canaletto, *The Tower of Malghera*, c. 1740–44, cat. no. 54

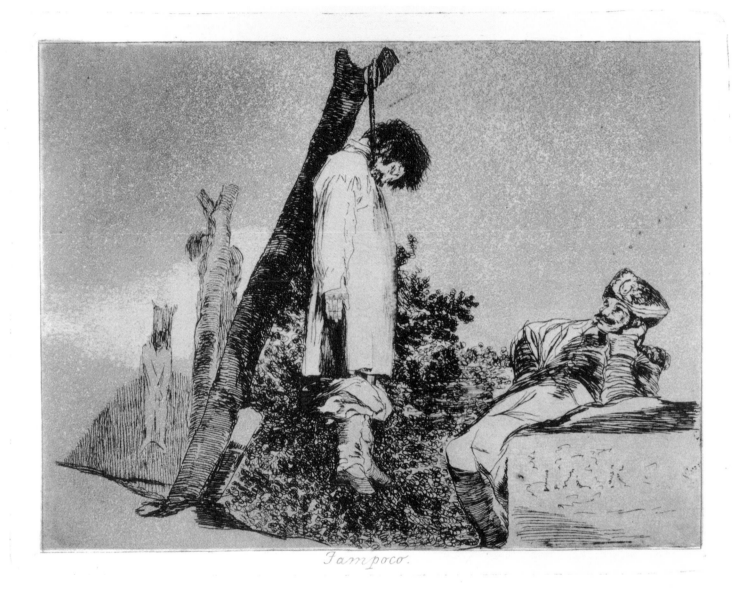

Tampoco.

Fig. 5 Francisco Goya, *Nor in this case*, c. 1810–20, cat. no. 137

grounds here, neither architecture nor landscape, and consequently no signposts with which to orient ourselves. Rather, the minimal settings that Goya offers us (so utterly different from the rich theatrical backdrop Callot designed for *The Stag Hunt*)—a simple platform, a gently sloping hillock, or the stump of a blasted tree—merely serve as props for the central action: an unflinching exploration of the savagery and brutality of war and its "fatal consequences" (to borrow a phrase from Goya's original title) for the Spanish people (fig. 5, cat. no. 111).

These two series also offer an instructive contrast in terms of the language of printmaking itself. For all of the remarkable descriptive effects he was able to achieve as an etcher, Canaletto's method was simple and, in a sense, formulaic. His compositions were painstakingly constructed through the use of parallel lines: shorter or longer, shallow or more deeply bitten, and closely or more widely spaced, as required by the nature of the object represented, be it a cloud, a building, or a figure (fig. 6). This methodical technique clearly reflects a historical trend in printmaking toward what William Ivins characterized in his perceptive essay of 1953 entitled *Prints and Visual Communication* as the development of a relatively standardized "linear scheme" or "syntax" for the medium that would allow artists (and their publishers) to take advantage of the unique capacity of the print to function, in Ivins's words, as an "exactly repeatable pictorial statement."[5]

How very different this is from the highly individualistic approaches taken by Rembrandt, who continually reworked his etchings and experimented constantly with different papers and different ways of

Fig. 6
Giovanni Antonio Canal,
called Canaletto
The Tower of Malghera, c. 1740–44,
cat. no. 54 (detail)

inking his plates, and by Goya, who combined etching and aquatint with several other techniques in the plates for *The Disasters of War* (fig. 7). In practice, such a distinction—between the print as a reproductive medium that allows for a certain degree of standardization and the print as a vehicle for the expression of artistic ideas that cannot be realized in any other form—is, however, rarely so easy to make. Take, for example, the series of prints entitled *English Landscape* (1830–32) that resulted from the creative collaboration between the English painter John Constable and the young specialist in mezzotint, David Lucas. Valued precisely because it was capable of reproducing with great fidelity the broad range of tonal values found in painting, this printmaking technique was chosen by Constable for a project he had decided to undertake himself: the publication of a number of landscapes (based on sketches that he had made) in the form of reproductive prints. What began, however, as a relatively straightforward arrangement soon proved to be fairly complicated, with Constable constantly correcting and altering the proofs that Lucas had produced for his approval. As Ivins notes, in so doing Constable

"introduced so many and such great changes that it is fair to say that the impressions should be called original prints and not reproductive prints. There can be few documents of greater interest to anyone who desires to watch the artist's mind at work. . . ."[6]

"To watch the artist's mind at work": This is the most compelling reason for the study of original works of art and, by extension, for the development of a teaching collection at a college or university museum. The gifts made to Dartmouth College by Mr. and Mrs. Weil were clearly motivated by such a purpose, and it is in this spirit that they will continue to educate and inspire generations of students to come.

Although by no means complete, this brief survey of the Weil donation provides ample evidence of the significance of this collection to the museum. It includes prints by some of the most influential artists who worked in this medium, many of whom, most notably Dürer, Lucas van Leyden, Rembrandt, Canaletto, and Goya, are represented in depth by impressions of very high quality. This gift also represents an important chapter in the history of collecting, and not simply because many of the works that Mr. Weil acquired have distinguished provenances. Faced with a myriad of possibilities—for, as Frank Weitenkampf suggested in the passage cited at the beginning of this essay, the field of print collecting is large and complex—he approached the task of building a collection with great patience and with deliberation, carefully developing his eye, broadening his knowledge of the history of printmaking, and wisely choosing those works that, by virtue of their subject matter or their creative use of the medium, held a special appeal for him.

TIMOTHY RUB

NOTES

1. Frank Weitenkampf, *The Quest of the Print* (New York, 1932), 17.

2. During his lifetime, Mr. Weil had been equally generous to the Montgomery Museum of Fine Arts in Montgomery, Alabama, an institution with which he and his family had a long history of involvement. In 1997, the same year that she made this gift to the Hood Museum of Art, Mrs. Weil also donated a large group of European and American prints to the Montgomery Museum of Fine Arts, including a number of important works by Dürer, Lucas van Leyden, Rembrandt, Tiepolo, and Whistler.

3. Cited in Carl Zigrosser, *Six Centuries of Fine Prints* (New York, 1937), 47.

4. At the time of the exhibition *A Humanist Vision: The Adolph Weil, Jr. Collection of Rembrandt Prints*, which the Hood Museum of Art presented in 1988, Mr. Weil had acquired over eighty etchings by Rembrandt. In the following years he acquired some thirty additional works by this artist, including excellent impressions of *Christ Presented to the People* and *Christ Crucified Between the Two Thieves: The Three Crosses*.

5. William M. Ivins Jr., *Prints and Visual Communication* (Cambridge, MA, 1953), p. 3, passim.

6. Ibid., 85.

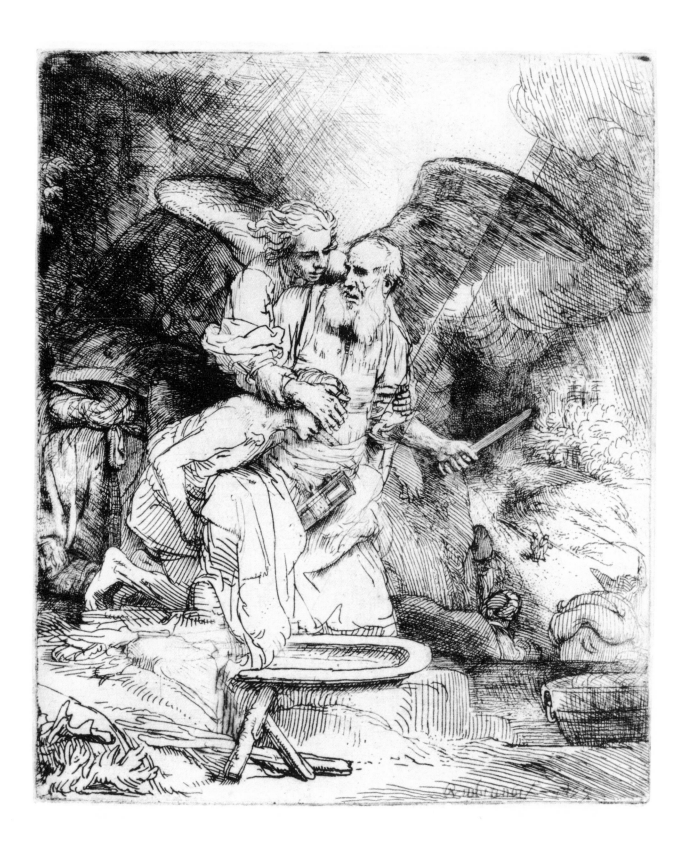

Fig. 1 Rembrandt van Rijn, *Abraham's Sacrifice*, 1655, cat. no. 230

THE POWER OF THE PRINT

The outstanding collection donated by Jean and Adolph Weil Jr. to the Hood Museum of Art presents a welcome opportunity to ask oneself what it is that makes prints so special. This question, obvious yet rarely asked, can be focused on Rembrandt van Rijn, whose genius as a printmaker is represented so well in the Weil collection. It can be examined, as well, in the context of other important printmakers, especially Albrecht Dürer, Lucas van Leyden, Canaletto, and Franciso Goya, whose works are also represented in the Weil collection in many excellent impressions.

Prints of past centuries are often misunderstood. Compared to works in other media, they are sometimes considered inferior because they are generally small and lack color; they often reproduce other works and are therefore not considered to be "creative;" and are, moreover, "multiple originals" and, in this respect, not unique like most paintings, sculptures, drawings, or watercolors. They are usually extremely detailed and require time and concentration to be appreciated, and are fragile because of their paper support. Consequently, Old Master prints are also thought to be less valuable than other works of art.

These last two misconceptions can be immediately dismissed. Anyone who has followed the art market or has tried to acquire a good quality print knows that prints can command high prices. And as long as it is on good paper and is not exposed to humidity and excessive light, a print is far more durable than a painting on canvas or wood panel.

As for the other assumptions, it is true that prints are typically small and require time to be enjoyed or "read" properly. However, this can be considered a virtue rather than a defect. Printmakers of the past knew that their work would be judged by a public with the sophistication and leisure to scrutinize them with care. Accustomed as we are today to a barrage of visual images—whether seen in magazines or on billboards, on television or the movie screen—we have to train ourselves to pay prolonged attention to the myriad of lines, dots, and tones that make up a print by Dürer or Rembrandt.

Not all prints are of an intimate size, however. Large prints—some, indeed, very large—have always been made throughout the Renaissance; large woodcuts printed from multiple plates were used to decorate grand ceremonial rooms. Descending from the tradition of mural painting and tapestry, they evolved in the nineteenth century into large-format

lithographs and, more recently, into large photomechanical images. Having been pasted or tacked up and later painted over or ripped down, most of this type of decoration from earlier centuries is now lost.

The small print, free of the programmatic burdens of public display, provided artists and their audiences with unique opportunities. Developed from antecedents in the craft of goldsmithing, manuscript illumination, and woodcut illustration for books, small prints were meant to be examined at close range. They were kept in portfolios or loosely inserted in blank-leaf books, first produced in quarto and folio size (Rembrandt included one in his etching, *Portrait of Abraham Francen*, B. 273), and growing gradually to imperial size in the eighteenth century, with many a single print pasted onto one page. Collectors would invite guests to look at prints and drawings in such portfolios undoubtedly after sharing a good meal, a drink, and conversation. The intricacy and quality of a print can be better appreciated when holding it in one's hand, or looking at it seated near the portfolio propped on a stand while discussing its merits and characteristics with one's friends (or in a seminar room with students) than—as is the case with exhibitions—by viewing it on a wall while moving forward to see the next one.

Practical reasons also limited the size of Old Master prints. Large copper plates were hard to handle, most hand-presses were fairly small, the even distribution of ink on a folio surface was difficult to achieve, and paper size discouraged large prints as well. The main reason, however, was artistic and cultural. Apart from broadsheets and wall prints, the print was a work of attention and concentration, of intellectual sophistication and high artistic performance. The artist wanted to satisfy and instruct a knowledgeable and demanding public, and viewers expected works of great visual interest and skill.

Since the introduction of the printer's press, which made the duplication of images on woodblocks and metal plates possible, some prints have reproduced works of art in different media, while others have been original designs by the printmakers themselves. This fundamental distinction has been maintained by scholars in their documentation of Old Master prints. In the monumental catalogue of prints that Adam Bartsch began to publish in 1802, still in constant use as a reference work, Bartsch limited himself to "peintre-graveurs," that is to "painter-printmakers"—in other words, only to those artists who put their own designs into print. Sometimes his ambition to present complete oeuvre catalogues of important artists made it necessary to include reproductive prints of the second category as well. The dividing line between an "original" and a "reproductive" print is sometimes difficult to draw. Many reproductive prints are of such excellent quality that they are true masterpieces. In the case of Andrea Mantegna, art historians have still not established exactly which prints he executed himself and which were made by a master printmaker after his designs. Also, the importance of

the role that reproductive prints played as vehicles for the distribution of artistic ideas should not be underestimated.

In spite of its relatively small size, the print always has been a major art form. Some of the greatest artists were more productive and, in many ways, more creative and influential as printmakers than as painters. Dürer was the son of a goldsmith, and early in his life he learned from his father the handling of precision instruments, including the burin in the craft of engraving. The same can be said of Martin Schongauer, whose father practiced the same craft. Not only did Dürer make many more engravings than paintings (not to speak of his woodcuts, which were probably cut by a professional specialist, and his few etchings and drypoints), but the art of engraving was fundamental to him. When painting, he adjusted the art of the brush to that of the burin, transferring the linearity of the print to a different medium. And when applying color to canvas or panel, Dürer never could forget the luminous tone and spatial effects the paper surface contributed to his prints (and also to his drawings). Although in greater demand as a painter, Dürer psychologically seems to have been an engraver first, and to have thought in line rather than in color. He also wrote explicitly of the commercial advantage of printmaking over painting.

Is the absence of color in Old Master prints a deficiency? On the contrary, the concentration on line and tone and on contrasts of black and white that printmaking requires often enhances formal definition and gives clarity to the ideas of the artist. Color may suggest detail without defining it; the printmaker does not have that luxury. Great artists like Dürer and Rembrandt clearly profited from the need to concentrate on the black line and white paper, and developed the skills they needed to equal and surpass the effects of color. Color would be superfluous in Dürer's engraving of *Saint Jerome in his Study* of 1514, with its enormous gourd realized so powerfully through the skillful use of the burin to render texture and volume (fig. 2, cat. no 99; also see p. 48).

To understand the potential of the print it is best to focus on an artist who made a highly personal use of the medium and, in doing so, elevated it to a level that had a profound effect on generations of artists after him. In seventeenth-century Holland prints were made in great quantities and for many different purposes: for political impact or for religious instruction; to portray people or to extol the beauty of the countryside. By this time, printmaking had come to be widely used for these and many other reasons, and many great artists were attracted to the medium. In France, for example, Jacques Callot worked almost exclusively as a draftsman and printmaker, producing images that were highly detailed and often deeply moving. In Flanders, publishers needed countless images to illustrate their books and Rubens effectively organized the distribution of his paintings by personally overseeing the production of excellent prints. But nowhere was there such a variety of style and subject matter as in Holland.

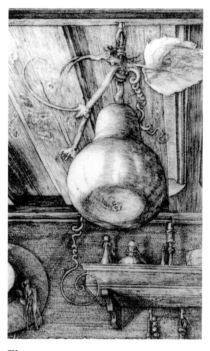

Fig. 2
Albrecht Dürer
Saint Jerome in his Study, 1514,
cat. no. 99 (detail)

Fig. 3 Lucas van Leyden, *The Raising of Lazarus*, c. 1508, cat. no. 182

In many respects the greatest printmaker among all these artists, whether living in Holland or elsewhere, was Rembrandt. Although a prolific painter it may well be that Rembrandt preferred printmaking. This was especially evident during the 1640s and early 1650s, and applies also to the way he treated certain types of subjects, especially religious narratives and landscapes. Very early in his career Rembrandt recognized the power of the line, unaided and unaffected by color. The engravings of Lucas van Leyden, whom he particularly admired, showed Rembrandt how line could express movement and feeling. Prints such as *The Raising of Lazarus* (fig. 3, cat. no. 182), *The Return of the Prodigal Son* (cat no. 183), and *Potiphar's Wife Accusing Joseph* (cat. no. 184, ill. p. 50) in which Lucas had demonstrated his admirable ability to portray gestures and to suggest subtle emotions, must have had a profound impact on Rembrandt.

Rembrandt depicted most of his religious subjects in painted form until the early 1640s, after which he turned increasingly to etching and drawing to render images from the Bible. It was during this period, when he was in his late thirties, that his views about man, religion, and history were shaped. Ironically, for their own paintings of biblical subjects, Rembrandt's pupils were greatly influenced by his etchings. They admired the formulation of narrative in his prints, his definition of space and light, and his creative use of gesture and expression. They may have felt, however, that they lacked the technical and mental discipline or simply the ability to make etchings that in quality and sophistication would come close to equaling, let alone surpassing, those that Rembrandt had produced. This may be the reason for the paucity of religious subjects etched by his pupils or followers.

We learn from the Florentine collector and writer on art Filippo Baldinucci, as well as from correspondence between Guercino and Rembrandt's patron Count Ruffo in Sicily, that in Italy the Dutch master was primarily known as an etcher. Rembrandt's etchings were collected not only by his Italian contemporaries, but soon after they were printed they also appeared in France and elsewhere in Europe. In the early sixteenth century, Dürer's engravings of biblical scenes and other subjects had a similar immediate influence on painting, printmaking, and the applied arts, including the work of some of the most prominent artists of his day. Indeed, the principal reason for the widespread familiarity with the works of Dürer and Rembrandt (and other sixteenth and seventeenth-century masters) was the broad distribution of their prints. The traffic in prints, which was associated with the book trade, was extensive during this period. In contrast, paintings were accessible to only a handful of viewers except when they were made for special occasions or for display in public institutions. No wonder Dürer and Rembrandt said more through prints than paintings.

The significance of the print for Rembrandt becomes manifest in several different ways through the analysis of his etchings. In the small *Self Portrait in a Fur Cap* of 1630 (fig. 4, cat. no. 228), Rembrandt

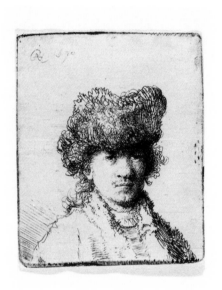

Fig. 4 Rembrandt van Rijn, *Self Portrait in a Fur Cap*, 1630, cat. no. 228

represented himself with his hair cut fashionably longer on one side in back than on the other, and with his coat trimmed in the same fur as that of his hat. The image of mature responsibility and self-conscious individuality that he presented here appears in painted portraits of the same time. In his face in this tiny etching (which lends itself remarkably well to enlargement), he explored the possibilities of representing three-dimensional form and expression through the use of short, curved little dashes (fig. 5). He did so for the sake of portraiture—for the sake of creating a lively rendering of his skin and hair in a manner that is differentiated from his equally lively rendering of the fur of his cap and coat, and to portray himself as a serious citizen with a distinct personal and social identity. This type of portrait was not unusual at the time, but as a self portrait it certainly was for Rembrandt. He made a number of small etchings around 1630 to study expressions like surprise, anger, and amusement and to cast himself in a vague historical or literary guise. In this small etching, by contrast, he offered a serious portrait of himself without any such allusions or posturing (as in the painted portrait of 1629)—an approach that was essentially new for him.

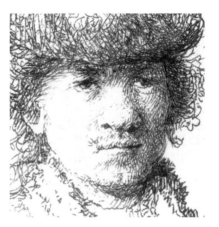

Fig. 5
Rembrandt van Rijn
Self Portrait in a Fur Cap, 1630,
cat. no. 228 (detail)

Rembrandt applied what he learned in this small self portrait to the painted and etched portraits that he produced during the remainder of his career. The portrait of *Jan Lutma, Goldsmith* (fig. 6, cat. no. 251; also see ill. p. 66), made twenty-six years later, is a descendent of this self portrait. A greatly respected goldsmith who also lived in Amsterdam, Lutma was the artist's senior by more than twenty years. Yet, the light in these two images, albeit in reverse, is similar, and Rembrandt renders Lutma's puffy flesh, wrinkles, and warts, by means of short lines similar to those used in the earlier print. In this case, however, he conveys a totally different personality marked by his sitter's enigmatic, yet benign smile. In the second state, also in the Weil collection, Rembrandt moved the sitter and his chair closer to us by adding a niche with a window behind him and by moving back the corner of the wall at the left (cat. no. 252; ill. p. 118). Lutma's features were further enhanced by additional short, flexible lines. This conception of old age differs notably from that of Dürer's. In the latter's *Saint Jerome in his Study*, mentioned above, the elderly saint is seen at a greater physical and thus psychological distance, his figure engraved with minute precision (fig. 7).

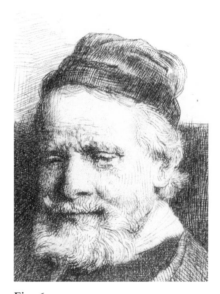

Fig. 6
Rembrandt van Rijn
Jan Lutma, Goldsmith, 1656,
cat. no. 251 (detail)

Rembrandt's late portraits, such as the one of Jan Lutma, are so well known today that it is easy to forget that they were most unusual in their own time. Conventional portrait prints were generally highly finished. They often combined engraving and etching and were usually done after drawings made by others. In the background or the margin, objects were typically added to function as symbols of the sitter's profession and achievements. In contrast, Rembrandt executed his portrait prints himself, in etching and drypoint, often with strong effects of light and dark that suppress detail and resemble the black tones obtained with the mezzotint technique that was invented and practiced by others at that

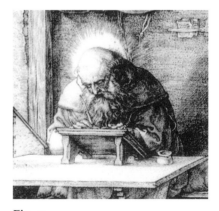

Fig. 7
Albrecht Dürer
Saint Jerome in his Study, 1514,
cat. no. 99 (detail)

33

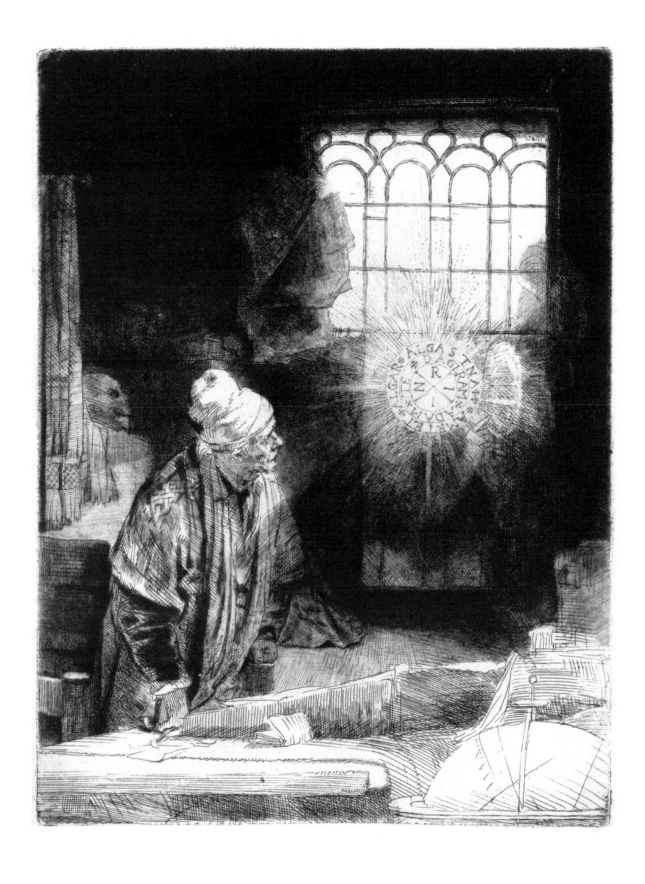

Fig. 8 Rembrandt van Rijn, *Faust*, c. 1652, cat. no. 249

time, but never used by Rembrandt himself (the dark areas in good impressions of *Faust* of c. 1652, [fig. 8, cat. no. 249] also have mezzotint-like passages). In such portraits, he often included a piece of furniture or another object that would naturally accompany the sitter and allude to his profession. Here it is the tools of the goldsmith and the bowl and statuette made by Lutma himself that identify his profession and suggest his stature. In other portraits, the object may be a painting on an easel (*Jan Asselijn*, B. 277), the Bible (*Jan Cornelis Sylvius, Preacher,* cat. no. 253, ill p. 18), or the paraphernalia of a learned man (e.g., the above-mentioned imaginary portrait of Faust).

The majority of men that Rembrandt portrayed in his later etchings—artists, clergymen, a collector, the man in charge of public auctions—belonged to his world of acquaintances. The reasons why he portrayed certain people and not others are not documented, but one cannot escape the impression that he etched portraits for personal reasons, to express respect, friendship, or to acquit himself of a debt or obligation. This last reason may explain the 1655 etched portrait of *Pieter Haaringh* (also called *Young Haaringh*, B. 275), the auctioneer in Amsterdam who presided in that year over a public auction that contained some of Rembrandt's possessions. It seems likely that the relationship between Rembrandt and his sitters in these instances differed from the usual arrangement in which a client commissioned a portrait for an agreed-upon fee. Rembrandt cherished his independence and preferred to do things as he pleased. The varied and highly personal style of these portraits may well reflect a different kind of relationship between the artist and his sitters. He may have felt free from established conventions when making portraits for which he was not required to satisfy the expectations of a paying client. It was also Rembrandt's sense of independence and, perhaps, pride that prevented him from using other artists' designs for his etched portraits, although late in life, possibly for financial reasons, he made a print after a painting, the *Portrait of Jan Antonides van der Linden* of 1655 (B. 264). This print was never used for the book it was intended to illustrate, possibly because the publisher had wanted an engraving rather than an etching.

Rembrandt's belief that printmaking was a creative medium led him to make few studies before beginning to work on the plate, although he may have thrown out some quick compositional drafts and may have made more figure studies than the handful we now have. In exceptionally complex cases he made oil sketches in preparation for an etching. Most of the preliminary drawing, however, such as the contours of figures, was done with the etching needle directly on the prepared (or unprepared) copper plate, with any corrections made along the way. The two large-plate prints, *Christ Presented to the People* of 1655 (cat. no. 233, ill. p. 64) and *The Three Crosses* of 1653–c. 1660 (cat. no. 234, ill. p. 68) are complex images for which Rembrandt apparently drew only a few figure studies. Not only did Rembrandt execute these two monumental prints with

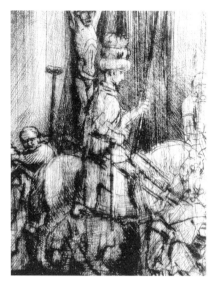

Fig. 9
Rembrandt van Rijn,
*Christ Crucified Between the Two
Thieves: The Three Crosses*, 1653–c.
1660, cat. no. 234 (detail)

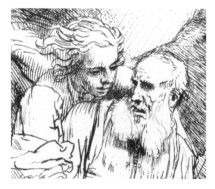

Fig. 10
Rembrandt van Rijn
Abraham's Sacrifice, 1655,
cat. no. 230 (detail)

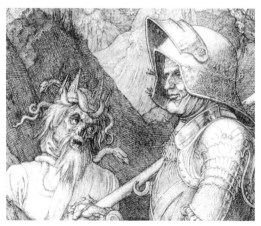

Fig. 11
Albrecht Dürer
Knight, Death and the Devil, 1513,
cat. no. 98 (detail)

virtually no preliminary drawings, he also drew with his needle directly on the bare plate without taking the customary step of preparing it with a ground and then biting the surface with acid wherever it was exposed by the needle. Both scenes were literally scratched into the plates and carved out with sharp needles and burins. This drypoint procedure reveals Rembrandt's respect for the print as a self-contained medium; it reflects his direct involvement with his materials and demonstrates his abundant inventiveness. Such a technique blurs the distinction between prints, drawings, and paintings, for the touch of the artist's hand is more keenly apparent in the drypoint than in any other printmaking method before lithography revolutionized graphic arts.

Monumental prints of this type designed by Peter Paul Rubens would have been copied by other artists such as Paulus Pontius or Lucas Vorsterman, who specialized in reproducing the master's paintings, oil sketches, or drawings. However, Rembrandt had neither his drawings nor his paintings copied in print form for the sake of publicizing his designs, as Rubens did so efficiently. Only in his early, ambitious years did Rembrandt choose to reproduce one of his own paintings, *The Descent from the Cross* of 1632–33 (Bayerische Staatsgemäldesammlungen, Munich), which resulted in an etching largely executed by another artist, probably J. G. van Vliet (B. 81).

Rembrandt's religious etchings rank among the greatest biblical images ever made. In *Christ Presented to the People* (cat. no. 233, ill. p. 64), he emphasized the contemporary relevance of the savior's sacrifice by likening the architectural setting of this image to the new Amsterdam City Hall, which was the site of public executions. In a different vein, to enhance the historical dimension of his rendering of the Crucifixion on Mount Golgotha, Rembrandt included in the fifth state of *The Three Crosses* a Roman soldier on horseback dressed in Italian Renaissance costume based on a figure in a medal by Pisanello (fig 9, cat. no. 234). In *Abraham's Sacrifice* (fig. 1, cat. no. 230), Rembrandt paid homage to his former teacher Pieter Lastman, as he had in 1635 with his painting of the same subject (Hermitage, St. Petersburg). But while he borrowed realistic detail and figural proportion from Lastman, he humanized the drama by making the silent dialogue between Abraham and the angel the focal point of the narrative (fig. 10). The expression of emotions was, indeed, one of Rembrandt's principal concerns, and the immediacy of the techniques of etching and drawing ideally suited this purpose. Almost a century and a half earlier, Dürer had represented a silent dialogue of a different nature in a different technique, in his engraving of *Knight, Death and the Devil* of 1513 (fig. 11, cat. no. 98; also see catalogue frontispiece). For Dürer, the presence of death and the devil were allegorical rather than real, and the knight does not see death, whereas in Rembrandt's etching the angel actually enters the earthly realm of Abraham and, as a result, their intense exchange becomes almost physically palpable.

In the etching *Christ Preaching* of c. 1652 (fig. 12, cat. no. 232),

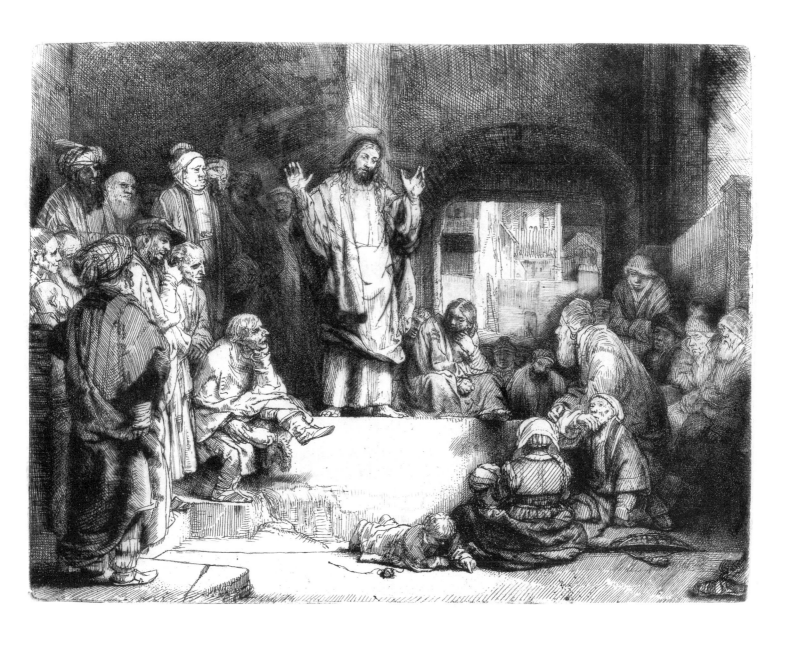

Fig. 12 Rembrandt van Rijn, *Christ Preaching*, c. 1652, cat. no. 232

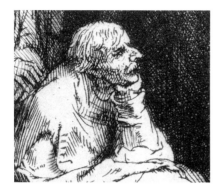

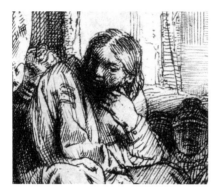

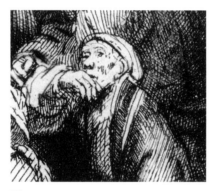

Figs. 13–15
Rembrandt van Rijn
Christ Preaching, c. 1652,
cat. no. 232 (details)

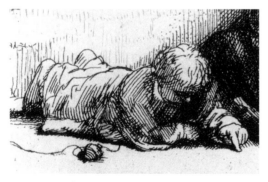

Fig. 16
Rembrandt van Rijn,
Christ Preaching, c. 1652,
cat. no. 232 (detail)

Rembrandt performed a remarkable creative act: he presented a subject that was new to art. Since sound cannot be depicted, Christ's spoken word is conveyed partly through his emphatic gesture of raising both hands, but more particularly and most emphatically through the reaction of his audience. The crowd listens intently to his words, each person in his own way (figs. 13-15). In the foreground a child draws in the dust, oblivious to the importance of the preacher and his message, thus providing the perfect foil to the rapt attention of his elders (fig. 16). Another etching that reveals Rembrandt's interest in the subject of preaching and listening is the very complex *The Hundred-guilder Print* (B. 74).This print, whose central theme is the healing of the sick, preceded *Christ Preaching* and was equally innovative. No artist had ever combined various passages from *Matthew 19* into one scene. Given the sophisticated audience for prints, etching lent itself well to the launching of new subjects, an extremely rare phenomenon in art. Rembrandt could not have introduced these idiosyncratic subjects in his paintings.

The medium of the print also fostered the creation of serial images. From the beginning, artists have made series of prints on all kind of subjects: biblical narratives, mythological scenes, allegories, the four continents, the four seasons, the seven virtues and seven vices, and so on. The series made it possible to illustrate a narrative by means of individual episodes, or define a subject by illustrating different aspects of it. Dürer's *The Large Passion* (cat. nos. 85-96), appeared at the time when the educational impact of printed series of images equaled and surpassed that of sermons or books. The series as a whole could also mean more than the sum of its constituent parts. The cumulative power of prints forming a series was understood perfectly by two later artists who both, at different times and with very different emphases, wished to explore the darker side of human nature. Jacques Callot's *The Miseries of War* and Francisco Goya's *The Disasters of War*, both parts of the Weil gift (cat. nos. 28-52 and 102-81) were created almost two centuries apart using very different printmaking techniques. These two series, probably the most powerful indictments of man's cruelty to man, are capable of overwhelming the viewer, particularly when seen together.

Rembrandt's concept of serialization was different. The closest he came to making a series of prints, similar in purpose to those just mentioned, was when around 1654 he etched six scenes from the youth of Christ (B. 45, 47, 55, 60, 63, 64). Although these prints apparently were never issued as a series and are not numbered or otherwise marked as forming one, their subject matter and size, and their style and date make them a coherent group. Certain of his etchings, however, are more loosely linked, sharing certain characteristics while differing in other respects. In spite of their varied dimensions, his early small self portraits showing exaggerated facial expressions (B. 8, 10, 16 316, 320, and others) certainly form a coherent group or series without having been explicitly defined as one. Another series (in the sense Rembrandt attached to it) consists of

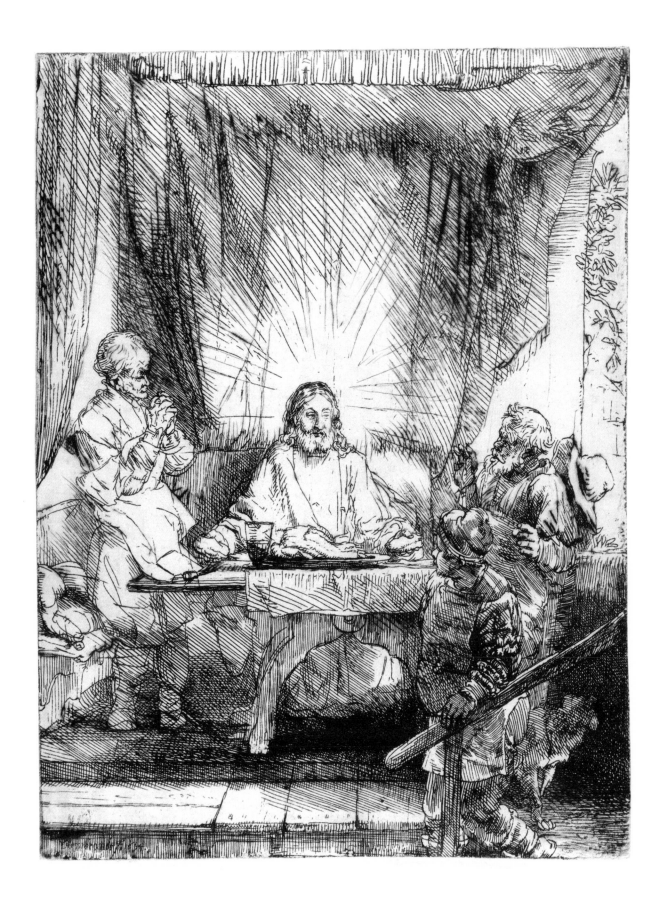

Fig. 17 Rembrandt van Rijn, *Christ at Emmaus*, 1654, cat. no. 235

Fig. 18
Rembrandt van Rijn
Christ at Emmaus, 1654,
cat. no. 235 (detail)

printed sheets of studies, mainly of quickly sketched heads grouped on one plate, dating from 1636 to 1641–42 (B. 365, 368, 369). Rembrandt himself probably thought of these as being in the tradition of drawing books for artists. Two studies of male nudes (B. 193, B. 194), likewise intended to serve as examples for artists, probably belong to the same series. Another similar "series," dating from a different period in his career, comprises female nudes done between 1658 and 1661 (B. 197, 199, 200, 202), including one of a model seated on pillows in front of a chair, a subject he transformed into a woman bathing her feet in a brook (cat. no. 237). Likewise, the etching *Christ at Emmaus* of 1654 (fig. 17, cat. no. 235) and three other etchings of that year formed a similar loose series (with B. 50, 83, 86). Some of these New Testament scenes are distinguished by details reflecting Rembrandt's observations of daily life around him. In *The Descent from the Cross by Torchlight* (B. 83), it is the man hammering back the nails that were driven through Christ's feet in the way that a packer would dismantle a crate. In *Christ at Emmaus,* it is the servant descending the steps in front of the dais-like flooring on which Christ and his disciples are seated (fig. 18). To create a comparable series of paintings on biblical or other historical themes would require a rare commission for a special location, and for most subjects, such opportunities did not exist. Furthermore, each print gained greater significance through its association with the broad theme as explored by the artist in the series. Instead of an isolated statement, the print became an illustration of one aspect of a larger concept.

Except for the *Winter Scene* in Kassel, Rembrandt's landscape paintings depict fantastic, imaginary mountain scenes. By contrast, the great majority of his etchings represent actual views in Holland or invented ones that are based on the Dutch landscape. He drew on a tradition of Dutch landscape prints that was initiated in the beginning of the seventeenth century, mainly by Claes Jansz. Visscher and Jan van de Velde. Many compositional features of Rembrandt's etched views can be traced to that tradition, including their oblong formats. Prints such as the large *The Goldweigher's Field* (fig. 19, cat. no. 248) and *Landscape with an Obelisk* (cat. no. 245) depict recognizable sites, but in reverse; Rembrandt did not bother to transpose the scene on the plate since he was not interested in producing a document. Etchings such as *Landscape with a Cottage and Haybarn* (fig. 20, cat. no. 244) are a mixture of fact and imagination, and carry a clear message. The distant views at left and right, while perhaps taken separately from life, are artificially juxtaposed in this scene. Rembrandt contrasted the active, bustling city of Amsterdam (fig. 21), then a world center of trade, with the country-house "Kostverloren," which literally means "expenses down the drain" (fig. 22). It was a notorious case of a building that because of poor construction kept on decaying in spite of continuous efforts to repair it. Its presence in the etching alludes to the destructive passage of time, as does the farm building in the center foreground with a hole in its roof, the empty haybarn, and the

Fig. 19 Rembrandt van Rijn, *The Goldweigher's Field*, 1651, cat no. 248

Fig. 20 Rembrandt van Rijn, *Landscape with a Cottage and Haybarn*, 1641, cat. no. 244

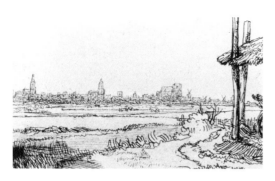

Fig. 21
Rembrandt van Rijn
*Landcape with a Cottage and
Haybarn*, 1641,
cat. no. 244 (detail)

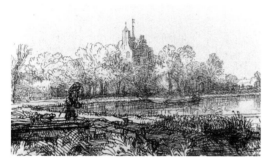

Fig. 22
Rembrandt van Rijn
*Landscape with a Cottage and
Haybarn*, 1641
cat. no. 244 (detail)

single wheel of a cart on the ground. The motifs of the boy fishing and
the child at play refer to indolence, and reinforce the theme of the power
of nature if not challenged by human industry. Earlier Dutch landscape
prints—for instance those after a series of designs by Abraham
Bloemaert—had often performed a dual function: to convey the beauty
of nature while providing moral instruction. Rembrandt's etched land-
scapes, some of which also form loose series, partake of that tradition. In
most of them, Rembrandt employed the landscape surrounding
Amsterdam to communicate his ideas about the relationship between
man and nature (Rembrandt was not interested in forests because they
provide no place for man).

About a century later, the Italian painter Canaletto etched his sun-
drenched views of buildings and monuments in Venice. The artist usu-
ally represented buildings faithfully while introducing his particular vision
of light and space, a notable exception being his *Imaginary View of Padua*
(cat. no. 63). He strove to produce recognizable sites that his viewers,
natives and tourists alike, could enjoy as souvenirs of their own experi-
ence, and populated his Venetian scenery with numerous little figures
strolling leisurely among well-known monuments. In contrast, Rembrandt
included only a few figures, implying rather than emphatically display-
ing the presence of man. Both, however, chose to make prints to reach a
wider audience, and preferred the medium of etching for its special char-
acteristics: the flexibility of line, and the effects of luminosity produced
by the contrasts of black ink on paper.

We tend to think of the various forms and media in the arts, and of
their functions, as occupying a certain place in a hierarchic order. Paint-
ing and sculpture are at the top, applied arts at the bottom, and some-
where in between one can find drawing and printmaking. It does justice
to each art form to try to recognize its own purposes, its own laws, and
its own characteristics. Certainly the artists mentioned here considered
printmaking the equal to other art forms, if not superior to them.

EGBERT HAVERKAMP-BEGEMANN
*John Langeloth Loeb Professor Emeritus of History of Art
Institute of Fine Arts, New York University*

CATALOGUE ENTRIES OF SELECTED PRINTS

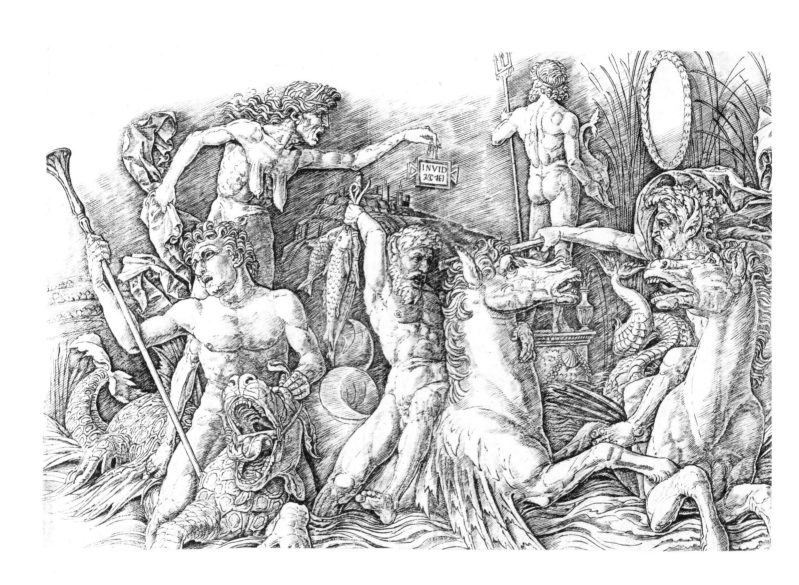

ANDREA MANTEGNA
(Italian, 1431–1506)

Battle of the Sea Gods *(left half)*, 1470s

Engraving, only state
Catalogue number 222

Andrea Mantegna, credited by Vasari and Cellini as the inventor of copper plate engraving, is central to the history of printmaking. Although he did not by any means invent copper plate engraving, he was perhaps the first important Italian painter to approach this printmaking technique as an equal and viable art form. Mantegna did not make many prints, and only seven have been definitively ascribed to his hand.[1] Thus the two engravings by the artist in the Weil collection, *The Risen Christ Between Saints Andrew and Longinus* (cat. no. 223, ill. p. 109) and *Battle of the Sea Gods,* offer a rare opportunity to study some of the earliest known examples of Italian printmaking.

The exact subject of *Battle of the Sea Gods,* one of Mantegna's most famous mythological works, has been much debated. The print in the Weil collection represents only the left half of a larger composition engraved on two copper plates and meant to be joined together. This format, along with the peculiar perspective known as *di sotto in sù,* which creates for the viewer the illusion of standing below the work and looking up, lends to the work the monumentality of a classical architectural frieze. That the figures themselves are derived from Roman sources is obvious, but a particular sarcophagus, sketchbook, or monument has not yet been identified. Indeed, the work was very likely conceived totally in the imagination of the artist himself. The grotesque personification of Envy, identifying herself by the plaque inscribed INVID dangling from her left hand, presides over and wildly encourages a fight between two marine deities. Even the fantastic horse-beasts, or hippocampi, seem to be caught up in the fight as they bare their teeth and grab at one another. The wickedness of these actions inspired by jealousy is implied by the presence of a heroic sculpture of Neptune, ruler of the seas, with his back turned to the distasteful scene.

This work has often been interpreted as a personal statement by Mantegna about the nature of envy among artists, the printmaker having had well-documented troubles with rival artists himself. Another interpretation reads the scene as an allegory of a tournament, with Envy ironically replacing the Queen of Beauty, patroness of such events. The man to the far left holds a tournament wand in his right hand and looks away in anguish as he realizes that the game has proceeded far beyond his control. Whatever the precise subject, Mantegna sought to depict in *Battle of the Sea Gods* the violence of jealousy inherent in human nature.

Mantegna's printmaking technique is very closely related to that of his painting and drawing, as all are guided by his preference for sculptural forms and bold chiaroscuro. In most of his prints, including *Battle of the Sea Gods,* he avoided the crosshatching technique to produce areas of shade, although it was certainly known to him, and instead engraved parallel hatching lines of varying depths to produce darker and lighter areas. Unfortunately, Mantegna often engraved both sides of the plate and the double printing very rapidly wore down the engraving, producing a finished work more evenly toned than intended. The print itself probably dates to the 1470s, and although trimmed at the lower edge, is nevertheless an early impression possibly printed by the artist himself, as indicated by the early watermark that the paper bears.[2]

JMB

1 For Mantegna's iconography, see Michael Jacobsen, "The Meaning of Mantegna's *Battle of Sea Monsters,*" *Art Bulletin* 64 (1982): 623–29; and Ronald Lightbown, *Mantegna: With a Complete Catalogue of the Paintings, Drawings and Prints* (Berkeley, 1986), 241.

2 For an excellent discussion on Mantegna's printmaking technique, see David Landau and Peter Parshall, *The Renaissance Print 1470–1550* (New Haven and London, 1994); although dating Mantegna's prints has always been a difficult task, the most recent scholarship points to a date in the 1470s; see the exhibition catalogue, Jane Martineau, ed., *Andrea Mantegna* (New York and London, 1992), cat. no. 79, 285–87 and Keith Christiansen, "The Case for Mantegna as Printmaker," *Burlington Magazine* 135 (1993): 606–07; the Scales in Circle watermark is also found on early impressions of this print in the Baltimore Museum of Art, the Cincinnati Art Museum, and the Hamburger Kunsthalle, according to the appendix of watermarks compiled by Suzanne Boorsch and David Landau in Martineau, ed., *Andrea Mantegna,* 471–76. This watermark is listed by Boorsch and Landau as the third earliest for this particular engraving.

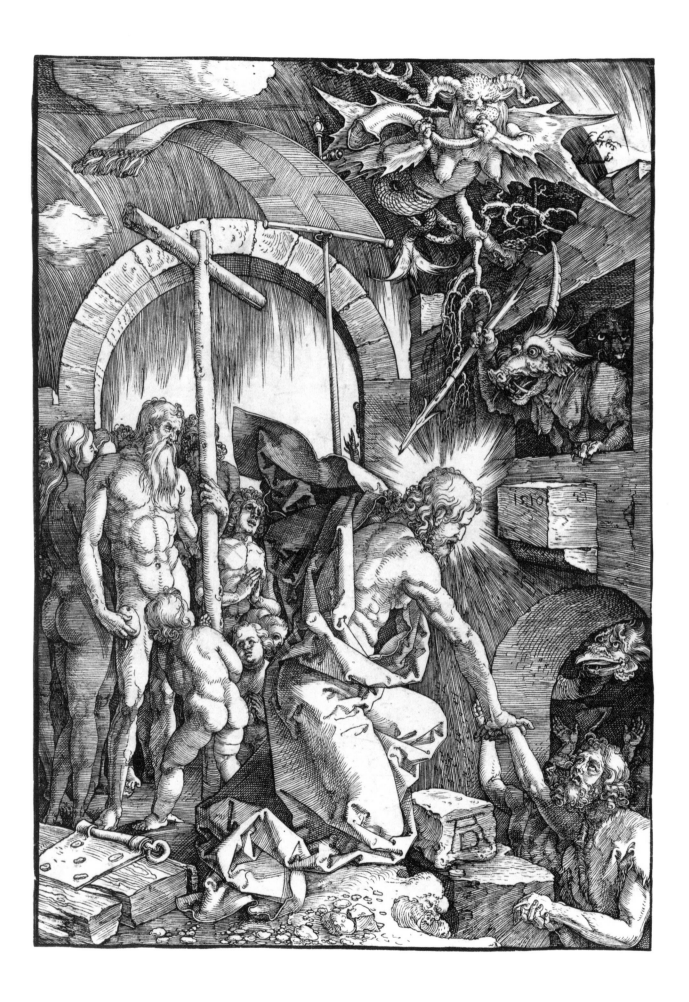

ALBRECHT DÜRER
(German, 1471–1528)

Christ in Limbo (The Harrowing of Hell), 1510, *from* The Large Passion

Woodcut
Proof impression
Catalogue number 95

The series of woodcuts entitled *The Large Passion* (cat. nos. 85–96), to which *Christ in Limbo* belongs, represents the achievement of a supremely confident and ambitious man. Albrecht Dürer began this project in 1497 at the age of twenty-six and completed it thirteen years later when he had reached the first pinnacle of his career. The vigor and drama with which Dürer imbued these woodcuts shows him worthy of the title "the new Apelles" bestowed upon him in 1502 by the Alsatian humanist Jakob Wimpheling.

The Large Passion was executed in two stages. The first seven woodcuts were designed around 1497 and issued individually before Dürer decided to add a frontispiece, four additional scenes, and Latin verses by Benedictus Chelidonius (Benedict Schwalbe) in 1510–11. The newly completed set was published as a book entitled *Passio domini nostri Jesu,* a large-scale format of the traditional pictorial books of devotion for the home. Dürer had expressed a particular commitment to such books, saying that one purpose of art was to convey the Passion of the Lord. In fact, over the course of his career he turned to that theme in two woodcut sets and one engraved version.

Christ in Limbo, also known as *The Harrowing of Hell,* was one of the scenes created in 1510, the date inscribed on the crossbar protruding from Hell. The scene records the moment when Christ, about to rise from the dead, pulls from Hell the souls of Old Testament forerunners. In Dürer's work, Christ kneels in the foreground and grasps the hands of two souls beseeching him from the arched opening of the inferno, one of whom appears to be John the Baptist in his fur covering. In the background are gathered people already drawn from the fire, one of whom is Adam holding the cross and apple with Eve behind him. While the grotesque devils rage to the right, the saved stand to the left in prayer. As in all of the woodcuts, in this scene Christ is emphasized through his foreground position, the strongly outlined contours of his body, and the relative simplicity with which he is rendered in comparison to the dense background patterning.[1]

The 1510 works of *The Large Passion* are a tribute to Dürer as a woodcut designer. In *Christ in Limbo,* for example, the variety of hatching and crosshatching perfectly exemplifies the style that Erwin Panofsky labeled "dynamic calligraphy." This technique is characterized by flowing lines which are carved without regard for the direction of the grain in the woodblock. While this method of carving is technically very difficult, it yields a broad range of tonal values and luminosity not often found in woodcuts. At this time Dürer also began to use parallel lines placed over describing lines to indicate figures in shadow. With such innovations he moved the woodcut beyond its traditional "coloring book" role and created more complex, yet easily read narrative images inhabited by heroic figures. Also revolutionary is the more spatially developed stage on which these events take place. At this point in his career, Vitruvius and Euclid, or perhaps the Nuremberg mathematicians Regiomontanus and Etzlaub, inspired Dürer to embark on the theoretical study of mathematics, human proportions, and especially perspective. The resulting new style made Dürer's woodcuts the equivalent of copper engraving.[2]

The *Christ in Limbo* from the Weil collection is a particularly crisp early impression with nuanced detailing. The distinguished connoisseur Karl von Liphart once owned this woodcut along with two others in *The Large Passion* series now at the Hood Museum of Art, the *Ecce Homo* (cat. no. 90) and *The Lamentation* (cat. no. 94). Adolph Weil collected the complete series over the course of more than eight years, carefully buying individual early proofs distinguished by the early watermarks on the paper and the strong, unbroken lines of the woodcuts.

JLC

1 For a general introduction to Dürer's works, see Peter Parshall and David Landau, *The Renaissance Print, 1470–1550* (New Haven and London, 1994). Some related aspects of Dürer's religious iconography are discussed in Peter Parshall, "Albrecht Dürer and the Axis of Meaning," *Bulletin of the Allen Memorial Art Museum* 50: 2 (1997): 431, and David Smith and Liz Guenther, *Realism and Invention in the Prints of Albrecht Dürer* (Durham, NH, 1995).

2 A discussion of his woodcut techniques can be found in Gretchen Heinze and David Moyer, *Cutter's Mark: Six German Printmakers* (Lebanon, PA, 1991) and *Albrecht Dürer: Master Printmaker* (Boston, 1971).

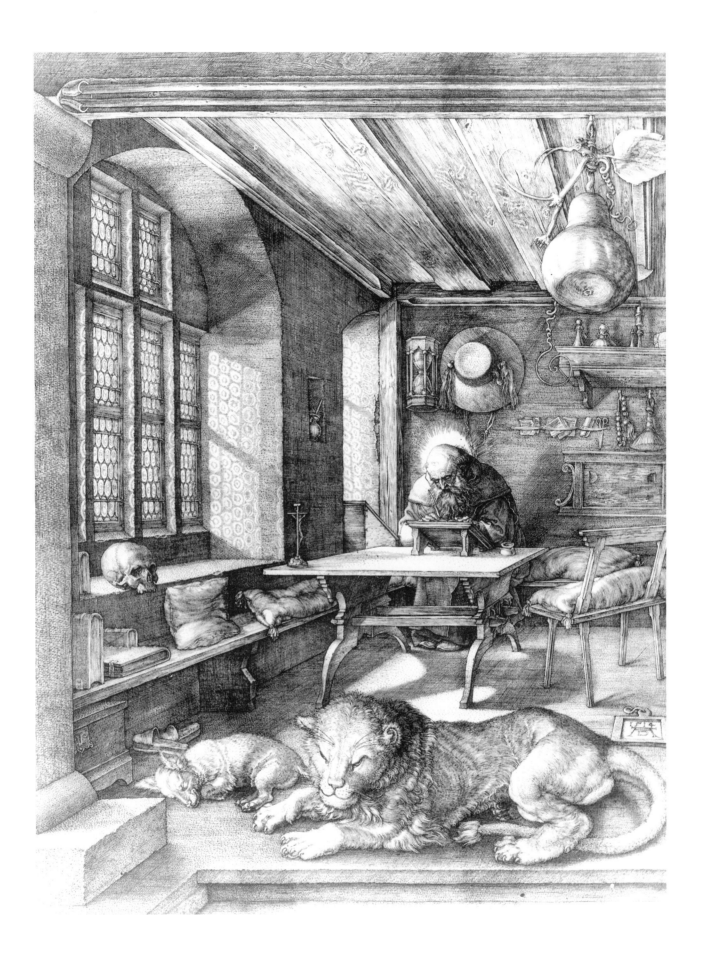

ALBRECHT DÜRER
(German, 1471–1528)

Saint Jerome in his Study, 1514

Engraving, only state
Promised gift of Jean K. Weil, in memory of
Adolph Weil Jr., Class of 1935
Catalogue number 99

Albrecht Dürer was, arguably, the premier printmaker of the fifteenth and sixteenth centuries. Certainly no other artist married such a range of subject matter to such versatility in this medium. Even before his first trip to Italy in 1495, Dürer had begun to experiment with the woodcut, bringing a much needed liveliness to what had become a very stilted genre. Shortly after his return to Nuremberg in 1496, the artist started working in the more expensive medium of copper engraving. By 1512, just before Dürer produced his celebrated engraving of *Saint Jerome in his Study,* Johannes Cochlaeus reported that his prints had brought him a fame unprecedented among Northern European artists.

With its depiction of a cozy scholar's world, *Saint Jerome* is one of the most beloved of Dürer's prints. Dürer depicted this subject seven times in his career. This version was perhaps inspired by the translation into German of Giovanni d'Andrea Bolognese's fourteenth-century biography of the saint by Lazarus Spengler, the First Secretary to the Nuremberg City Council and a friend and neighbor of the artist.

Saint Jerome sits in the middle distance, bent over his writing table and absorbed, one suspects, in his translation of the New Testament into Latin (the Vulgate). Jerome's silence is guarded by a sleeping pair, a lion and a dog. Light streams in from the two windows to the left and illuminates, among other things, a skull and an hourglass— a reminder of the passage of time and the transitory nature of human life—cushions, books, a rosary, various letters and jars, scissors, and a candle. The cell is indeed, in Erwin Panofsky's words, a "place of enchanted beatitude." In creating a world of the scholar filled with anachronistic details, Dürer transformed a fourth-century theologian into a sixteenth-century Nuremberg Humanist.

Dürer's *Saint Jerome in his Study* has been called "the engraver's engraving." With *Melencolia I* and *Knight, Death and the Devil* (cat. no. 98, catalogue frontispiece), it constitutes the group that Panofsky called the *Meisterstücke,* or Masterworks. The importance of these three works for the history of printmaking lies in their extraordinary naturalism. For example, the broad range of textures and the subtle nuances of light that Dürer achieved in *Saint Jerome* exemplify how simple hatching and crosshatching can be manipulated to produce atmosphere and color. Increasing the impression of realism is the perfect mathematical precision with which the perspective has been rendered,

making the space read as rational and orderly. As viewers we are, however, cut off from this perfect world and forced to stand on the lower stair step, unable to enter the space of the print and unwilling to disturb its palpable quiet.[1]

Dürer recorded in his diary that he gave away twelve impressions of *Saint Jerome in his Study* during his trip to the Netherlands in 1521. Most often he paired it with *Melencolia I,* an engraving understood as the genius of art and science surrounded by the tools of its calling. Since that time, scholars have attempted to decode their symbolic unity, suggesting the works represent two of the four human temperaments or symbolize sacred and profane learning; Panofsky summed up the two graphic works, when viewed in this light, as the peace of divine wisdom compared to the tragic unrest of human endeavor.[2]

The popularity of Dürer's image is attested to by its twelve known copies, the best-known being a print by Jerome Wierix. The most famous work inspired by this engraving may be Lucas Cranach's painted portrait of Cardinal Albrecht of Brandenberg (Hessisches Landesmuseum, Darmstadt) in which the learned prelate assumes the attributes of Jerome without the saint's humility.

JLC

1 For a general introduction to Dürer's works, see Peter Parshall and David Landau, *The Renaissance Print, 1470–1550* (New Haven and London, 1994). As so many interpretations of *Saint Jerome in his Study* have relied upon biographical information, Jane Hutchison, *Albrecht Dürer: A Biography* (Princeton, NJ, 1990), may prove helpful.

2 The pivotal interpretation for this print is found in Erwin Panofsky, *Albrecht Dürer* (Princeton, 1945), while the most recent examinations of it came in A. R. Bodenheimer, "Hieronymus im Gehaus: der genesene Melancholiker," *Du* 11 (November 1988): 93, 96ff., and Wojciech Balus, "Dürer's Melencolia I: Melancholy and the Undecidable," *Artibus et Historiae* 15: 30 (1994): 9–21.

LUCAS VAN LEYDEN
(Netherlandish, c. 1489 or 1494–1533)

Potiphar's Wife Accusing Joseph, *from* The History of Joseph, 1512

Engraving, state i/II
Catalogue number 184

In 1508 the young Lucas van Leyden burst upon the print world with a group of engravings that brought him acclaim as a *Wunderkind,* an artistic genius, and a master print designer. He often has been compared to his near contemporary, Albrecht Dürer, as both were encouraged by their artist-fathers and both showed artistic promise at an early age. Both men also studied the works of other artists and continued to evolve throughout their careers each taking a fundamentally different approach to printmaking. Whereas Dürer thought of description in terms of line, Lucas retained a painter's sense of pictorial structure articulated through gradations of color and light. In fact, Vasari praised Lucas for the deep landscape settings of his prints and for his ability to create atmospheric perspective through contrasts of shading and spatial relationships. Lucas's skill was so extraordinary that his prints were collected extensively by no less a printmaker than Rembrandt.[1]

Potiphar's Wife Accusing Joseph is the third in a series of five engravings which detail the history of the Old Testament hero. The tale, from Genesis 39, relates how Joseph, a favored slave of the pharaoh's bodyguard, Potiphar, became renowned for his facility for interpreting dreams. With Potiphar away, the captain's wife attempted to seduce Joseph, and when the young man fled, his cloak was left behind. Upon her husband's return, Potiphar's wife sought revenge on Joseph by accusing him of molesting her. This print depicts the scene in which she kneels with the cloak before Potiphar, surrounded by courtiers discussing the event.

In *Potiphar's Wife Accusing Joseph* Lucas has chosen to place the figures in contemporary costume. The man on the far left, for example, wears the striped outfit of a *Landesknecht,* a knight for hire. While the scene of Joseph's flight was always more popular than the confrontation, any series of images depicting Joseph's life included both. Unusual in Lucas's print is the fact that Joseph is not present; his cloak instead serves as the focus of the composition. The absence of the young man shifts the emphasis onto the interaction between the duplicitous wife and her stunned and sorrowing husband. By eliminating Joseph, Lucas has forced the viewer to confront the tension between disbelieving husband and scheming wife.

Although three of the five engravings in Lucas's *The History of Joseph* depict the young man's ability to interpret dreams, the two middle prints portray his encounter with Potiphar's wife. The moral which can be drawn from this part of the tale, that women are deceivers and that their sexuality threatens men, is related to the popular sixteenth-century theme called the "power of women." Lucas van Leyden twice designed a print series on that subject and painted several panels which refer to women's sly and treacherous nature. In those works, as in *Potiphar's Wife Accusing Joseph,* males are the subjugated victims. In representing women in such a negative way, Lucas's work reflected widespread contemporary beliefs. In the fifteenth-century Gerard Groote's essay, *De Matrimonie,* had declared women to be morally weak, while Sebastian Brant's moralizing poem of 1494, *Das Narrenshiff (The Ship of Fools),* often mentioned female treachery. Yet of all the highly charged moments in the story, Lucas chooses one that occurs after the drama is past, when emotions are being weighed.[2]

This impression of quiet is aided by Lucas's extensive use of parallel lines within the refined and carefully balanced composition. The Italian engraver Marcantonio Raimondi influenced Lucas to create such large passages of closely packed hatching as those found in this print on the back wall or in the sun's rays. Such finely engraved lines often resulted in difficulties in inking, as the narrow furrows would either be wiped clean of tint or too much ink would be left on the surface. This impression is especially lucky to have escaped both mistreatments.

JLC

1 The artist's life and career are discussed in Elise Smith, *The Paintings of Lucas van Leyden: A New Appraisal, with Catalogue Raisonné* (Columbia, MO, 1992). An introduction to his printmaking techniques and oeuvre can be found in Ellen S. Jacobowitz and Stephanie Loeb, *The Prints of Lucas van Leyden & his Contemporaries* (Washington, D.C., 1983) and Ger Luijten, ed., *Lucas van Leyden* (Rotterdam, 1996).

2 Van Leyden's depiction of women and his use of the "power of women" theme is discussed in Elise Smith, "Women and the Moral Argument of Lucas van Leyden's *Dance Around the Golden Calf,*" *Art History* 15 (1992): 296–316 and Craig Harbison, "Lucas van Leyden, the Magdalen and the Problem of Secularization in Early Sixteenth-Century Northern Art," *Oud Holland* 98: 3 (1984): 117–29.

LUCAS VAN LEYDEN
(Netherlandish, c. 1489 or 1494–1533)

The Mocking of Christ, *from* The Passion of Christ, 1521

Engraving, state i/II
Catalogue number 190

The Mocking of Christ is one of the canonical scenes included in most series of prints illustrating the Passion. Lucas van Leyden included it among the fourteen episodes he engraved for this set he made in 1521 (cat. nos. 186–99). In this series Lucas emphasized the humiliation to which Jesus was subjected by allocating four sheets to Christ's tormentors; *The Mocking* is accompanied by *The Flagellation, Christ Crowned with Thorns,* and *Ecce Homo.* This central theme of suffering is preceded by four scenes that set the stage, and followed by another four that enact the events of Good Friday. The final two sheets in the series provide the grace note of salvation with their depictions of *Christ in Limbo* and *The Resurrection.* The narrative structure possesses a pace and rhythm as it marches toward the final goal of joyful celebration.

The inspiration for this engraved series came in 1521 when Lucas went to Antwerp to meet the great artist, Albrecht Dürer. Dürer recorded the event in his diary, saying, "I was invited to be the guest of Master Lucas, who engraves in copper; he is a small man and native of Leyden in Holland, he was at Antwerp.... I have also traded eight guilders' worth of my prints for Lucas's complete graphic oeuvre." Although Lucas had been aware of Dürer's work, this meeting changed Lucas's print style in a fundamental fashion. After 1521, he increased the complexity and detail in his prints, giving them a more decorative appearance, a new direction that was clearly influenced by Dürer's compositions. The lighting in the engravings also became more intense and contrasting. These new elements can be seen in Lucas's *The Passion of Christ,* which also displays a debt to Dürer's *Engraved Passion* of 1512 and his *Small Woodcut Passion* of 1511.[1]

Lucas's experimental approach to printmaking and his willingness to incorporate new subjects and techniques into his works makes him a pivotal figure in the history of Netherlandish art. *The Mocking of Christ* contains elements of the old, such as the distorted mockers who dance around Jesus like a macabre group of Morris dancers, while the technique of this engraving incorporates a number of Dürer's innovations, such as the calligraphic line which follows the topography of an object. Like his German counterpart, Lucas learned to weave his hatching and crosshatching until the lines swell and describe rather than outline the form. The individual expressions and distorted grimaces of the tormentors also owe a debt to Dürer, and

show how well Lucas had learned the lesson of particularizing his figures.

Sources for the scene of mocking can be found in Matthew 26:67, Mark 14:65, and Luke 22: 63–65. All of these accounts tell how Caiaphas, the high priest of the Jews, gave Jesus over to his tormentors who beat him, spit upon him, and called him names. At times artists have conflated this torture with the act of crowning him with thorns, which occurred later, after Christ's confrontation with Pilate. Here, however, Lucas has stayed true to the biblical version and separated the two events. While images of the mocking of Christ can be found as early as a 1514 Evangelary from St. Peter's in Salzburg (Morgan Library, New York), the popularity of the scene only became pronounced in the late Gothic period when the proliferation of Passion plays became widespread. In all scenes of the mocking of Christ, including Lucas's engraving, the bestial behavior of the persecutors stands in sharp contrast to the mild acceptance of Jesus. By such juxtapositions the audience is brought to feel the suffering and anguish that Christ assumed for sinners.[2]

The prints in Lucas's *The Passion of Christ* from the Weil collection are all of exceptional quality and clarity. The artist often experimented with mixtures for ink and at times his engravings can seem grainy or uneven, yet under Dürer's influence he created a Passion series whose lines are unbroken and glossy. The Weil images are some of the best examples of this high point in his career.

JLC

1 For discussions of the related influences of Albrecht Dürer and the Reformation on this print, see Julius Held, *Dürers Wirkung auf die Niederländische Kunst seiner Zeit* (The Haag, 1931) and the more recent Peter Parshall, "Kunst en reformatie in de noordelijke Nederlanden—enkele gezichtspunten," *Bulletin van het Rijksmuseum* 35: 3 (1987): 164–75.

2 Lucas's life and career are discussed in Elise Smith, *The Paintings of Lucas van Leyden: A New Appraisal, with Catalogue Raisonné* (Columbia, MO, 1992). An introduction to his printmaking techniques and oeuvre can be found in Ellen S. Jacobowitz and Stephanie Loeb, *The Prints of Lucas van Leyden & his Contemporaries* (Washington, D. C., 1983) and Ger Luijten, ed., *Lucas van Leyden* (Rotterdam, 1996).

JACQUES CALLOT
(French, 1592–1635)

The Stag Hunt, c. 1619

Etching, state i/IV
Catalogue number 6

Born in the duchy of Lorraine, Jacques Callot spent a major part of his early career as a professional printmaker in Italy, particularly in Rome and Florence. Over the course of his relatively short life (he died of stomach cancer at the age of forty-three), Callot created some 1,400 prints, many of which were commissioned by the most prestigious European leaders of his time, including Duke Cosimo II de'Medici of Florence, the dukes of Lorraine, and King Louis XIII of France. His prints were collected not only during his lifetime but also in the eighteenth century by the illustrious connoisseur, P. J. Mariette, whose documentation of Callot's work has provided an invaluable foundation for contemporary scholarship. It was during Callot's time in Florence that he executed *The Stag Hunt,* perhaps the most widely recognized and admired etching in his entire oeuvre.

Although Callot devoted much of his time to the depiction of religious subjects, his personal love for the theater and for hunting provided material for a great number of etchings. These interests are combined in *The Stag Hunt,* which is a fancifully staged, though realistically situated, depiction of a private hunting party in the hills of Tuscany. The location is quite possibly the town of Signa, the site of the castle built for the Medici family by the architect Bernardo Buontalenti, seen in the left background of the print.[1] The balanced, stage-like setting is suggested not only in the perspective, which is consistent with the beholder's viewpoint, and the extreme contrast between dark and light from foreground to background, but also in the juxtaposition of animated figures and curved trees, as they all focus the viewer's attention inward toward the center of the print. This perfect harmony of perspective, technique, and subject is Callot's signature, and testimony to his mastery of the only craft he ever pursued.

Perhaps the most far-reaching contributions Callot made to the art of printmaking were his technical innovations. Having begun his training as an engraver, Callot soon became fascinated with etching and worked almost exclusively in this technique for the rest of his career. While in Florence, he developed a new, very stable ground of mastic and linseed oil that adhered well to the copper plate, giving him much greater control over the quality of his lines while eliminating the chance of foul biting. Using the *échoppe,* an etching tool with an oval cutting edge rather than a sharp needle, Callot was able to create etched lines that took on the characteristics of those engraved with a burin. This allowed him to model the figures and elements of the landscape in *The Stag Hunt* with remarkable elegance and fluidity. In addition, his deft use of stopout and the different lengths of time for biting various parts of the plate enabled him to combine strong deep lines with those of greater delicacy, as seen in the heavily inked and articulated trees of the foreground and the faint hills and castle in the far distance.[2]

Callot was a very methodical artist, often completely working out every detail of a composition on paper before pulling a single image off the plate. Unlike artists such as Rembrandt, he seldom returned to the plate when he considered a work to be finished. *The Stag Hunt* does exist in four states, yet the changes from one to the next are relatively minor. The very rare first state of the print in the Weil collection is a remarkably rich and vivid impression of one of Callot's largest and most complex works.

JMB

1 J. Lieure, *Jacques Callot,* vol. 2 (Paris, 1927; reprinted 1969), no. 353.

2 For Callot's technical accomplishments, see the discussions in the exhibition catalogue by Sue Welsh Reed in *Italian Etchers of the Renaissance & Baroque* (Boston, 1989), 222ff., and H. Diane Russell in *Callot: Prints & Related Drawings* (Washington, D.C., 1975), xvii–xxiv.

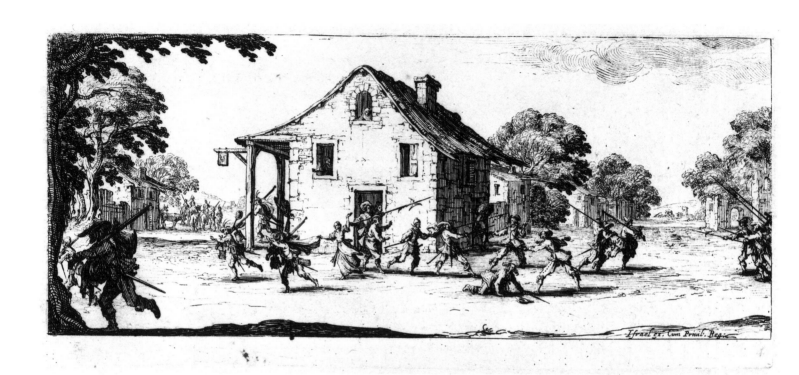

JACQUES CALLOT
(French, 1592–1635)

The Pillage of an Inn *from* The Large Miseries of War, 1633

Etching, state i/III
Catalogue number 38

At the age of twenty-eight, Callot returned from Italy to Nancy, his birthplace in the duchy of Lorraine, where he continued to work for the rest of his life. The publication of *The Large Miseries of War,* a suite of eighteen etchings, in the last years of Callot's life coincided with the invasion of Lorraine by the troops of King Louis XIII of France. Nancy was besieged and the most prominent members of the city were forced to sign allegiance to the king, a step which Callot refused to take until it became absolutely necessary to do so in early December 1634. Although there is no evidence to support a theory that this powerful series of prints documents the invasion of Lorraine or was intended to serve as propaganda against France (indeed, he began the series years before fighting broke out in Lorraine), Callot's familiarity with the horrors of war—the Thirty Year's War (1618–48) raged during much of his adult life—must have been a powerful inspiration.

Officially titled *Les Misères et les malheurs de la guerre (The Miseries and Misfortunes of War),* the suite consists of a title page and seventeen vignettes chronicling Callot's view of the cyclical nature of military life, with its sufferings and rewards. Arranged in a narrative fashion, the series begins with recruitment and battle scenes, then moves on to five plates showing soldiers plundering and pillaging the countryside. In the last plates, these corrupt soldiers are discovered and then punished in five scenes of torture and execution. *The Pillage of an Inn,* the fourth print in the suite, initiates the depictions of the soldiers' atrocities, which include the plundering of a farmhouse, the destruction of a convent, the burning of a village, and an attack on a carriage. The series ends with scenes of wounded and dying soldiers, peasants retaliating, and good soldiers receiving recompense for their actions. Both the first and last prints of the series imply that a primary motivation for the soldier to go to war is monetary reward; thus, according to Callot, war is perpetuated in part by individual greed.

The depiction of difficult and, at times, gruesome subject matter in a stylistically elegant manner was popular in Florence during the years that Callot spent there and the influence of this approach to picture making is perhaps most felt in this series. While the theme is indeed horrific, the diminutive scale and Mannerist depiction of the rather dainty figures and their settings (itself a marvelous technical feat) belie its gravity. In addition, the shadowed tree and scurrying marauder at the far left of *The Pillage of an Inn* frame the image, removing the central action from

reality by creating the stage-like setting that so much appealed to Callot. This technique is even more evident in *The Stag Hunt* (cat. no. 6).

The series was immensely popular, inspiring numerous copies and interpretations of its principal themes, the most well-known being Goya's *The Disasters of War* (cat. nos. 102–81). Later states of these prints include rhyming verses by a Parisian collector printed in the apron below each image. Examples of the first state with blank aprons, seen here in all but the final plate, are exceedingly rare. This suite was preceded by the so-called *The Small Miseries of War* (cat. nos. 28–34), which the artist apparently abandoned in favor of a larger format, thereby giving us the titles by which both series are commonly known today.[1]

JMB

1 In addition to Lieure's basic catalogue, see the study by Diane Wolfthal, "Jacques Callot's *Miseries of War,*" *Art Bulletin* 54: 2 (1977): 222–33. Both the small and large *Miseries of War* from the Weil collection were exhibited in their entirety in 1990, for which see Hilliard T. Goldfarb and Reva Wolf, *Fatal Consequences: Callot, Goya, and the Horrors of War* (Hanover, NH, 1990).

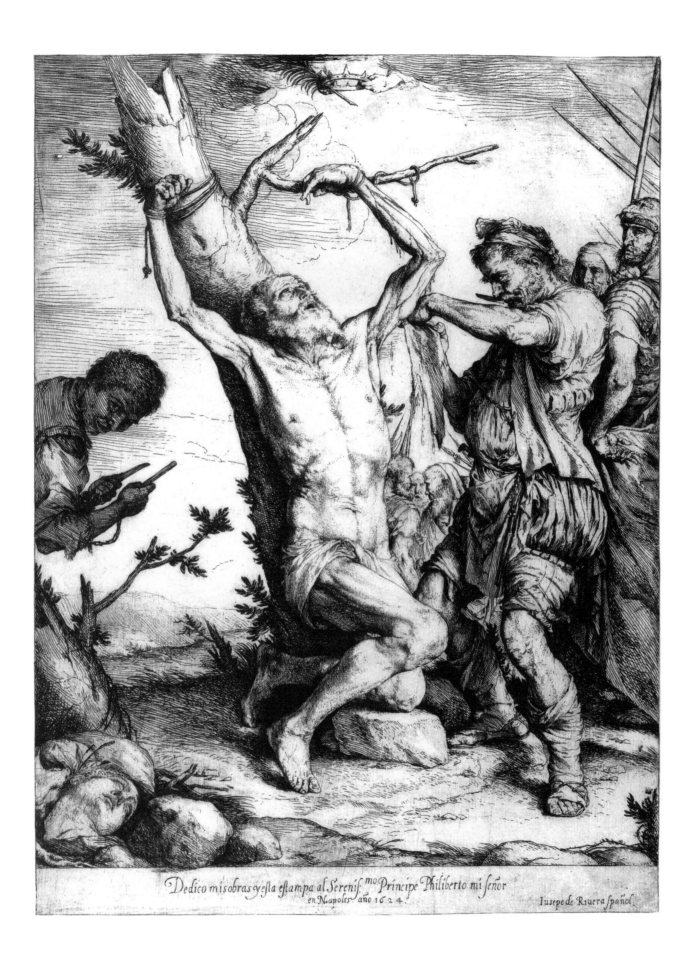

Dedico mis obras y esta estampa al Serenis.^{mo} Principe Philiberto mi señor
en Napoles año 1624.

Iusepe de Riuera spañol

JUSEPE DE RIBERA
(Spanish, 1591–1652)

The Martyrdom of Saint Bartholomew, 1624

Etching and engraving, state i/II
Catalogue number 227

Although Ribera was very prolific as a painter, his career as a printmaker was confined to a period between 1616, the year he arrived in Naples, and about 1630. Only eighteen etchings can be attributed to him, yet they represent the work of an artist who gained such control of the medium that his reputation spread throughout Europe, producing a strong contingent of followers.[1] Indeed, it is likely that Ribera clearly understood that a small series of well-executed prints, reproduced in numbers, could disseminate knowledge of his talent and enhance his fame much more effectively than paintings. After his early attempts at etching, a few physiognomic and anatomical studies and several successful religious prints, Ribera produced *The Martyrdom of Saint Bartholomew,* signed and dated 1624. This is surely the work of a mature printmaker, fully conversant with the intricacies of the etching process.

The subject, depicted here by Ribera apparently for the first time in his career, is one to which he returned often in painting and drawing; he constantly reconfigured it compositionally and psychologically.[2] Bartholomew is presented at the center of the composition, in the process of being flayed alive by order of King Astragas of Armenia after he refused to worship the king's god presented to him as an idol. The head of the idol, broken miraculously during the dispute, lies on the ground in the bottom left foreground. Ribera's rendition of this story is both horrific and poignant. The primary torturer's concentration on the macabre task at hand is visible in his tense leg and arm muscles as well as his deeply furrowed brow as he clenches the knife between his teeth, leaving his bare hands to tear at Bartholomew's flesh. The second torturer, cast in deep shadow at the far left, smiles grotesquely at the viewer, obviously relishing his imminent participation in the event as he whets his knife as well as his appetite for torture. Bartholomew, tied loosely to a dying tree, offers his arm almost willingly to his executioner, barely flinching. Confident of his salvation, Bartholomew raises his eyes to the sky from which the hand of God appears bestowing the crown of martyrdom and sainthood upon his head. The beauty and religious intensity of this direct communication is almost powerful enough to divert the beholder's attention away from the hideous corporeal reality of Bartholomew's execution.

The visual and interpretive complexity of this work attest to Ribera's well-deserved reputation as a master etcher and engraver, despite his short career. His technique was already highly refined by the mid–1620s, most evidently in the fine stippling in the martyr's chest, which casts his torso in a soft warm glow. Even the parallel hatching that Ribera employed throughout much of the composition produces a wide range of light and tone while making the image very crisp as a whole. The print in the Weil collection is the first of two states; to the second Ribera made only a few minor changes with the burin. The print bears a dedication to a nephew of Philip III of Spain, Prince Philibert Emmanuel of Savoy (1588–1624), whose premature death prevented the patronage Ribera may have been seeking from him.[3]

JMB

1 For the prints of Ribera, see the following studies by Jonathan Brown: *Jusepe de Ribera: Prints and Drawings* (Princeton, 1973); *Jusepe de Ribera, grabador: 1591–1652* (Valencia and Madrid, 1989); "Jusepe de Ribera as Printmaker," in Alfonso E. Pérez Sánchez and Nicola Spinosa, *Jusepe de Ribera 1591–1652* (New York, 1992).

2 It has been suggested that this particular composition may represent a lost painting. See Marjorie B. Cohn, *A Noble Collection: The Spencer Albums of Old Master Prints* (Cambridge, 1992), 92, no. 10; Cohn cites three painted copies of this composition in reverse.

3 Brown, *Jusepe de Ribera: Prints and Drawings,* cat. no. 12.

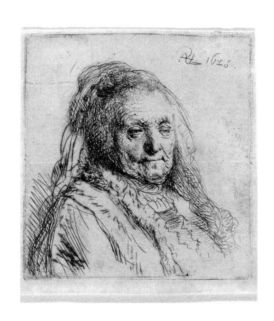

REMBRANDT VAN RIJN
(Dutch, 1606–1669)

The Artist's Mother, Head and Bust: Three Quarters Right, 1628

Etching and drypoint, state ii/II
Catalogue number 257

Over the course of his career, Rembrandt produced some 287 etchings. Unlike his paintings or drawings, they have maintained an almost unwavering appeal in the shifting tastes of the past 350 years. Part of the reason for Rembrandt's popularity as a printmaker is that he himself established many of the standards by which the art of etching is still judged. More than any other artist, he created a vocabulary for this rather informal medium, using it to capture the subtlest nuances of description and mood, as well as compelling drama. His constant experiments and improvisations eventually brought him to the very technical and expressive boundaries of the medium.

This small portrait is Rembrandt's first dated etching, and the rich burr left by the drypoint lines on the sitter's veil, along her right sleeve, and above her left eye indicates that this was one of the first impressions he pulled from the plate. Issues of rarity aside, this print shows that in 1628, at the age of only twenty-two, he had already mastered his graphic style. In little more than two years, Rembrandt has moved beyond the undifferentiated lines and loose modeling of his first attempts at printmaking to create a disciplined and expressive vocabulary that is distinctly his own. The lines move freely from close description of wrinkled skin and fine, tangled hair, to shorthand evocations of costume, to complex cross-hatchings where substance and shadow mingle together. He also has learned to lighten or darken his lines by biting them to different depths on the etching plate, as he would continue to do with ever richer results.

This old woman is the commonest face in Rembrandt's early work next to his own. She appears in paintings and drawings as well as prints, history scenes as well as portraits, from 1628 to 1639, the year before her death. That she was his mother we know from the 1679 inventory of the printdealer Clement de Jonghe (cat. no. 250), whose information must have come from the artist himself. He identifies her as the sitter in this and five other etchings dated 1628–33 (B. 343, 348, 349, 351, and 352). A miller's wife and a baker's daughter, her name was Neeltje Willemsdochter van Suyttbroeck, and Rembrandt was the sixth of her seven surviving children.[1]

Despite the scrupulous likeness, this etching is not a portrait in the usual sense. Rembrandt's mother does not pose, does not engage in the self-conscious rhetoric of social identity. She simply allows herself to be drawn on a sedentary day. In this respect the picture is less a portrait than a face-study—what the Dutch called a *tronie*. Yet she seems to have represented more than just a convenient model for Rembrandt, for she continues to appear in his art long after he left home to move to Amsterdam late in 1631. Part of her meaning for him was as an image of old age, a subject that fascinated him throughout his life. The mood of unselfconscious reverie that he gives her here and elsewhere seems to have enhanced this theme, for it suggests the ongoing flow of time more vividly than would a more fixed and formal portrait-pose. This same quality of temporality also enabled Rembrandt to turn his tronies into history scenes.[2] More than once he shows his mother as the prophetess Hannah (Br. 69, 535). At the same time, the artist also began to mix narrative into some of his commissioned portraits soon after his arrival in Amsterdam. Works like *The Shipbuilder and his Wife* of 1633 (Br. 408) or his *Portrait of an 83-Year-Old Woman* of 1634 (Br. 343) seem to look forward to our modern, novelistic conception of the self. From these perspectives this early etched portrait is a seminal work.[3]

DRS

1 For more on Rembrandt's depictions of his parents, see Ludwig Münz, "Rembrandts Bild von Mutter und Vater," *Jahrbuch der Kunsthistorischen Sammlungen in Wien* 50 (NF 14) (1953): 143–63. For Rembrandt's prints, see Holm Bevers et al., *Rembrandt: The Master and his Workshop,* vol. 2: *Drawings and Etchings* (London,1991), 161, and Christopher White, *Rembrandt as an Etcher* (London, 1969).

2 Lyckle de Vries, "Tronies and Other Single Figured Netherlandish Paintings," *Leids Kunsthistorisch Jaarboek* 8 (1989): 185–202; Frederic Schwartz, "'The Motions of the Countenance': Rembrandt's Early Portraits and the *Tronie,*" *Res* 17/18 (1989): 89–116.

3 David R. Smith, *Masks of Wedlock: 17th-Century Dutch Marriage Portraiture* (Ann Arbor, 1982), ch. 6.

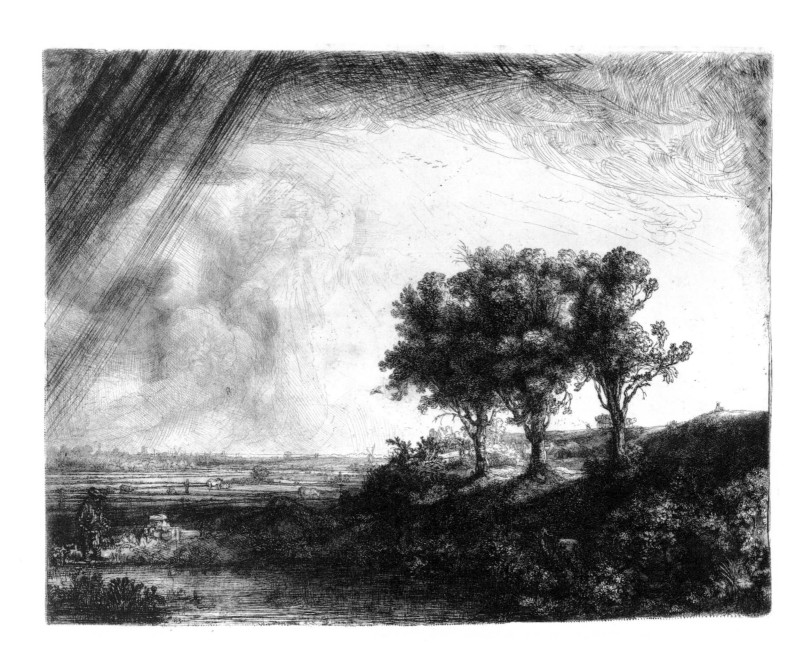

REMBRANDT VAN RIJN
(Dutch, 1606–1669)

The Three Trees, 1643

Etching, drypoint, and engraving, only state
Promised gift of Jean K. Weil, in memory
of Adolph Weil Jr., Class of 1935
Catalogue number 240

The Three Trees is Rembrandt's largest landscape etching and by far the most ambitious. It is first of all an extraordinary exercise in description. From foreground to background and from the bottom to the top of the plate, the artist seems to have laid out every detail of a world seen, reinforcing the dense variety of his etching lines with engraving in the foreground and drypoint in the sky. Yet one of the effects of this linear density is a dramatic chiaroscuro that gives the scene a heroic quality seemingly at odds with the prosaic "Dutchness" of the topography. The resulting tension between poetry and prose has raised a host of questions about matters of fact, mood, and metaphor.

Scholars have tried to identify the scene as a view of Amsterdam, either from the Diemerdijk on the east or the Haarlemmerdijk on the west. Yet we cannot identify a single one of the distinctively Dutch details in this landscape, not even Amsterdam. Equally uncertain is the weather. Many have read the clouds and the parallel lines in the upper left as a passing rainstorm. But the wind is blowing from right to left, and no one in the landscape is taking cover. On the other hand, some have interpreted the parallel lines as rays of divine light and the trees themselves as a metaphor for the three crosses. In the absence of a storm, however, the analogy to Calvary weakens considerably. Moreover, the lovers cavorting in the bushes in the lower right hardly suit a religious reading of the scene.[1]

Up to this point Rembrandt had confined his landscape prints to more prosaic scenes, such as the Weil collection's *Landscape with a Cottage and Haybarn* of 1641 (cat. no. 244, ill. p. 41). He had reserved dramatic chiaroscuro effects for narrative scenes or for his much more fanciful painted landscapes. In *The Three Trees* he has tried to create a synthesis of what are, in effect, high and low pictorial modes. In this respect the print resembles *The Nightwatch* of the previous year, where he had mixed portraiture and history. There, the members of an Amsterdam militia company take their places in a composition based on his etching *The Triumph of Mordecai* (cat. no. 231, ill. p. 114).

These are not the only examples of a striving for synthesis at this moment, midway in Rembrandt's career. But the very ambiguities of interpretation in *The Three Trees* suggest why this moment proved difficult to sustain. Just two years later, the synthesis attempted here almost literally breaks in half in his landscape etching *The Omval* (B. 209) of 1645. There, a pastoral couple much like the lovers in *The Three Trees* occupy a poetic bower that is formally and thematically cut off from a flat, banal riverscape in the other half of the composition. Apparently, the print represents an ironic commentary on the incompatibility of love and "the world," a theme also found in contemporary poetry.

Rembrandt seems to acknowledge this disjuncture in *The Three Trees,* for he places his lovers in its darkest corner. And just as he seems to set them against the squat, stolid peasant couple on the far left, so he builds the composition around the fundamental oppositions of vertical versus horizontal and shadow versus light. Its meaning evidently lies in the principle of contrast itself, including that of poetry and prose. Perhaps this is why the sketching artist in the upper right looks away from the scene: the artistic issues here go deeper than description. But in Rembrandt's later prints the modes of landscape that he brought together here part company. The poetic strain moves toward the *Saint Jerome in an Italian Landscape* (B. 104). His realism becomes less transcendent, more horizontal, in works like *The Goldweigher's Field* (cat. no. 248, ill. p. 41) or *Landscape with an Obelisk* (cat. no. 245).

DRS

1 Frits Lugt, *Wandelingen met Rembrandt in en om Amsterdam* (Amsterdam, 1915), 143; Colin Campbell, "Rembrandt's *Het Sterfbed van Maria* en *De drie bomen,*" in *De Kroniek van het Rembrandthuis,* vol. 32 (1980), 16–17; Holm Bevers et al., *Rembrandt: The Master and his Workshop,* vol. 2: *Drawing and Etchings* (London, 1991), 218–20; Cynthia P. Schneider, *Rembrandt's Landscapes: Drawings and Prints* (Washington, D.C., 1990), 240–42; idem, *Rembrandt's Landscapes* (New Haven and London, 1990); Christopher White, *Rembrandt as an Etcher* (London, 1969), 198–200; Susan Donahue Kuretsky, "Worldly Creation in Rembrandt's *Landscape with Three Trees,*" *Artibus et Historiae* 20 (1994): 157–91.

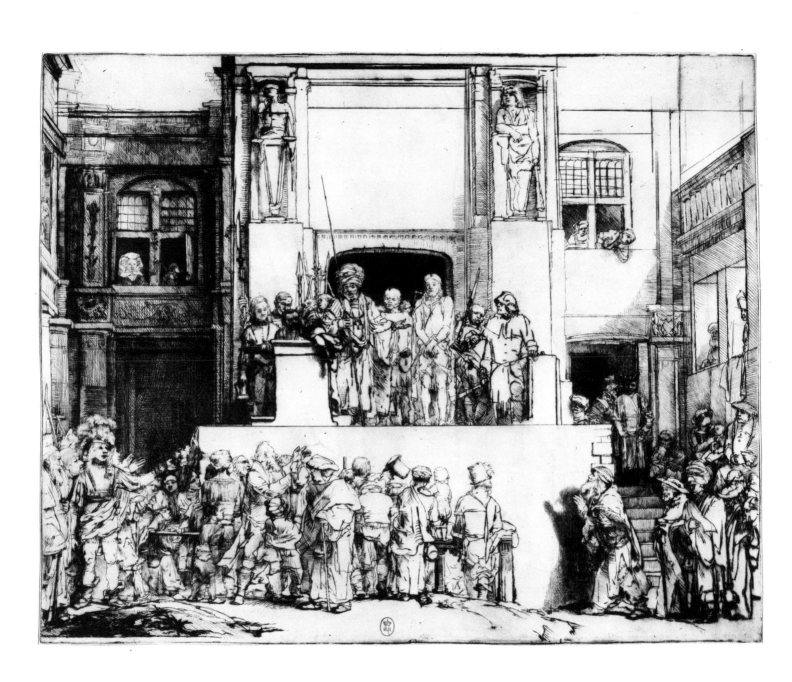

REMBRANDT VAN RIJN
(Dutch, 1606–1669)

Christ Presented to the People (Ecce Homo), 1655

Drypoint, state v/VII
Catalogue number 233

Due to its grand scale and the number of changes Rembrandt made in the plate over seven states, the *Ecce Homo* is one of his most complicated prints. The date 1655 only appears in the sixth state, when he radically altered the composition, so some have argued that he finished the first five states two years earlier as a companion-piece to the first version of *The Three Crosses,* dated 1653 (cat. no. 234, ill. p. 68). They are, in fact, alike in size and technique, and they also share the influence of Lucas van Leyden, whose large, engraved *Ecce Homo* of 1510 (B.71) was one of Rembrandt's main models, along with prints by Jacques Callot and Nicolaas de Bruyn. Like Lucas, Rembrandt has focused on the account in the Gospel according to St. Matthew, which tells of how Pontius Pilate's wife warned him to spare "that just man." In *Ecce Homo* she appears in the window in the upper left, with the departing messenger beside her.[1]

The scene's setting is almost the only example of classical architecture in Rembrandt's work, and it appears at a significant moment. For the etching coincides with the opening in 1655 of the new Amsterdam Town Hall, a classical building that the Dutch considered the eighth wonder of the world. Executions were decreed and performed on a temporary podium set up in the center of its facade, much as in the *Ecce Homo.* Rembrandt may also have been commenting on the Town Hall and the established order in placing a statue of Fortitude in the niche above Christ on the right. Customarily, the blind Justice on the left ought to be accompanied by Prudence. Fortitude is a militaristic virtue, not a judicial one, and in the sixth state Rembrandt gave her face a grotesque snarl. Winternitz has interpreted this mutation as an allegory of Violence.[2]

The print depicts the moment when Pilate offers the people of Jerusalem the choice of releasing Christ or the murderer Barabbas, the brutal figure standing between them. When they scream for Barabbas, Pilate will wash his hands in the basin held by the man on the left of the podium. Yet Rembrandt gives a curiously sympathetic view of this crowd. They are not the monsters found in so many earlier Netherlandish *Ecce Homo* scenes, but an awkward and confused humanity. Some strain for a better look, some turn in upon themselves, others turn away. In their range of response and their evident befuddlement, some of these people rather resemble the listeners in Rembrandt's slightly earlier etching of *Christ Preaching* (cat. no. 232, ill. p. 37).

That he was less concerned with moral condemnation than with questions of understanding is also apparent from the number of onlookers in windows. Time and again in Rembrandt's art, this motif alludes to the problematics of beholding. This preoccupation with beholding also underlies his removal of the figures in front of the podium in the sixth state. Looking out across a chasm, it is now we who are confronted with the choice of Christ or Barabbas.

Although later impressions of the fifth state of the *Ecce Homo* show the wearing of the plate that occasioned the radical revisions in the sixth state, the impression exhibited here is still quite good. Especially in the lower left, there are even traces of the heavy burr thrown up by drawing directly on the copper in drypoint. But in general Rembrandt seems to have been less concerned here with chiaroscuro effects of inking than he was in works like *The Three Crosses.* The geometric structure of the architecture does not lend itself to painterliness. On the other hand, the awkward, block-like character of his figures is an evocative effect of his stiff drypoint lines.

DRS

1 On various aspects of this print, see J.P. Filedt Kok, *Rembrandt Etchings and Drawings in the Rembrandt House: A Catalogue* (Maarssen, 1972), 69–71; Holm Bevers et al., *Rembrandt: The Master and his Workshop,* vol. 2: *Drawings and Etchings* (London: 1991), 274–76; Margaret Deutsch Carroll, "Rembrandt as Meditational Printmaker," *Art Bulletin* 63 (1981): 585–610; Christopher White, *The Late Etchings of Rembrandt* (London, 1969), 23–24.

2 For more on this subject, see Emanuel Winternitz, "Rembrandt's 'Christ Presented to the People'–1655: A Meditation on Justice and Collective Guilt," *Oud Holland* 84 (1969): 177–90.

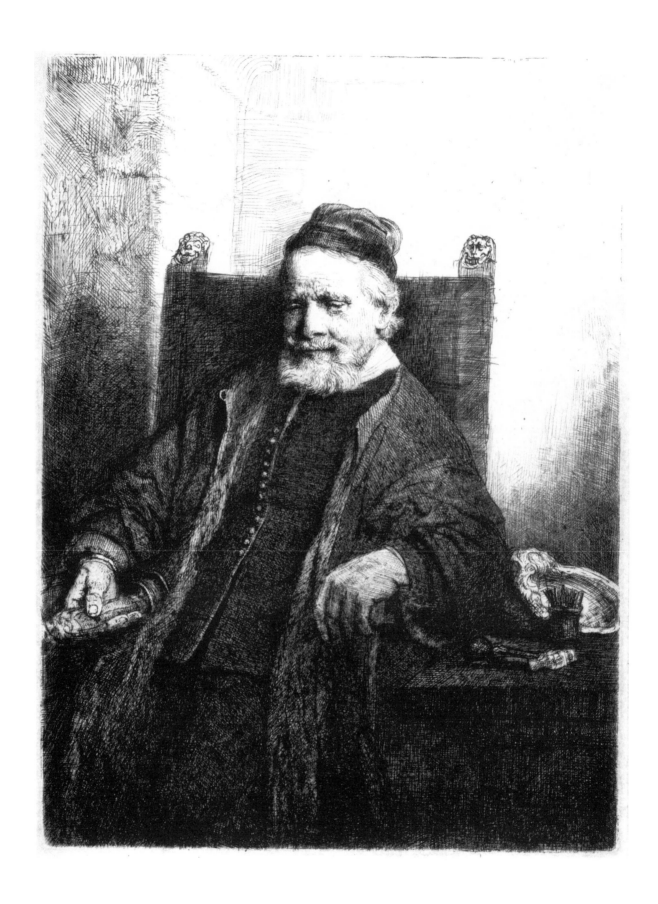

REMBRANDT VAN RIJN
(Dutch, 1606–1669)

Jan Lutma, Goldsmith, 1656

Etching and drypoint, state i/III
Catalogue number 251

Jan Lutma, Goldsmith belongs to a group of unconventional portraits that Rembrandt created between 1647 and about 1657. This decade of activity followed a period in the early 1640s when he had almost entirely abandoned the art of portraiture after the success he had experienced as a fashionable portrait painter in the 1630s. While Rembrandt's earlier works in the genre are mainly paintings of formal patrons, these later portraits deal with friends, personal acquaintances, and fellow artists, and most of them are etchings. The subject of this print, Jan Lutma, was one of the best goldsmiths in Amsterdam and, in all likelihood, a personal friend, whose son, the printmaker Jan Lutma the Younger, seems to have studied with Rembrandt (it was probably he who engraved the elegant Latin inscription in the center right of the second state). In any case, Rembrandt has focused on Lutma the artist. On the table beside him are some tools and a silver bowl that closely resembles one in the Rijksmuseum. In his hand he holds what appears to be a candlestick.[1]

What most of these late portraits share is a sense of the tangibility of the setting and the moment depicted, which is less evident in Rembrandt's earlier, more formal portraits. Yet they also carry on a dialogue of sorts with one another and with the larger conventions of the genre. Jan Lutma's seated pose, for example, belongs to a Venetian portrait convention, which Rembrandt used for a number of other portraits in this group, among them *Clement de Jonghe* of 1651 (cat. no. 250). More specifically, though, he seems to have based both works on Anthony van Dyck's portrait of the painter Martin Rijckaert, reproduced in the Flemish master's *Iconography*. Clement de Jonghe shares Rijckaert's outwardly directed gaze and the distinctive diagonal fold falling across his knee. Lutma wears a rakish hat much like Rijckaert's, and his hand grips the arm of his chair in a similar way.[2] But Rembrandt has turned the old goldsmith's gaze inward upon himself, and the diagonal of his coat has become a falling line, which seems to pull against the stable rectangle of the chair. Set side by side, the two etchings present, in effect, a dualistic vision of personhood, alternatively stable or transitory, outwardly or inwardly directed. Moreover, the same dichotomy appears in other late portraits. The Frick *Self-Portrait* (Br. 50) of 1658, for example, structurally resembles the Clement de Jonghe, while the *Nicolaes Bruyningh* (Br. 268) of 1652 in Cassel looks forward to the Jan Lutma, though there the diagonal is a rising, upbeat line.[3]

The differences between the two states of the Jan Lutma presented in the exhibition seem to cut deeper than a simple contrast between finished and unfinished (see cat. no. 252, ill. p. 118). Although he was not yet ready to sign it, Rembrandt liked the first state well enough to print numerous impressions, and some critics have felt that adding the window in the second state was a mistake. The window motif belongs to a long tradition in Netherlandish portraiture, but here it appears less integral to the image than the windows in the portraits of Jan Six (B. 285), Abraham Francen (B.273), or Thomas and Jacob Haaring (B. 274 and 275). As in those works, Lutma's window alludes to the interplay between inside and outside, self and world. But the sense of light in the unfinished background of the first state seems to serve that function more evocatively. The lightly inked impression exhibited here brings out this subtle luminosity especially well. The lines Rembrandt added or deepened in the second state certainly enhance the tangibility of his forms; but he may also have lost some of the earlier version's openness of form and mood.

DRS

1 J.P. Filedt Kok, *Rembrandt Etchings and Drawings in the Rembrandt House: A Catalogue* (Maarssen, 1972), 144–45; Ludwig Münz, ed., *Rembrandt's Etchings* (London, 1952), 69; Christopher White, *Rembrandt as an Etcher* (London, 1969), 142.

2 This relationship to Van Dyck's portrait was first noted by Perry Chapman in a paper read at the annual meeting of the College Art Association in 1982.

3 David R. Smith, "Rembrandt and the Portrait Tradition," in *600 Years of Netherlandish Art: Selected Symposium Lectures* (Memphis, 1982), 43–64.

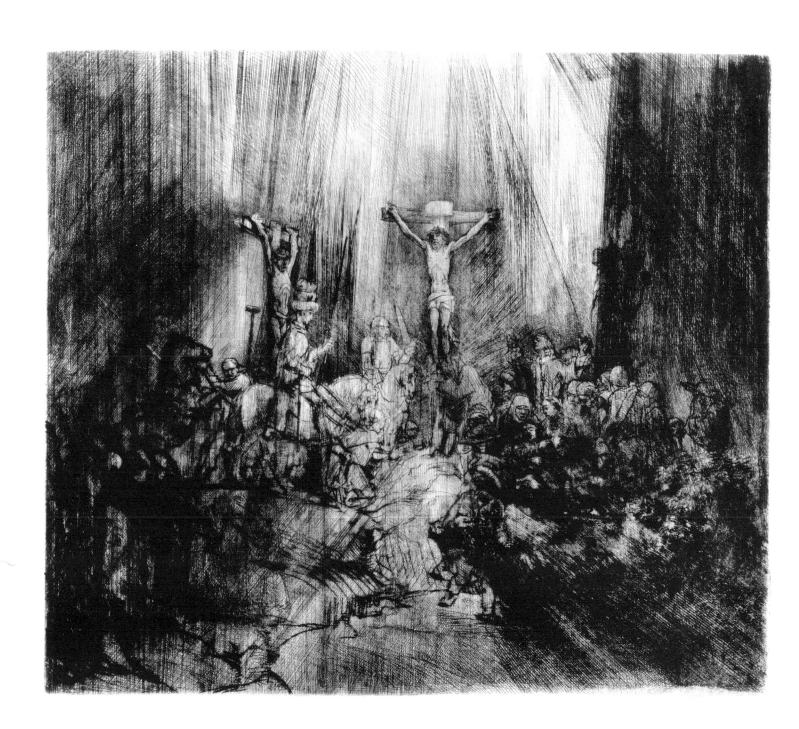

REMBRANDT VAN RIJN
(Dutch, 1606–1669)

Christ Crucified Between the Two Thieves: The Three Crosses, 1653–c.1660

Drypoint, state iv/V
Catalogue number 234

The fourth state of Rembrandt's monumental etching *The Three Crosses* represents the culmination of a Netherlandish tradition of the crowded Calvary, which goes back to the fifteenth century. In fact, one of his most important models for the first version of the plate (states i–iii) was Lucas van Leyden's large engraving of *Calvary* from 1517 (cat. no. 185), which we know Rembrandt owned. Instead of envisioning the Crucifixion in simple, iconic symmetry, both these Dutch artists have reconstructed the messy historical texture of the event. Rembrandt in particular paid close attention to the biblical text. In the earlier states he focused on the moment of Christ's death in the Gospel of Luke, when light breaks through after three hours of darkness and the converted centurion kneels at the foot of the cross. In the fourth state, however, Rembrandt went back to the earlier moment when Christ cries out "My God, my God, why hast thou forsaken me?" as described by Matthew and Mark.[1]

About seven years separate the third state of *The Three Crosses,* dated 1653, from the fourth. Possibly, Rembrandt chose to rethink the subject simply because the earlier version of the plate had worn down beyond usability. Whatever the case, the changes are more radical than in any of his other prints. The only figures surviving from the third state are the thief on the left, the running figure in the lower right, and Christ himself, whose face has become older and more desperate. All the others have been scraped away, and the "ghosts" left by some of them only add to the confusion of the scene. So does the figure holding the rearing horse on the left, whom Rembrandt borrowed from one of the *Horse-Tamers* of the Quirinal in Rome. Another, still more striking addition is the horseman with the weird, mushroom-shaped hat, adapted from a fifteenth-century medallion of *Gian Francesco Gonzaga* by Pisanello. With the grim, frontal, almost archaic rider beside him, he calls to mind the barbaric figure of Claudius Civilis, who wears the same hat in Rembrandt's huge painting *The Conspiracy of the Batavians* of 1661. Despite their different subjects, the two pictures seem to share the theme of the world turned upside down.[2] Another key theme in *The Three Crosses* is human isolation. For Rembrandt has broken up the groups in the earlier version and replaced them with a scattering of solitary, traumatized individuals. In effect, he has transformed the descriptive narrative of the third state into an internal, expressionistic one here.

Shortly after finishing the fourth state of *The Three Crosses,* Rembrandt gave up graphic art altogether and turned to painting alone. So it is no surprise that his late graphic style in this canvas-sized print is so painterly. The impression exhibited here is a somewhat later one: note the worn lines of the rider beneath the cross. Nor has Rembrandt used the rich surface-tone that adds painterly chiaroscuro to other impressions. For this very reason, however, this impression reveals the linear structure of the image especially clearly. Many of the lines have no representational function at all, save as rays of light or bearers of shadow. Thus, in the lower left, a crowded figure-group in the first version has become just an abstract network of lines. The sheer blackness of some of these lines shows how deeply Rembrandt gouged the copper with his drypoint needle. The difficulty of drawing directly on the plate partly accounts for the powerful archaistic effect of these stark, inflexible lines, which resemble Rembrandt's late reed-pen drawings. But in both media such lines also seem to represent a consciously humble and direct "plain style" suited to his Christian subject matter.[3]

DRS

1 On this print, see Christian Tümpel, *Rembrandt legt die Bibel aus* (Berlin, 1970), no. 103; J. P. Filedt Kok, *Rembrandt Etchings and Drawings in the Rembrandthuis: A Catalogue* (Maarssen, 1972), 72–75; Christopher White, *The Late Etchings of Rembrandt* (London, 1969), 18–19; idem, *Rembrandt as an Etcher* (London, 1969), 76, 99–103.

2 See David R. Smith, "Inversion, Revolution, and the Carnivalesque in Rembrandt's Civilis," *Res* 27 (1995): 89–110.

3 For Rembrandt's "plain style," see Nicola Courtright, "Origins and Meanings of Rembrandt's Late Drawing Style," *Art Bulletin* 78 (1996): 485–510.

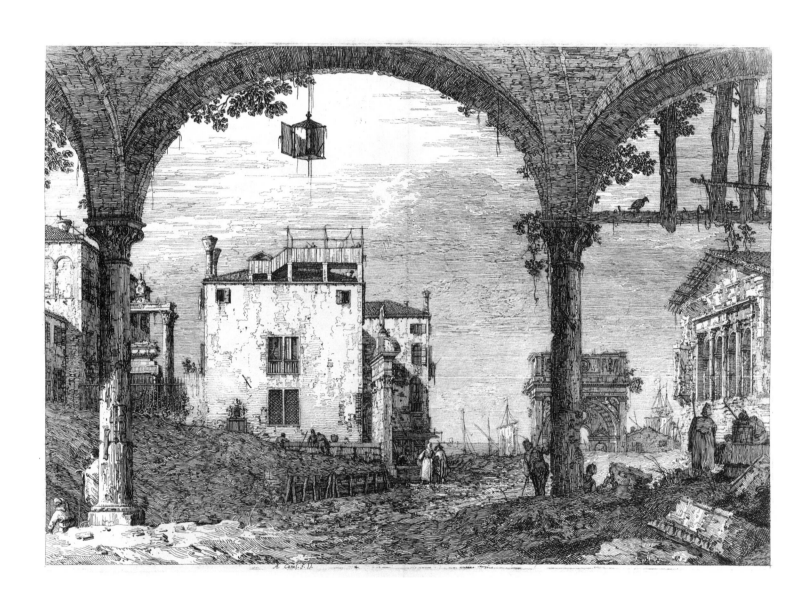

A. Canal. f. V.

GIOVANNI ANTONIO CANAL,
called Canaletto
(Italian, 1697–1768)

The Portico with the Lantern, c. 1740–44

Etching, state ii/III
Catalogue number 62

Famous as a painter of topographical views of Venice and London, Canaletto is less well known as a printmaker, largely due the small number of etchings that comprise his oeuvre in this medium. Trained as a set designer, he began painting *vedute,* or views, of Venice in 1725, and on occasion also produced *capricci,* or imaginary landscapes, which were popular among Italian art patrons in the early eighteenth century. After a lucrative period painting *vedute* of Venice—particularly for foreign visitors who came to Italy on the Grand Tour—his commissions for paintings declined in the early 1730s. It was at this time that Canaletto began to produce a series of masterful etchings, the entire set of which is in the Weil collection (cat. nos. 53–83). Created between 1735, when Canaletto seems to have first taken up printmaking, and the early 1740s, these prints were sold by the individual sheet as well as bound together in a single volume. Dedicated to the artist's greatest patron, the British collector Joseph Smith, the suite was first issued sometime after June 1744 under the title *Vedute altre prese da i luoghi altre ideate da Antonio Canal (Views, Some Taken from Places, Others Invented, by Antonio Canal).*[1] As its title indicates, the series contains both real and imaginary views of Venice, other nearby towns such as Padua and Mestre, and the surrounding countryside.[2] The *Vedute,* however, was probably not a commercial success, judging from the few impressions that survive from the one published edition. Canaletto abandoned printmaking and in 1746 traveled to London, where he hoped to receive painting commissions from the British gentry, who had been among his most devoted admirers in Venice. Despite having created a suite of landscape etchings that are a high point in the history of the genre, the artist never worked as a printmaker again.

The Portico with the Lantern is perhaps the best-known of the artist's prints, as well as the largest. It combines a number of different elements found in the other etchings from the series, such as ancient buildings, a lagoon, domestic Venetian architecture, and a bishop's tomb. On the house to the left of center, Canaletto has placed his coat of arms over the door—an emblem which appears in a number of the prints. Canaletto did not title this etching; its current appellation is taken from the lantern, with its open hatch and broken pane of glass, that hangs picturesquely from the center arch of the portico. What makes the print unusual is its point of view. The composition is framed by the shadowed portico, through which one looks out on a scene drenched in sunlight. One of Canaletto's achievements in these prints is his ability to convey a sense of atmosphere solely by means of an etched line.

The etchings by Canaletto in this collection were brought together by Adolph Weil over the course of nearly fourteen years.[3] Many of the prints, particularly those that are larger in format, are the first of two states or the second of three states. Together with the richness of the impressions and the early watermarks several of the sheets bear, this indicates that they are among the earliest printings of these celebrated plates.

KWH & KP

1 The title page refers to "Giuseppe Smith Console di S. M. Britannica," a position assumed by Smith only in June of 1744; therefore, the publication must follow this date.

2 For a chronology of the prints, see Ruth Bromberg, *Canaletto's Etchings* (London and New York, 1974), 22–27.

3 The entire Weil suite of Canaletto prints was exhibited most recently in 1995; for the publication which accompanied the exhibition, see Richard Rand and John Varriano, *Two Views of Italy: Master Prints by Canaletto and Piranesi* (Hanover, NH, 1995).

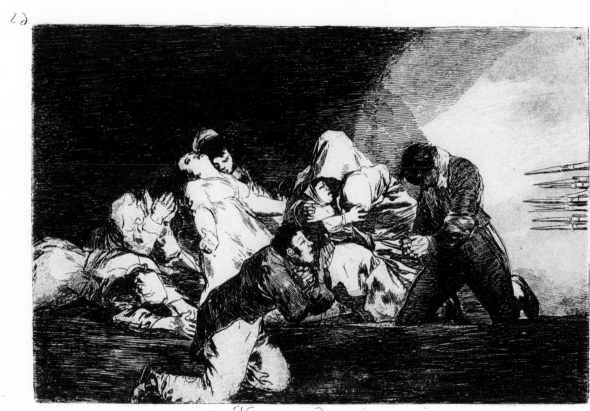

27 No se puede mirar.

FRANCISCO GOYA
(Spanish, 1746–1828)

One Cannot Look, *from* The Disasters of War, c. 1810-20, *published 1863*

Etching and aquatint
Catalogue number 127

The Disasters of War is Francisco Goya's response to the invasion of Spain by Napoleon's forces, which began in 1808.[1] Not a chronicle of the war itself but a psychological reflection of the atrocities characteristic of the Napoleonic campaign, this series of eighty prints shows horrific scenes of torture, murder, and rape. *The Disasters* marked a great departure from earlier depictions of war, which tended to glorify battle, often using allegorical symbols of nation or abstract ideals. Indeed, Goya's prints were not created to rally support for his homeland—in a few prints he even makes reference to the venality of Spanish clerics as well as the brutality of Spanish patriots. The series probably evolved instead from Goya's own visceral reaction to witnessing the war's effects on both the invaders and their victims: he lived in Madrid at the time of the May uprising of 1808 and traveled to the town of Zaragoza, which came under siege at the beginning of the conflict. While many of the first sixty-five prints were inspired by historical circumstance, the last fifteen prints in the suite, referred to in an early title given to the series as "emphatic *caprichos*," may be more symbolic in meaning.

To create this series, which is a tour de force of printmaking, Goya used an extremely complicated mixture of intaglio techniques—etching, drypoint, aquatint, lavis, burnishing and scraping in various combinations—to produce effects that range from subtly atmospheric to darkly foreboding. Although the artist printed a number of proofs of these plates during his lifetime, it was not until 1863, long after the artist's death, that *The Disasters of War* was published in its entirety. The first edition, issued by the Royal Academy of Fine Arts of San Fernando in Madrid, was preceded by ten trial proofs in which eight errors in the captions were subsequently corrected before the edition of five hundred copies was printed. The set in the Weil collection, which retains the uncorrected captions, thus was one of the earliest to be printed for the published edition. Originally bound in a brown leather album, this suite previously belonged to the important Swiss collector Felix Somary, who incidentally once owned the impressions of Rembrandt's *Faust* and *The Little Jewish Bride* also in the Weil collection.

One Cannot Look (No se puede mirar) shows the execution of Spanish civilians by firing squad. Its composition bears close relation to the artist's masterpiece, the large-scale painting *The Executions of the Third of May, 1808,* which documented the killings that took place in Madrid on the day following the failed civilian uprising against the occupation forces. The woman at the center leans back and extends her arms in the same gesture of martyrdom as the central figure of the painting. Execution by firing squad was the method used by the Napoleonic army to kill persons of standing, including members of the nobility, the church, or those highly placed in the military. After October 1809 this distinction was done away with and most executions were performed by use of the garrote.[2] By showing only the tips of the executioners's bayonets, Goya focuses on the humanity of the victims, who meet their death with dignity and resignation. The title of this plate refers not only to the people about to be killed—who cover or avert their faces to avoid the sight of their executioners—but also to the viewer, implying the scene is too horrible for any to witness, even the artist himself. One of the most powerful themes of *The Disasters* is the psychological ramifications of seeing atrocities. The victims are not the only subject of this theme. In some of the prints, executioners—unaffected by the pain and suffering of others—calmly gaze upon their handiwork: a hanged corpse or a mutilated body. In *One Cannot Look* this is taken one step further—the killers become part of the anonymous machinery of war.

KWH & KP

1 The series has been thoroughly discussed in the extensive literature on the artist. The primary source on Goya's prints is Tomás Harris, *Goya: Engravings and Lithographs,* Oxford, 1964. See also Reva Wolf's essay and checklist in *Fatal Consequences: Callot, Goya, and the Horrors of War* (Hanover, NH, 1990).

2 See Jesusa Vega, entries on *The Disasters of War,* in *Goya and the Spirit of Enlightenment,* exhibition catalogue, ed. A. E. Pérez Sánchez and E. A. Sayre (Boston, 1989), 194.

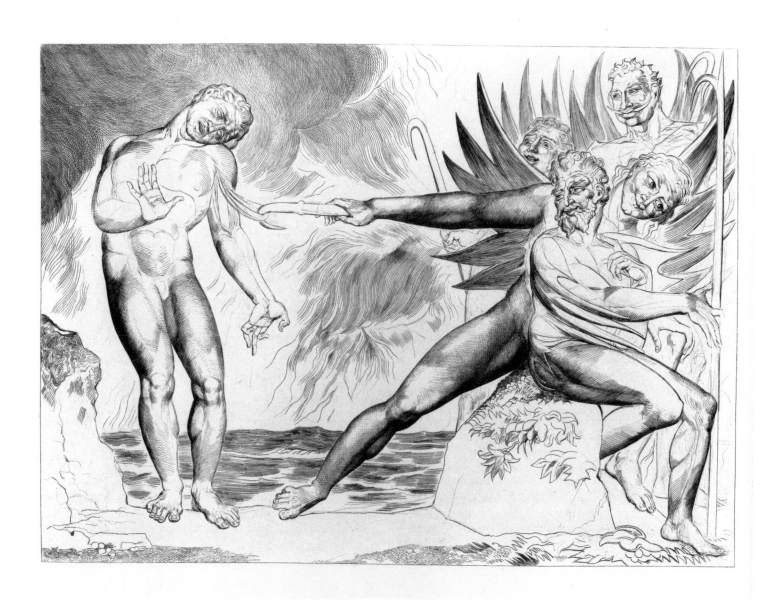

WILLIAM BLAKE
(British, 1757–1827)

The Circle of the Corrupt Officials: The Devils Tormenting Ciampolo, 1827, *from Dante's* Divine Comedy

Engraving
Catalogue number 3

The poet and artist William Blake was a reproductive engraver by profession, a trade to which he was apprenticed as a young man. In his early career, the income he earned as an engraver enabled him to work independently on his visionary watercolors and printed books. In addition to copy work, Blake received commissions to illustrate the works of others, including a set of watercolor illustrations for the Bible and watercolor designs and engravings for poems by Milton, Thomas Graves, and Edward Young (see cat. no. 1). By 1800 the artist's eccentric behavior and irritable disposition were affecting his ability to secure such work. Although he continued to receive commissions from a small number of patrons, these were not enough to sustain him and he became impoverished in the latter years of his life. His situation considerably improved in 1818 when he met the artist and publisher John Linnell (1792–1882). Linnell introduced Blake to a small group of younger artists—among them the landscape painter Samuel Palmer—who were sympathetic to his work. This close-knit group of admirers provided moral and material support for the aging artist. Linnell, in particular, was motivated to secure work for Blake and commissioned him to engrave plates based on watercolors of the story of Job that the artist had made earlier in his career.

In 1824 Linnell also engaged Blake to create over one hundred watercolors and engravings for a publication of Dante's *Divine Comedy*. By the time of the artist's death three years later, he had completed a large number of the preparatory watercolors for this project and had worked on, but not completed, seven of the plates.[1] These seven plates, all depicting episodes from the *Inferno*, were published for the first time in 1838, probably in an edition of thirty-eight; they were re-issued in an edition of fifty around 1892. Both editions were printed on India appliqué mounted to wove paper, as is the case for the Paolo and Francesca print in the Weil collection (cat. no. 2). However, the three other prints by Blake in the collection are printed directly on a thick laid paper. This, together with the extremely high quality of these prints, strongly suggests that they are part of a small number of impressions (as few as three) pulled before Linnell's initial run of thirty-eight proofs.[2]

The Circle of the Corrupt Officials: The Devils Tormenting Ciampolo depicts an episode from the twenty-second canto of the *Inferno*, the first section of the *Divine Comedy*. At this point in the narrative, the author/poet Dante and his guide,

the shade of the Roman poet Virgil, have descended far into the depths of Hell. They have arrived at the Eighth Circle, which is inhabited by sinners who have committed various forms of fraud. Within the Eighth Circle are ten ravines, each containing different types of fraudulent sinners who suffer appropriately for their crimes: panderers and seducers, flatterers, simoniacs, sorcerers, barrators, hypocrites, thieves, deceivers, sowers of discord, and falsifiers. As Dante and Virgil approach the pit of the barrators, or grafters, they observe that it is guarded by a group of winged devils called the *Malebranche* ("Evil Claws") who torment the sinners. A particular sinner, named Ciampolo, a Spaniard from Navarre, emerges just far enough from the pitch so that a devil snags him with his grappling hook and brings him up to the edge of the ravine. Another proceeds to entertain his fellow devils by mangling the wretch's arm, pulling out the sinews with his hook. Ciampolo, true to his reputation as an adept cheater, tricks the devils and dives back underneath the pitch.

In Blake's illustration of the episode, he has chosen not to show Dante and Virgil, although they are included in each of the other six plates. Instead, he concentrates on the torture of Ciampolo. All of the devils in Dante's text have descriptive, buffoonish names. Blake depicts four of them, three of which are identifiable: Kinkybeard, Doublewind (who hooks Ciampolo), and Hogtusk. The impish faces of Doublewind and the others reflect the burlesque quality of this episode, providing a foil for the gesturing hands and agonized expression of Ciampolo. Blake captures the odd quality of Dante's and Virgil's encounter with these devils—which is different from all other episodes of the *Inferno*—by contrasting the amusement and glee of the tormentors with the pain and suffering of Ciampolo. The bodies of all the figures are highly sculptural and the placement of the highlights suggests an unnaturally intense light, the type that might be cast in a fiery hell.

KWH and KP

1 For a description of the engravings, see David Bindman, *The Complete Graphic Works of William Blake* (New York, 1978), 22, 487.

2 Robert N. Essick, "The Printings of Blake's Dante Engravings," *Blake: An Illustrated Quarterly* 24: 3 (Winter 1990/1991): 84-85.

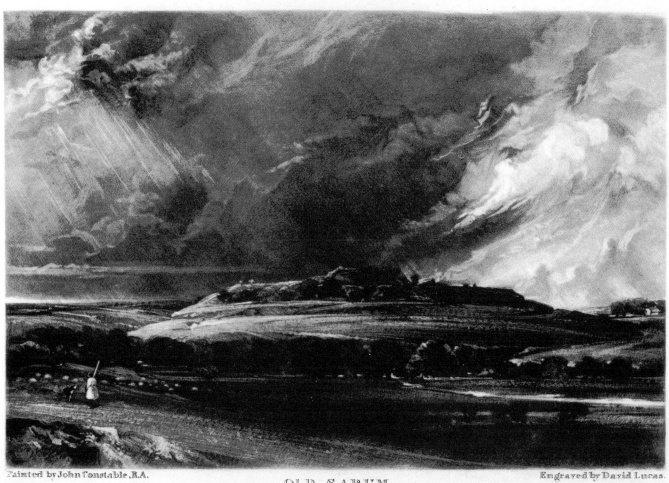

Painted by John Constable, R.A.

Engraved by David Lucas.

OLD SARUM.

HERE WE HAVE NO CONTINUING CITY." Sᵗ PAUL

London Pubᵈ by Mʳ Constable 35 Charlotte Sᵗ Fitzroy Square 1834

DAVID LUCAS
(British, 1802–1881)

JOHN CONSTABLE
(British, 1776–1837)

Old Sarum, 1832, *from* English Landscape, 1833

Mezzotint on chine collé
Second plate, state ii/III
Catalogue number 215

In the eighteenth and nineteenth centuries the art of re-productive printmaking flourished, fueled by an expand-ing art market. The relationship between the creator of the original work of art and the professional printmaker/copier was primarily a business arrangement brokered by a print publisher. *English Landscape* was, however, very differ-ent. This project, which yielded twenty-two mezzotints in five portfolios, was the result of an unusually close work-ing collaboration between the printmaker David Lucas and the landscape painter John Constable. He worked proof by proof with Lucas to create works that were not always direct copies of his original oil paintings or sketches. This artistic partnership, which began in 1827, was highly un-usual; every step in the creation of these prints was moni-tored by the artist, who inspired Lucas to create some of the greatest masterpieces of the mezzotint medium.[1]

Constable underwrote the project's expenses and pub-lished the prints himself, and therefore chose to employ a younger artisan who would be more malleable and con-siderably cheaper than an established engraver. The young Lucas was an independent printmaker probably already known to Constable through his master, Samuel Williams Reynolds. Like Reynolds, Lucas specialized in mezzotint, a method widely used to reproduce paintings, which re-lied on tonal variations, rather than line, to convey form. This professional relationship with Constable defined Lucas's career. After Constable's death, Lucas engraved a new series of prints after the artist's paintings and would later retool the plates of *English Landscape* for the pub-lisher Henry Bohn's reissue in 1855. At his death in 1881, Lucas left behind almost every piece of correspondence from the artist during their eight-year collaboration, a tes-tament of its value to him. These letters and the many surviving proof states of the prints attest to Constable's close attention to every detail in the creation of the series: he touched up proofs, occasionally added figures himself, and even made changes after the plates had been lettered.

Originally, Constable conceived of the series as two portfolios of four prints, but by July 1832 the project had expanded to include twenty-two mezzotints. For a subse-quent publication of the entire set the next year (the edi-tion of the set in the Weil collection), Constable rearranged the prints in the portfolios, rewrote and expanded the in-troduction, and added commentaries to some of the plates,

while Lucas made numerous small changes to the prints under Constable's instruction.[2] The rearrangement of the prints in each portfolio was intended to emphasize the variety of his subjects—Turner had done the same in his earlier compendium of landscape prints, the *Liber Studiorum.* One of the major changes in the 1833 edition was the substitution of an entirely new plate (illustrated here) for *Old Sarum* with which Constable had been dissatisfied. This print, based on a sketch of 1829, depicts an ancient deserted landscape—the site of ruins that had once been the first city of Salisbury. The artist had been deeply opposed to the government reforms of 1832 and to him *Old Sarum,* where, he wrote, "our earliest parlia-ments on record were convened," represented the old tra-ditions that were being threatened. The drama of the dark sky with windswept thunderclouds symbolized Constable's gloomy view of England's political future.

KWH

1 A comprehensive listing of the mezzotints can be found in Andrew Shirley, *The Published Mezzotints of David Lucas, after John Constable, R.A.* (Oxford, 1990). The Shirley catalogue was further amended by Osbert H. Barnard, "Lucas-Constable: *English Landscape:* Revised List of States," *Print Quarterly* 1: 2 (June 1984): 120–23; a new catalogue raisonné of Constable's mezzotints is currently being undertaken by Judy Crosby Ivy. For a discussion of the plates and proof impres-sions, see Leslie Parris, *John Constable & David Lucas* (New York, 1993), and for their correspondence and relationship see R.B. Beckett, ed., *John Constable's Correspondence IV* (London, 1962–68), 314–443. Reproductions of both the original works and the mezzotints can be found in David Hill, *Constable's English Landscape Scenery* (Lon-don, 1985).

2 The wrappers for the Weil set of portfolios are annotated in the upper left hand corner "Sir G. Beaumont," indicating that this set was assembled by Constable for Sir George Howland Willoughby Beaumont, the 8th Baronet, and heir and cousin to the 7th Baronet, the art collector. A letter dated May 5th [1833] from Beaumont to Constable thanks him for a set of *English Landscape.* See pp. 150–52 in Ian Fleming-Williams, ed., *John Constable: Further Documents and Correspondence* (London and Suffolk, 1975).

Nº 15 Paysage à l'hermitage/Pontoise C. Pissarro
 manière grise

CAMILLE PISSARRO
(French, 1830–1903)

Landscape at the Hermitage, Pontoise, 1880

Drypoint, state iii/III
Catalogue number 225

In the late nineteenth century intaglio as an art form—not as a reproductive medium—was revived by such figures as the publisher Alfred Cadart and the amateur artist and printer Auguste Delâtre. The Impressionists, in particular, experimented with intaglio's effects and expanded its expressive potential. Around 1863, one of the leading members of this group, Camille Pissarro, made his first intaglio, a landscape similar in style to those produced by Barbizon artists such as Jean Baptiste Camille Corot. It was not until 1879, however, when he began a year-long collaboration with Edgar Degas and Mary Cassatt, that Pissarro began to push the boundaries of the medium, employing a variety of techniques including softground, liquid aquatint, drypoint, and etching. Some of Pissarro's two hundred-odd prints that date from this period were made for *Le Jour de la Nuit,* a monthly journal of etchings that Degas intended to publish. Despite the failure of this enterprise, it served to spark a fertile period of printmaking by Degas, Pissarro, and Cassatt. Degas, who owned an intaglio press, engaged Pissarro in a visual give-and-take that inspired him to make his best work in this medium. For the last two decades of his career, Pissarro became a prolific printmaker, working in monotype, lithograph, and intaglio, often drawing directly on the plate or stone. One of Pissarro's chief innovations was his exploration of the serial nature of the printmaking process; he altered and marked states over a series of impressions, each intended as a significant expression of the print's meaning.[1]

Landscape at the Hermitage, Pontoise was executed in 1880, not long after Pissarro's intense period of printmaking alongside Degas and Cassatt. Pontoise, a small agricultural town located just northwest of Paris, was frequently the subject of Pissarro's landscapes. He also lived there periodically from the late 1860s onward. The print portrays the houses of a small hermitage where Pissarro rented a house for himself and his family and where he had played host to fellow painters such as Paul Cézanne and Paul Gauguin. Cézanne and Pissarro had painted side by side in Pontoise in the 1870s. The effect of their interaction can be detected in this print where the geometric forms of the houses are seen behind a scrim of trees—a motif that appears frequently in Cézanne's work after 1870.

The drypoint in the Weil collection is from the third state and printed on the Dutch handmade buff-colored paper favored by Pissarro. The artist has signed and inscribed the print in pencil, as was his custom. The notation *"manière grise"* refers to a method employed by both Degas and Pissarro in which they used a piece of emery, sharpened to a point at one end, to draw directly on the plate or to abrade its surface, giving the image a gray tonality.[2]

KWH

1 On the artist's printmaking practices see Barbara Shapiro, *Camille Pissarro: The Impressionist Printmaker* (Boston, 1973). For an addendum to Loys Deteil's catalogue raisonné of Pissarro, Sisley, and Renoir prints (Paris, 1923), see Jean Cailac, "The Prints of Camile Pissarro: A Supplement to the Catalogue by Loys Deteil," *The Print Collector's Quarterly* 19 (1932): 74–86. Also see Antonia Lant, "Purpose and Printmaking in French Avant-Garde Printmaking of the 1880s," *Oxford Art Journal* 6: 1 (1983): 19–29.

2 See Barbara Shapiro's introduction for a description of this technique.

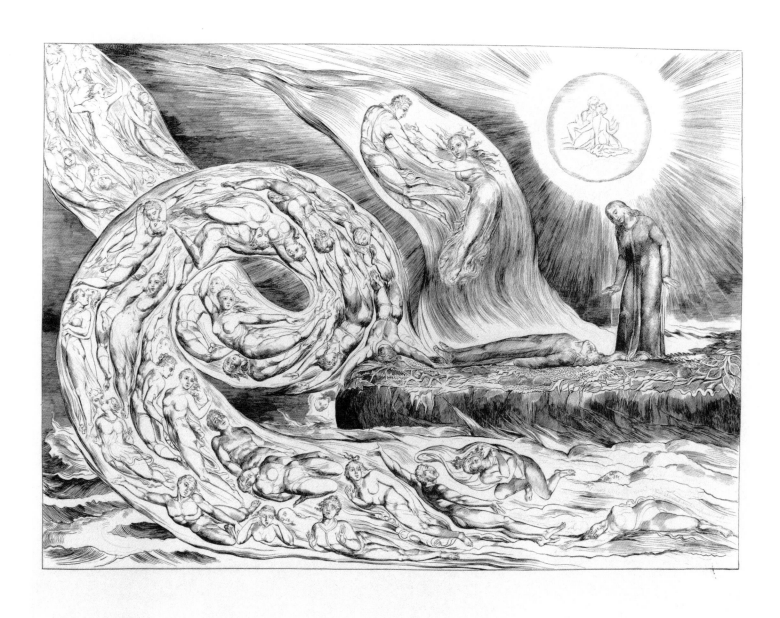

William Blake, *The Circle of the Lustful: Paolo and Francesca,* 1827, cat. no. 2

by Kelly Pask

Note to the Reader: Dimensions for the prints and books are in millimeters, height followed by width and depth. When the paper of the print has been trimmed to or near the platemark or image, only sheet dimensions are given. When the term "thread margin" is used, it refers to the size of the margin, literally the width of a piece of thread. When prints in a series were purchased together, the provenance is given at the end of the series. Similarly, marks and inscriptions are only given for separate prints in a series when they vary between individual prints. Printed inscriptions in books are not given; if a print has no marks or inscriptions, this line of information is omitted. Those prints with accession numbers dating before 1997 (e.g., PR.992.12.1) were the gift of Adolph Weil Jr., Class of 1935. The 121 prints that were donated to the museum in 1997 were the gift of Jean K. Weil in memory of Adolph Weil Jr., Class of 1935.

WILLIAM BLAKE
(British, 1757–1827)

1. Edward Young's *The Complaint, and the Consolation; or, Night Thoughts*
Published London 1797 by R. Edwards
Forty–three line engravings, bound in one volume
Book (closed): 423 x 330 x 21 mm.
Bindman 337–79
MIS.992.18

MARKS AND INSCRIPTIONS: Inscribed, on verso of the title page, in brown ink: *13 Aug: 1842* [undecipherable]

PROVENANCE: Sold Sotheby's, London, May 29, 1980, lot 296.

2. *The Circle of the Lustful: Paolo and Francesca,* 1827, from Dante's *Divine Comedy*
Engraving
Plate: 279 x 354 mm.
Sheet: 341 x 508 mm.
Bindman 647
PR.997.5.117

3. *The Circle of the Corrupt Officials: The Devils Tormenting Ciampolo,* 1827, from Dante's *Divine Comedy*
Engraving
Plate: 279 x 355 mm.
Sheet: 346 x 498 mm.
Bindman 648
PR.997.5.118

4. *The Circle of the Thieves: Buoso Donati Attacked by the Serpent,* 1827, from Dante's *Divine Comedy*
Engraving
Plate: 281 x 353 mm.
Sheet: 347 x 499 mm.
Bindman 651
PR.997.5.119

5. *The Circle of Falsifiers: Dante and Virgil Covering their Noses because of the Stench,* 1827, from Dante's *Divine Comedy*
Engraving
Plate: 277 x 354 mm.
Sheet: 339 x 501 mm.
Bindman 652
PR.997.5.120

PROVENANCE: Sold Christie's, London, June 29, 1989, lot 13; acquired from William Weston Gallery, London.

JACQUES CALLOT
(French, 1592–1635)

6. *The Stag Hunt (La Grand Chasse)*, c. 1619
Etching, state i/IV
Sheet: 195 x 460 mm., trimmed unevenly
to and just within platemark
Lieure 353
PR.997.5.121

MARKS AND INSCRIPTIONS: Inscribed, in plate,
lower left: *Iac Callot In. et Fe;* inscribed,
in brown ink, lower right: G (not in Lugt)

PROVENANCE: Acquired from R. S. Johnson
Fine Art, Chicago, in 1992.

(7–27)
THE MYSTERIES OF THE PASSION, c. 1631
Twenty etchings, state i/II,
and frontispiece by Abraham Bosse
Lieure 679–98

7. ABRAHAM BOSSE (French, 1602–1676)
Frontispiece, c. 1635
Etching, only state
Plate: 88 x 77 mm.
Sheet: 100 x 86 mm.
PR.997.5.1

8. *The Annunciation*
9. *Christ Among the Doctors*
10. *The Circumcision*
11. *The Presentation in the Temple*
Four oval images printed on one sheet
Each plate: 48 x 36 mm.
Sheet: 50 x 156 mm.
PR.997.5.2–5

12. *The Adoration of the Shepherds*
13. *The Visitation*
14. *The Adoration of the Magi*
Three oval images printed on one sheet
Each plate: 47 x 35 mm.
Sheet: 52 x 116 mm.
PR.997.5.6–8

15. *The Carrying of the Cross*
16. *The Presentation to the People*
17. *The Crowning of Thorns*
18. *The Flagellation*
19. *Christ Before Pilate*
20. *The Capture of Christ*
Six oval images printed on one sheet
Each plate: 36 x 27 mm.
Sheet: 50 x 185 mm.
PR.997.5.9–14

21. *Christ in Limbo*
22. *The Descent of the Holy Spirit*

23. *The Entombment*
Three circular images printed on
one sheet
Each plate: 31 x 31 mm.
Sheet: 35 x 117 mm.
PR.997.5.15–17

24. *The Transfiguration*
25. *The Crucifixion*
26. *The Deposition*
27. *The Resurrection*
Four circular images printed on
one sheet
Each plate: 31 x 31 mm.
Sheet: 38 x 157 mm.
PR.997.5.18–21

MARKS AND INSCRIPTIONS: Inscribed, in plate,
on frontispiece: *VARIÆ / TVM PASSIONIS /
CHRISTI, TVM VITÆ BEATÆ / MARIÆ /
VIRGINIS / Israel ex. / cum priuil Regis*; in
circles surrounding title: *IHS* and *MA*; stamped,
on verso of frontispiece, in purple ink:
unidentified collector's mark DrR [in square]

PROVENANCE: Acquired from William
H. Schab Gallery, Inc., New York, on
May 20, 1982.

(28–34)
THE SMALL MISERIES OF WAR, c. 1632
Six etchings, state ii/II,
and frontispiece by Abraham Bosse
Each sheet trimmed to platemark or
possesses thread margins
Lieure 1333–38

28. ABRAHAM BOSSE (French 1602–1676)
Frontispiece, 1636
Etching, only state
Plate: 57 x 119 mm.
PR.991.50.2.1

29. *The Encampment*
Plate: 56 x 116 mm.
PR.991.50.2.2

30. *The Attack on the Highway*
Plate: 56 x 116 mm.
PR.991.50.2.3

31. *Destruction of a Convent*
Plate: 53 x 116 mm.
PR.991.50.2.4

32. *Plundering and Burning of a Village*
Plate: 56 x 116 mm.
PR.991.50.2.5

33. *The Peasants Avenge Themselves*
Plate: 57 x 116 mm.
PR.991.50.2.6

Jacques Callot, *The Hanging,* from *The Large Miseries of War,* 1633, cat. no. 45

34. *The Hospital*
Plate: 53 x 116 mm.
PR.991.50.2.7

MARKS AND INSCRIPTIONS: Inscribed, in each plate: *Israel excud. cum priuil. Regis,* or an abbreviation of this phrase; plates numbered sequentially, except cat. no. 28, in lower left or right (1–6); inscribed, on frontispiece, in plate: *Misere de la guerre; faict / Par Iaques Callot. Et mise en / Lumiere par Israel Henriet. / A Paris. /Auec Priuilege du Roy / 1636.*

PROVENANCE: Sold Grosjean, Paris, October 27, 1930; sold Sotheby Parke Bernet, New York, February 15, 1980, lot 846.

(35–52)
THE LARGE MISERIES OF WAR, 1633
Eighteen etchings
Lieure 1339–56

35. *Frontispiece*
State ii/III
Plate: 90 x 192 mm.
Sheet: 112 x 211 mm.
PR.991.8.1

MARKS AND INSCRIPTIONS: Inscribed, in black ink, upper left: *no. 14–* [undecipherable]; in brown ink, upper center: *GL* [?]; inscribed in plate, center: *LES / MISERE ET LES MAL-HEVRS / DE LA GVERRE / Representez Par IAQVES CALLOT / Noble Lorrain. /ET mis en lumiere Par Israel / Son amy. / A Paris / 1633 / Avec Priuilege du Roy*

36. *The Recruitment of the Troops*
State i/III (?)
Sheet: 83 x 185 mm., irregularly trimmed
PR.991.8.2

37. *The Battle*
State i/III
Plate: 82 x 185 mm.
Sheet: 95 x 200 mm.
PR.991.8.3

38. *The Pillage of an Inn*
State i/III
Plate: 82 x 185 mm.
Sheet: 97 x 201 mm.
PR.991.8.4

39. *The Plundering of a Farmhouse*
State i/III
Plate: 82 x 185 mm.
Sheet: 97 x 200 mm.
PR.991.8.5

40. *Destruction of a Convent*
State i/III
Plate: 82 x 185 mm.
Sheet: 95 x 200 mm.
PR.991.8.6

41. *Plundering and Burning of a Village*
State i/III
Plate: 82 x 185 mm.
Sheet: 96 x 200 mm.
PR.991.8.7

42. *The Attack of the Coach*
State i/III
Plate: 82 x 185 mm.
Sheet: 105 x 209 mm.
PR.991.8.8

43. *Discovery of the Criminal Soldiers*
State i/III
Plate: 83 x 186 mm.
Sheet: 97 x 198 mm.
PR.991.8.9

44. *The Strappado*
State i/III
Plate: 83 x 191 mm.
Sheet: 97 x 204 mm.
PR.991.8.10

45. *The Hanging*
State i/III
Plate: 82 x 185 mm.
Sheet: 95 x 199 mm.
PR.991.8.11

46. *The Firing Squad*
State i/III
Plate: 82 x 185 mm.
Sheet: 95 x 199 mm.
PR.991.8.12

47. *The Stake*
State i/III
Plate: 82 x 186 mm.
Sheet: 96 x 201 mm.
PR.991.8.13

48. *The Wheel*
State i/III
Plate: 82 x 185 mm.
Sheet: 96 x 201 mm.
PR.991.8.14

49. *The Hospital*
State i/III
Plate: 82 x 185 mm.
Sheet: 96 x 200 mm.
PR.991.8.15

50. *Dying Soldiers by the Roadside*
State i/III
Plate: 82 x 185 mm.
Sheet: 96 x 200 mm.
PR.991.8.16

51. *The Peasants Avenge Themselves*
State i/III
Plate: 82 x 185 mm.
Sheet: 96 x 200 mm.
PR.991.8.17

52. *Distribution of Rewards*
State iii/V
Plate: 82 x 185 mm.
Sheet: 85 x 189 mm.
PR.991.8.18

MARKS AND INSCRIPTIONS: Inscribed, in plate, lower right: *Callot fecit / Israel excudit.*; beneath image: *Cet example d'un Chef plein de reconnoisance, / Qui punit les méchans et les bons recompance, Doit piquer les soldats d'un aiguillon d'honneur, / Puis que de la vertu., depend tout leur bonheur, / Et qu'ordinairement ils reçoivent du Vice, / La honte, le mespris, et le dernier supplice. / 18*

MARKS AND INSCRIPTIONS: Inscribed, in each plate, except cat. nos. 35 and 52, lower left, right, or center: *Israel excud. Cum Priuilegio Regis* or some abbreviation of this phrase; sheets numbered sequentially, in pencil, lower right, (2–17)

PROVENANCE: Christie's, New York, November 2, 1983, lot 18 (bought in); acquired privately after the sale.

GIOVANNI ANTONIO CANAL,
called CANALETTO (Italian, 1697–1768)

(53–83)
VIEWS, SOME TAKEN FROM PLACES, OTHERS INVENTED, BY ANTONIO CANAL,
c. 1740–44
Thirty–one etchings

53. *Frontispiece to the Vedute*
Etching, state ii/II
Plate: 295 x 428 mm.
Sheet: 349 x 485 mm.
Bromberg 1
PR.997.5.22

MARKS AND INSCRIPTIONS: Inscribed, in plate, center: *VEDUTE / Altre prese da i Luoghi altre ideate / DA / ANTONIO CANAL / e da esso*

intagliate poste in prospetiva / umiliate / All'Ill.mo Signor / GIUSEPPE SMITH / Console di S.M. Britanica appresso la Ser.ma / Repubblica di Venezia. / In segno di stima ed ossequio; stamped, in brown ink, on verso: *PROVIDENCE / RHODE ISLAND / R.I.S.D. / MUSEUM / OF ART*

PROVENANCE: Duplicate deaccessioned from the Rhode Island School of Design, Providence; sold Kornfeld & Klipstein, Bern, June 26, 1981, lot 19.

54. *The Tower of Malghera*, c. 1740–44
Etching, state ii/III
Plate: 295 x 422 mm.
Sheet: 341 x 478 mm.
Bromberg 2
PR.997.5.23

MARKS AND INSCRIPTIONS: Inscribed, in plate, lower left: *A. Canal f.*; lower center: *la Torre di Malghera*; watermark: R

PROVENANCE: Acquired from William H. Schab Gallery, Inc., New York, on May 19, 1983.

55. *Mestre*, c. 1740–44
Etching, state i/II
Plate: 299 x 428 mm.
Sheet: 301 x 433 mm.
Bromberg 3
PR.997.5.24

MARKS AND INSCRIPTIONS: Inscribed, in plate, lower left: *A. Canal. f.*; lower center: *Mestre*

PROVENANCE: Sold Sotheby Parke Bernet, New York, May 12, 1972, lot 526.

56. *At Dolo*, c. 1740–44
Etching, state ii/III
Sheet: 299 x 430 mm., trimmed to platemark
Bromberg 4
PR.997.5.25

MARKS AND INSCRIPTIONS: Inscribed, in plate, lower left: *A.n Canal f.*; lower center: *Al Dolo*

PROVENANCE: Sold Sotheby Parke Bernet, New York, May 12, 1972, lot 527.

Giovanni Antonio Canal, called Canaletto, *The Locks of Dolo,* c. 1740–44, cat. no. 58

57. *At the Locks of Dolo,* c. 1740–44
Etching, state ii/III
Plate: 301 x 433 mm.
Sheet: 353 x 480 mm.
Bromberg 5
PR.997.5.26

MARKS AND INSCRIPTIONS: Inscribed,
in plate, lower left: *A. Canal f.;* lower
center: *Alle Porte del Dolo*

PROVENANCE: Sold Karl & Faber,
Munich, December 1, 1972, lot 269.

58. *The Locks of Dolo,* c. 1740–44
Etching, state ii/III
Plate: 298 x 428 mm.
Sheet: 448 x 568 mm.
Bromberg 6
PR.997.5.27

MARKS AND INSCRIPTIONS: Inscribed,
in plate, lower left: *A. Canal f.;* lower
center: *le Porte Del Dolo*

PROVENANCE: Sold Sotheby's, London,
April 26, 1979, lot 343.

59. *Santa Giustina in Prà della Valle,*
c. 1740–44
Etching, state i/II
Plate: 297 x 428 mm.
Sheet: 459 x 623 mm.
Bromberg 7
PR.997.5.28

MARKS AND INSCRIPTIONS: Inscribed,
in plate, lower left: *A. Canal f.;* lower
center: *S.a Giustina in prà della Vale*

PROVENANCE: Acquired from Kennedy
Galleries, New York, on November 23,
1977.

60. *Prà della Valle,* c. 1740–44
Etching, state i/II
Plate: 302 x 437 mm.
Sheet: 403 x 544 mm.
Bromberg 8
PR.997.5.29

MARKS AND INSCRIPTIONS: Inscribed,
in plate, lower left: *A. Canal f.;* lower
center: *Prà della Vale*

PROVENANCE: Sold Sotheby Parke
Bernet, New York, November 7, 1974,
lot 23A.

61. *View of a Town on a Riverbank,*
c. 1740–44
Etching, state i/II

Sheet: 299 x 433 mm., trimmed to
platemark
Bromberg 9
PR.997.5.30

MARKS AND INSCRIPTIONS: Inscribed,
in plate, lower center: *A. Canal f.;*
watermark: Three Crescents

PROVENANCE: Sold Sotheby Parke
Bernet, New York, May 7, 1976, lot
471.

62. *The Portico with the Lantern,* c. 1740–44
Etching, state ii/III
Plate: 298 x 431 mm.
Sheet: 417 x 523 mm.
Bromberg 10
PR.997.5.31

MARKS AND INSCRIPTIONS: Inscribed,
in plate, lower center: *A. Canal. f. V.;*
watermark: Three Crescents

PROVENANCE: Acquired from William H.
Schab Gallery, Inc., New York, on June
14, 1983.

63. *Imaginary View of Padua,* c. 1740–44
Etching, state ii/III
Plate: 295 x 430 mm.
Sheet: 304 x 434 mm.
Bromberg 11
PR.997.5.32

MARKS AND INSCRIPTIONS: Inscribed,
in plate, lower center: *A. Canal f.*

PROVENANCE: Acquired from William H.
Schab Gallery, Inc., New York, on April
6, 1972.

64. *Imaginary View of Venice:*
The House with the Inscription, 1741
Etching, only state
Plate: 296 x 215 mm.
Sheet: 328 x 466 mm.
Bromberg 13
PR.997.5.33

MARKS AND INSCRIPTIONS: Inscribed,
in plate, left center: *MDCCXLI. A.C.*

PROVENANCE: Sold Kornfeld &
Klipstein, Bern, June 11, 1976, lot 42.

65. *Imaginary View of Venice:*
The House with the Peristyle, c. 1740–44
Etching, state ii/II
Plate: 296 x 215 mm.
Sheet: 328 x 466 mm.
Bromberg 14
PR.997.5.34

MARKS AND INSCRIPTIONS: Inscribed, in plate, lower right: *A.C.*

PROVENANCE: Sold Kornfeld & Klipstein, Bern, June 11, 1976, lot 42.

66. *The Bishop's Tomb,* c. 1740–44
Etching, only state
Plate: 223 x 131 mm.
Sheet: 258 x 155 mm.
Bromberg 15
PR.997.5.35

PROVENANCE: Sold Karl & Faber, Munich, June 2, 1972, lot 231.

67. *View of a Town with a Bishop's Tomb,*
c. 1740–44
Etching, state ii/II
Plate: 298 x 302 mm.
Sheet: 375 x 494 mm.
Bromberg 16
PR.997.5.36

MARKS AND INSCRIPTIONS: Inscribed, in plate, lower center: *A. Canal f. V.;* watermark: R

PROVENANCE: Sold Kornfeld & Klipstein, Bern, June 17, 1970, lot 56.

68. *The Library, Venice,* c. 1740–44
Etching, state iii/III
Sheet: 143 x 209 mm., with narrow margins
Bromberg 18
PR.997.5.37

MARKS AND INSCRIPTIONS: Inscribed, in plate, lower left: *A. Canal f.;* inscribed, in black ink, on verso: *No., 296 da lc* [?]; stamped, in purple ink, on verso: *JVM* (not in Lugt); inscribed, in pencil, on verso: *AW*

PROVENANCE: Sold Kornfeld & Klipstein, Bern, June 9, 1971, lot 35.

69. *The Piera del Bando, Venice,* c. 1740–44
Etching, state iii/III
Sheet: 142 x 209 mm., trimmed to platemark
Bromberg 19
PR.997.5.38

MARKS AND INSCRIPTIONS: Inscribed, in plate, lower left: *A. Canal. f.*

PROVENANCE: Sold Kornfeld & Klipstein, Bern, June 9, 1971, lot 37.

70. *The Market on the Molo,* c. 1740–44
Etching, state iii/IV
Plate: 143 x 208 mm.
Sheet: 190 x 269 mm.
Bromberg 20
PR.997.5.39

MARKS AND INSCRIPTIONS: Inscribed, in plate, lower left: *A. Canal f.;* inscribed, in pencil, on verso: *AW*

PROVENANCE: Sold Sotheby's, New York, date unknown, lot 13.

71. *The Prisons, Venice,* c. 1740–44
Etching, state ii/III
Plate: 143 x 209 mm.
Sheet: 161 x 228 mm.
Bromberg 21
PR.997.5.40

MARKS AND INSCRIPTIONS: Inscribed, in plate, lower left: *A. Canal. f.;* lower center: *le Preson. V.*

PROVENANCE: Acquired from R.E. Lewis, Inc., San Francisco, on October 15, 1979.

72. *Mountain Landscape with Five Bridges,*
c. 1740–44
Printed on sheet with cat. nos. 73, 74, and 75
Etching, state iia/IIb
Plate: 144 x 210 mm.
Sheet: 463 x 632 mm.
Bromberg 22
PR.997.5.41

MARKS AND INSCRIPTIONS: Inscribed, in plate, lower center: *A. Canal. f.;* inscribed, in pencil, on verso: *AW*

PROVENANCE: Sold Sotheby Parke Bernet, New York, May 10, 1973, lot 38.

73. *The Equestrian Monument,* c. 1740–44
Etching, only state
Printed on sheet with cat. nos. 72, 74, and 75
Plate: 144 x 210 mm.
Sheet: 463 x 632 mm.
Bromberg 23
PR.997.5.42

MARKS AND INSCRIPTIONS: Inscribed, in plate, lower center: *A. Canal. f.;* inscribed, in pencil, on verso: *AW*

PROVENANCE: Sold Sotheby Parke Bernet, New York, May 10, 1973, lot 38.

74. *Landscape with the Pilgrim at Prayer,*
c. 1740–44
Etching, state iii/III
Printed on sheet with cat. nos. 72, 73,
and 75
Plate: 143 x 211 mm.
Sheet: 463 x 632 mm.
Bromberg 27
PR.997.5.43

MARKS AND INSCRIPTIONS: Inscribed,
in plate, lower center: *A. Canal. f.*;
inscribed, in pencil, on verso: *AW*

PROVENANCE: Sold Sotheby Parke
Bernet, New York, May 10, 1973, lot 38.

75. *Landscape with a Woman at a Well,*
c. 1740–44
Etching, state iia/III
Printed on sheet with cat. nos. 72, 73,
and 74
Plate: 143 x 211 mm.
Sheet: 463 x 632 mm.
Bromberg 29
PR.997.5.44

MARKS AND INSCRIPTIONS: Inscribed,
in plate, lower left: *A.C.*; inscribed,
in pencil, on verso: *AW*

PROVENANCE: Sold Sotheby Parke
Bernet, New York, May 10, 1973, lot 38.

76. *The Terrace,* c. 1740–44
Etching, state ii/III
Plate: 145 x 210 mm.
Sheet: 178 x 251 mm.
Bromberg 24
PR.997.5.45

MARKS AND INSCRIPTIONS: Inscribed,
in plate, lower center: *A. Canal. f.*;
inscribed, in pencil, upper right: *12*;
on verso: *AW*

PROVENANCE: Sold Sotheby Parke
Bernet, New York, May 16, 1974, lot
148.

77. *The Procuratie Nuove and San Ziminian,
Venice,* c. 1740–44
Etching, state i/II
Plate: 144 x 211 mm., trimmed to
platemark
Bromberg 25
PR.997.5.46

MARKS AND INSCRIPTIONS: Inscribed,
in plate, lower left: *A. Canal f.*; lower
center: *le Procuratie niove e S. Ziminian
V.*; inscribed, in pencil, on verso: *AW*

PROVENANCE: Sold Sotheby Parke
Bernet, New York, May 7, 1976, lot
477.

78. *The Market at Dolo,* c. 1740–44
Etching, state iii/IV
Plate: 145 x 210 mm.
Sheet: 182 x 245 mm.
Bromberg 26
PR.997.5.47

MARKS AND INSCRIPTIONS: Inscribed,
in plate, lower left: *A. Canal f.*;
inscribed, in pencil, upper right: *23*;
on verso: *AW*

PROVENANCE: Sold Sotheby Parke
Bernet, New York, May 16, 1974, lot
149.

79. *Landscape with Tower and Two Ruined
Pillars,* c. 1740–44
Etching, state ii/II
Sheet: 143 x 209 mm., trimmed to
platemark
Bromberg 28
PR.997.5.48

MARKS AND INSCRIPTIONS: Inscribed,
in plate, lower center: *A. Canal. f.*;
stamped, in black ink, lower right: *JC*
[encircled] (not in Lugt)

PROVENANCE: J. Cantacuzene; sold
Sotheby Parke Bernet, New York,
November 19, 1982, lot 470.

80. *Imaginary View of San Giacomo di Rialto,*
c. 1740–44
Etching, state i/II
Plate: 144 x 216 mm.
Sheet: 189 x 255 mm.
Bromberg 30
PR.997.5.49

MARKS AND INSCRIPTIONS: Inscribed,
in plate, lower center: *A. Canal f.*;
inscribed, in pencil, upper right: *26*

PROVENANCE: Sold Sotheby Parke
Bernet, New York, May 14, 1974,
lot 148.

81. *Landscape with Ruined Monuments,*
c. 1740–44
Etching, only state
Plate: 145 x 217 mm.
Sheet: 180 x 248 mm.
Bromberg 31
PR.997.5.50

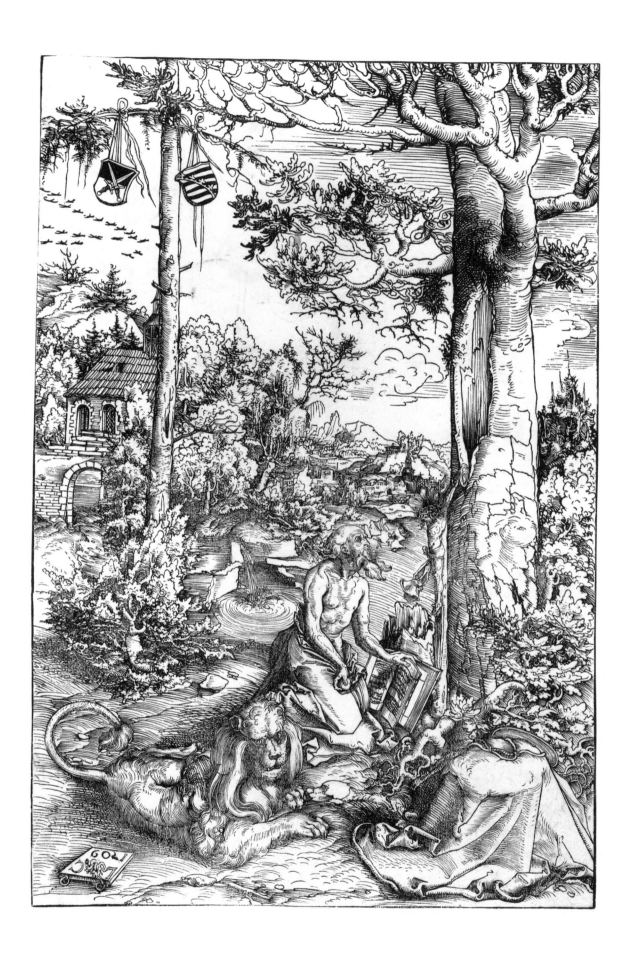

Lucas Cranach the Elder, *The Penitence of Saint Jerome*, 1509, cat. no. 84

MARKS AND INSCRIPTIONS: Inscribed, in plate, lower center: *A. Canal f.*; inscribed, in pencil, upper right: *6*; on verso: *AW*

PROVENANCE: Sold Sotheby Parke Bernet, New York, May 14, 1974, lot 152.

82. *The Little Monument*, c. 1740–44
Etching, state ii/II
Plate: 115 x 82 mm.
Sheet: 414 x 290 mm.
Bromberg 33
PR.997.5.51

MARKS AND INSCRIPTIONS: Inscribed, in plate, lower center: *A.C.*

PROVENANCE: Acquired from Colnaghi & Co., Ltd., London, on June 19, 1984.

83. *The Wagon Passing Over a Bridge*, c. 1740–44
Etching, state ii/II
Plate: 143 x 125 mm.
Sheet: 414 x 290 mm.
Bromberg 32
PR.997.5.52

MARKS AND INSCRIPTIONS: Inscribed, in plate, lower right: *A. Canal. f.*

PROVENANCE: Acquired from Colnaghi & Co., Ltd., London, on June 19, 1984.

LUCAS CRANACH THE ELDER
(German, 1472–1553)

84. *The Penitence of Saint Jerome*, 1509
Woodcut
Sheet: 336 x 229 mm., trimmed to and just within borderline
Bartsch 63; Hollstein 84
PR.991.50.3

MARKS AND INSCRIPTIONS: Inscribed, in block, lower left: *LC / 1509* [reversed]; stamped, on verso, in brown ink: *FURST ZU FURSTENBERG KUPFERSTICHKABINETT* (not in Lugt); stamped, in black ink, collection mark of Fürst zu Fürstenberg (Lugt 2811); watermark: Jug

PROVENANCE: Fürst zu Fürstenberg collection, Donaueschingen (sold C. G. Boerner, Leipzig, November 8, 1932, lot 258); sold Sotheby Parke Bernet, London, June 18, 1982, lot 486.

ALBRECHT DÜRER
(German, 1471–1528)

(85–96)
THE LARGE PASSION, c. 1496–1511
Twelve woodcuts

85. *Title Page: The Mocking of Christ*, 1511
Woodcut
Proof impression
Sheet: 200 x 189 mm., trimmed just within border of image on three sides and narrow margin at top
Bartsch 4; Hollstein 113
PR.997.5.55

MARKS AND INSCRIPTIONS: Watermark: Bull's Head with Cross and Flower

PROVENANCE: Sold Sotheby's, London, date unknown, lot 77.

86. *The Last Supper*, 1510
Woodcut
Proof impression
Sheet: 402 x 285 mm., trimmed to and just within borderline at left
Bartsch 5; Hollstein 114
PR.997.5.56

MARKS AND INSCRIPTIONS: Inscribed, in block, lower center: *1510 / AD* [monogram]; stamped, in black ink, on verso: collection mark of M. J. Perry (Lugt 1880); watermark: Name of Mary

PROVENANCE: Marsden Jasael Perry (1850–1935), Providence, Rhode Island (sold H. G. Gutekunst, Stuttgart, May 18–23, 1908, part of lot 313); sold Sotheby's, London, November 15, 1980, lot 866.

87. *Agony in the Garden (Christ on the Mount of Olives)*, c. 1496–97
Woodcut
Proof impression
Sheet: 388 x 280 mm., trimmed to borderline
Bartsch 6; Hollstein 115
PR.997.5.57

MARKS AND INSCRIPTIONS: Inscribed, in block, lower center: *AD* [monogram]; inscribed, in pencil, on verso: *AW*; watermark: Large Imperial Orb

PROVENANCE: Acquired from Colnaghi & Co., London, on February 26, 1976.

88. *The Betrayal of Christ*, 1510
Woodcut
Proof impression
Sheet: 400 x 282 mm., trimmed to
borderline
Bartsch 7; Hollstein 116
PR.997.5.58

MARKS AND INSCRIPTIONS: Inscribed,
in block, upper left: *1510*; lower left:
AD [monogram]; watermark: Name
of Mary

PROVENANCE: Acquired from Kennedy
Galleries, New York, on November 14,
1980.

89. *The Flagellation*, c. 1496–97
Woodcut
Proof impression
Image: 396 x 288 mm.
Sheet: 398 x 298 mm.
Bartsch 8; Hollstein 117
PR.997.5.59

MARKS AND INSCRIPTIONS: Inscribed,
in block, lower center: *AD* [monogram];
stamped, in black ink, lower center: *PS*;
on verso: *Ex impressionibus et formis /
Petri Stramenti idem et / PIERRE
STROOBANTS / Inventaire No.*;
watermark: Large Imperial Orb

PROVENANCE: Pierre Stroobants; Norton
Simon, Pasadena, California; acquired
from Robert M. Light, Santa Barbara,
California, on May 17, 1980.

90. *Ecce Homo (Christ Before the People)*,
c. 1498
Woodcut
Proof impression
Sheet: 391 x 283 mm., trimmed to
borderline
Bartsch 9; Hollstein 118
PR.997.5.60

MARKS AND INSCRIPTIONS: Inscribed,
in block, lower center: *AD* [monogram];
stamped, in black ink, on verso:
collection mark of K. E. von Liphart (Lugt
1687); inscribed, in pencil, on verso:
EMV [in rectangle] / *AW*; watermark:
Name of Mary

PROVENANCE: Karl Eduard von Liphart
(1808–1891), Dorpat, Bonn and
Florence (sold C. G. Boerner, Leipzig,
December 5, 1876, part of lot 410);
acquired from Kennedy Galleries, New
York, on August 17, 1976.

91. *The Bearing of the Cross*, c. 1498–99
Woodcut
Proof impression
Sheet: 388 x 283 mm., trimmed to
borderline
Bartsch 10; Hollstein 119
PR.997.5.61

MARKS AND INSCRIPTIONS: Inscribed,
in block, lower center: *AD* [monogram];
inscribed, in pencil, on verso: *AW*;
watermark: Large Imperial Orb

PROVENANCE: Sold Kornfeld &
Klipstein, Bern, May 29, 1976, lot 29.

92. *The Crucifixion*, c. 1498
Woodcut
Proof impression
Sheet: 390 x 282 mm., trimmed to
borderline
Bartsch 11; Hollstein 120
PR.997.5.62

MARKS AND INSCRIPTIONS: Inscribed,
in block, lower center: *AD* [monogram];
stamped, in black ink, on verso: *P* (not
in Lugt); inscribed, in pencil, on verso:
AW; watermark: Bull's Head with
Caduceus

PROVENANCE: Sold Kornfeld &
Klipstein, Bern, May 29, 1976, lot 159.

93. *The Deposition of Christ*, c. 1496–97
Woodcut
Proof impression
Sheet: 388 x 278 mm., trimmed to
borderline
Bartsch 12; Hollstein 123
PR.997.5.63

MARKS AND INSCRIPTIONS: Inscribed, in
block, lower center: *AD* [monogram];
inscribed, in pencil, on verso: *AW*;
watermark: Name of Mary

PROVENANCE: Sold Sotheby Parke
Bernet, New York, May 14, 1974, lot 48.

94. *The Lamentation*, c. 1498–99
Woodcut
Proof impression
Sheet: 391 x 284 mm., trimmed to
borderline
Bartsch 13; Hollstein 122
PR.997.5.64

MARKS AND INSCRIPTIONS: Inscribed,
in block, lower center: *AD* [monogram];
stamped, in black ink, on verso:

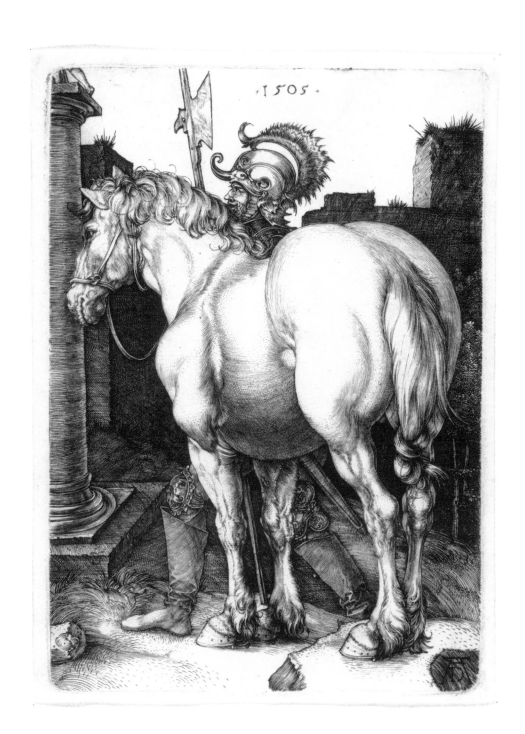

Albrecht Dürer, *The Large Horse*, 1505, cat. no. 97

collection mark of K. E. von Liphart (Lugt 1687); watermark: Large Imperial Orb

PROVENANCE: Karl Eduard von Liphart (1808–1891), Dorpat, Bonn and Florence (sold C. G. Boerner, Leipzig, December 5, 1876, part of lot 410); acquired from Kennedy Galleries, New York, on July 31, 1975.

95. *Christ in Limbo (The Harrowing of Hell)*, 1510
Woodcut
Proof impression
Sheet: 395 x 284 mm., trimmed to borderline
Bartsch 14; Hollstein 121
PR.997.5.65

MARKS AND INSCRIPTIONS: Inscribed, in block, lower right: *AD* [monogram] and *1510* on crossbeam in middle right; stamped, in black ink, on verso: collection mark of K. E. von Liphart (Lugt 1687); inscribed, in pencil, on verso: *AW*; watermark: Name of Mary

PROVENANCE: Karl Eduard von Liphart (1808–1891), Dorpat, Bonn and Florence (sold C. G. Boerner, Leipzig, December 5, 1876, part of lot 410); sold Kornfeld and Klipstein, Bern, May 29, 1976, lot 81.

96. *The Resurrection*, 1510
Woodcut
Proof impression
Sheet: 394 x 280 mm., trimmed to borderline with thread margins
Bartsch 15; Hollstein 124
PR.997.5.66

MARKS AND INSCRIPTIONS: Inscribed, in block, lower center: *AD* [monogram]; center: *1510*; inscribed, in pencil, on verso: filigrane *NM / LB*; watermark: Name of Mary

PROVENANCE: Sold Sotheby Parke Bernet, New York, November 14, 1981, lot 697.

97. *The Large Horse*, 1505
Engraving, only state
Plate: 167 x 119 mm.
Sheet: 174 x 128 mm.
Bartsch 97; Hollstein 94; Strauss 45
PR.997.5.54

MARKS AND INSCRIPTIONS: Inscribed, in plate, lower right: upper center: *1505*; lower right: *AD* [monogram]

PROVENANCE: Acquired from William H. Schab Gallery, Inc., New York, on May 24, 1984.

98. *Knight, Death and the Devil*, 1513
Engraving, only state
Sheet: 251 x 192 mm., remargined with penned borderline
Bartsch 98; Hollstein 74; Strauss 71
PR.997.5.53

MARKS AND INSCRIPTIONS: Inscribed, in plate, lower left: *S. 1513. / AD* [monogram]

PROVENANCE: Acquired from Kennedy Galleries, New York, on June 12, 1970.

99. *Saint Jerome in his Study*, 1514
Engraving, only state
Plate: 247 x 188 mm.
Sheet: 250 x 190 mm.
Bartsch 60; Hollstein 59; Strauss 77
Promised gift of Jean K. Weil, in memory of Adolph Weil Jr., Class of 1935

MARKS AND INSCRIPTIONS: Inscribed, in plate, lower right: *1514 / AD* [monogram]; inscribed, in ink, on verso: *P. Mariette* (L. 1790); stamped, in black ink, on verso: collection mark of R. S. Holford (L. 2242); stamped, in red ink, on verso: collection mark of T. van Rysselberghe (L. 2538)

PROVENANCE: Pierre Mariette (1634–1716), Paris; Robert Stayner Holford (1808–1892), London and Westonbirt, Gloucester (sold Christie's, London, July 11, 1893, lot 100); V. Mayer (1831–1918); Theo van Rysselberghe (1862–1926), Paris; Henry Graves, Jr. (1868–1953), New York (sold American Art Association, New York, April 3, 1936, lot 10); acquired from Kennedy Galleries, New York, on February 26, 1970.

RICHARD EARLOM
(British, 1743–1822)
After
CLAUDE LORRAIN
(French, 1600–1682)

100. *Liber Veritatis; or A Collection of Prints*
After the Original Designs of Claude Le Lorrain,
c. 1774–1819
Three hundred aquatints, bound in three
volumes
Each volume (approx. size closed): 440 x
300 x 60 mm.
MIS.989.26A–C

PROVENANCE: James Slevin (?), Philadelphia,
until 1857; Mother Cecilia Brooks, Academy
of the Visitation at Mount de Sales.

MAURITS CORNELIS ESCHER
(Dutch, 1898–1972)

101. *Puddle,* 1952
Color woodcut
Image: 239 x 317 mm.
Sheet: 286 x 360 mm.
PR.991.50.4

MARKS AND INSCRIPTIONS: Inscribed and
dated, in block, upper left: *MCE / II–'52;*
signed, in pencil, lower left: *M.C. Escher;*
inscribed, in pencil, lower right: *eigendruck*

PROVENANCE: The artist; John Eden, Barnet,
England, January 1955; sold Sotheby's,
London, June 28, 1985, lot 705.

FRANCISCO GOYA
(Spanish, 1746–1828)

(102–181)
THE DISASTERS OF WAR, c. 1810–20
Eighty etchings and aquatints
First published edition, 1863
Harris 121–200; Delteil 120–199

102. *Sad presentiments of what must come*
to pass
Plate: 177 x 220 mm.
Sheet: 246 x 326 mm.
PR.991.50.1.1

MARKS AND INSCRIPTIONS: Inscribed,
in plate, lower center: *Tristes*
presentimientos de lo que ha de acontecer

103. *With or without reason*
Plate: 152 x 206 mm.
Sheet: 246 x 328 mm.
PR.991.50.1.2

MARKS AND INSCRIPTIONS: Inscribed, in
plate, lower center: *Con razon ó sin ella.*

104. *The same*
Plate: 160 x 218 mm.
Sheet: 246 x 327 mm.
PR.991.50.1.3

MARKS AND INSCRIPTIONS: Inscribed,
in plate, lower left: *48* [?]; lower center:
Lo mismo.

105. *The women give courage*
Plate: 157 x 206 mm.
Sheet: 247 x 327 mm.
PR.991.50.1.4

MARKS AND INSCRIPTIONS: Inscribed,
in plate, lower center: *Las mugeres dan*
valor.

106. *And they are wild beasts*
Plate: 158 x 206 mm.
Sheet: 242 x 327 mm.
PR.991.50.1.5

MARKS AND INSCRIPTIONS: Inscribed,
in plate, lower center: *Y son fieras*

107. *It serves you right*
Plate: 143 x 208 mm.
Sheet: 247 x 325 mm.
PR.991.50.1.6

MARKS AND INSCRIPTIONS: Inscribed,
in plate, lower left: *Goya;* lower center:
Bien te se está.

108. *What courage!*
Plate: 155 x 205 mm.
Sheet: 247 x 325 mm.
PR.991.50.1.7

MARKS AND INSCRIPTIONS: Inscribed,
in plate, lower center: *Que valor!*

109. *It always happens*
Plate: 177 x 220 mm.
Sheet: 243 x 327 mm.
PR.991.50.1.8

MARKS AND INSCRIPTIONS: Inscribed,
in plate, lower center: *Siempre sucede.*

110. *They do not want to*
Plate: 153 x 206 mm.
Sheet: 243 x 326 mm.
PR.991.50.1.9

Marks and inscriptions: Inscribed,
in plate, lower left: *29*; lower center:
No quiren.

111. *Neither do they*
Plate: 147 x 215 mm.
Sheet: 242 x 326 mm.
PR.991.50.1.10

MARKS AND INSCRIPTIONS: Inscribed,
in plate, lower left: *19*; lower center:
Tampoco

112. *Nor for them*
Plate: 161 x 211 mm.
Sheet: 246 x 327 mm.
PR.991.50.1.11

MARKS AND INSCRIPTIONS: Inscribed,
in plate, lower center: *Ni por esas.*

113. *This is what you were born for*
Plate: 161 x 235 mm.
Sheet: 245 x 325 mm.
PR.991.50.1.12

MARKS AND INSCRIPTIONS: Inscribed,
in plate, center left: *Goya*; lower left:
24; lower center: *Para eso habeis nacido.*

114. *Bitter presence*
Plate: 144 x 171 mm.
Sheet: 247 x 324 mm.
PR.991.50.1.13

MARKS AND INSCRIPTIONS: Inscribed, in
plate, lower left: *Goya*; lower center:
Amarga presencia.

115. *The way is hard!; It's a difficult step!*
Plate: 143 x 168 mm.
Sheet; 247 x 326 mm.
PR.991.50.1.14

MARKS AND INSCRIPTIONS: Inscribed,
in plate, lower center: *Duro es el paso!*

116. *And nothing can be done*
Plate: 143 x 168 mm.
Sheet: 246 x 325 mm.
PR.991.50.1.15

MARKS AND INSCRIPTIONS: Inscribed,
in plate, lower center: *Y no hai remedio.*

117. *They profit*
Plate: 161 x 235 mm.
Sheet: 247 x 325 mm.
PR.991.50.1.16

MARKS AND INSCRIPTIONS: Inscribed, in
plate, center left: *Goya*; lower left: *1* [?];
lower center: *Se aprovechan.*

118. *They do not agree*
Plate: 147 x 215 mm.
Sheet: 246 x 323 mm.
PR.991.50.1.17

MARKS AND INSCRIPTIONS: Inscribed, in
plate, lower left: *Goya*; lower left: *16*;
lower center: *No se convienen.*

119. *Bury them and keep quiet*
Plate: 160 x 235 mm.
Sheet: 246 x 325 mm.
PR.991.50.1.18

MARKS AND INSCRIPTIONS: Inscribed,
in plate, lower center: *Enterrar y callar.*

120. *Time has run out*
Plate: 164 x 236 mm.
Sheet: 247 x 326 mm.
PR.991.50.1.19

MARKS AND INSCRIPTIONS: Inscribed, in
plate, lower left: *Goya*; lower left: *91*;
lower center: *Ya no hay tiempo.*

121. *Treat them, and on to other matters*
Plate: 160 x 235 mm.
Sheet: 247 x 326 mm.
PR.991.50.1.20

MARKS AND INSCRIPTIONS: Inscribed, in
plate, lower left: *Goya*; lower center:
Cuarlos, y á otra.

122. *It will be the same*
Plate: 146 x 218 mm.
Sheet: 247 x 326 mm.
PR.991.50.1.21

MARKS AND INSCRIPTIONS: Inscribed, in
plate, lower left: *Goya / 25*; lower
center: *Será lo mismo*

123. *As many and more*
Plate: 160 x 250 mm.
Sheet: 248 x 325 mm.
PR.991.50.1.22

MARKS AND INSCRIPTIONS: Inscribed, in
plate, lower left: *Goya 1810 / 7*; lower
center: *Tanto y mas*

124. *The same elsewhere*
Plate: 160 x 238 mm.
Sheet: 247 x 327 mm.
PR.991.50.1.23

MARKS AND INSCRIPTIONS: Inscribed, in
plate, lower left: *Goya / 14*; lower
center: *Lo mismo en otras partes*

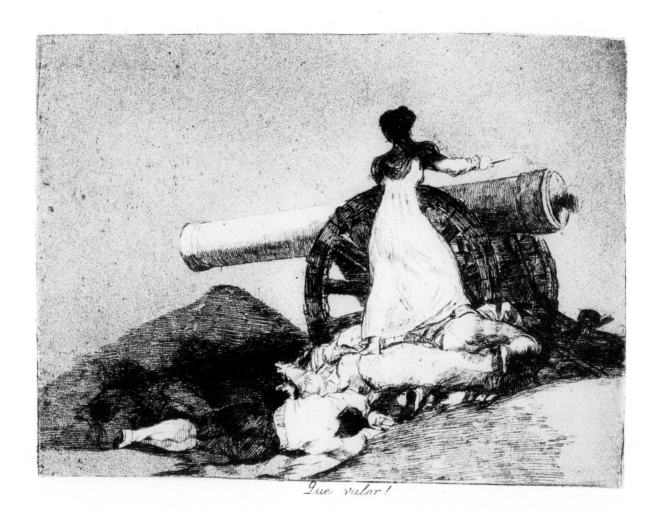

Que valor!

Francisco Goya, *What courage!*, c. 1810–20, cat. no. 108

125. *They still can be of use; They still can serve*
Plate: 161 x 254 mm.
Sheet: 247 x 326 mm.
PR.991.50.1.24

MARKS AND INSCRIPTIONS: Inscribed, in plate, lower left: *Goya / 12*; lower center: *Aun podrán servir.*

126. *These too*
Plate: 161 x 233 mm.
Sheet: 246 x 325 mm.
PR.991.50.1.25

MARKS AND INSCRIPTIONS: Inscribed, in plate, lower left: *Goya / 13*; lower center: *Tambien estos.*

127. *One cannot look*
Plate: 142 x 207 mm.
Sheet: 245 x 324 mm.
PR.991.50.1.26

MARKS AND INSCRIPTIONS: Inscribed, in plate, lower left: *Goya / 27*; lower center: *No se puede mirar.*

128. *Charity*
Plate: 161 x 235 mm.
Sheet: 247 x 325 mm.
PR.991.50.1.27

MARKS AND INSCRIPTIONS: Inscribed, in plate, lower left: *Goya 1810 / 11*; lower center: *Caridad.*

129. *Rabble*
Plate: 175 x 217 mm.
Sheet: 246 x 325 mm.
PR.991.50.1.28

MARKS AND INSCRIPTIONS: Inscribed, in plate, lower center: *Populacho.*

130. *He deserved it*
Plate: 175 x 215 mm.
Sheet: 247 x 326 mm.
PR.991.50.1.29

MARKS AND INSCRIPTIONS: Inscribed, in plate, lower center: *Lo merecia.*

131. *Ravages of war*
Plate: 141 x 168 mm.
Sheet: 245 x 325 mm.
PR.991.50.1.30

MARKS AND INSCRIPTIONS: Inscribed, in plate, lower left: *Goya / 3* [?]; lower center: *Estragos de la guerra*

132. *This is too much!*
Plate: 155 x 206 mm.
Sheet: 247 x 324 mm.
PR.991.50.1.31

MARKS AND INSCRIPTIONS: Inscribed, in plate, lower left: *32*; lower center: *Fuerte cosa es!*

133. *Why?*
Plate: 155 x 206 mm.
Sheet: 243 x 324 mm.
PR.991.50.1.32

MARKS AND INSCRIPTIONS: Inscribed, in plate, lower left: *39*; lower center: *Por que?*

134. *What else is there to do?*
Plate: 155 x 206 mm.
Sheet: 243 x 324 mm.
PR.991.50.1.33

MARKS AND INSCRIPTIONS: Inscribed, in plate, lower center: *Que hai que hacer mas?*

135. *Because of a knife*
Plate: 155 x 206 mm.
Sheet: 245 x 324 mm.
PR.991.50.1.34

MARKS AND INSCRIPTIONS: Inscribed, in plate, lower center: *Por una nabaja.*

136. *One cannot know why*
Plate: 155 x 206 mm.
Sheet: 246 x 326 mm.
PR.991.50.1.35

MARKS AND INSCRIPTIONS: Inscribed, in plate, lower center: *No se puede saber por que.*

137. *Nor in this case*
Plate: 155 x 206 mm.
Sheet; 245 x 326 mm.
PR.991.50.1.36

MARKS AND INSCRIPTIONS: Inscribed, in plate, lower left: *39*; lower center: *Tampoco.*

138. *This is worse*
Plate: 155 x 206 mm.
Sheet: 241 x 324 mm.
PR.991.50.1.37

MARKS AND INSCRIPTIONS: Inscribed, in plate, lower left: *52* [?]; lower center: *Esto es peor.*

139. *Barbarians!*
Plate: 155 x 206 mm.
Sheet: 243 x 325 mm.
PR.991.50.1.38

MARKS AND INSCRIPTIONS: Inscribed, in plate, lower center: *Bárbaros!*

140. *Great deeds—against the dead*
Plate: 155 x 206 mm.
Sheet: 243 x 324 mm.
PR.991.50.1.39

MARKS AND INSCRIPTIONS: Inscribed, in plate, lower left: *Goya*; lower center: *Grande hazaña. con muertos.*

141. *Something may be gained*
Plate: 174 x 218 mm.
Sheet: 246 x 324 mm.
PR.991.50.1.40

MARKS AND INSCRIPTIONS: Inscribed, in plate, lower center: *Algun partido saca.*

142. *They escape through the flames*
Plate: 160 x 233 mm.
Sheet: 247 x 326 mm.
PR.991.50.1.41

MARKS AND INSCRIPTIONS: Inscribed, in plate, lower left: *Goya*; / *10*; lower center: *Escapan entre las llamas.*

143. *Everything is upside-down*
Plate: 175 x 218 mm.
Sheet: 247 x 325 mm.
PR.991.50.1.42

MARKS AND INSCRIPTIONS: Inscribed, in plate, lower center: *Todo va revuelto.*

144. *This too*
Plate: 155 x 206 mm.
Sheet: 244 x 325 mm.
PR.991.50.1.43

MARKS AND INSCRIPTIONS: Inscribed, in plate, lower center: *Tambien esto.*

145. *I saw it*
Plate: 159 x 235 mm.
Sheet: 246 x 327 mm.
PR.991.50.1.44

MARKS AND INSCRIPTIONS: Inscribed, in plate, lower left: *Goya*; lower left: *15*; lower center: *Yo lo vi.*

146. *And this too*
Plate: 163 x 220 mm.
Sheet: 247 x 327 mm.
PR.991.50.1.45

MARKS AND INSCRIPTIONS: Signed, in plate, lower left: *Goya*; lower center: *Y esto tambien.*

147. *This is bad*
Plate: 152 x 205 mm.
Sheet: 246 x 323 mm.
PR.991.50.1.46

MARKS AND INSCRIPTIONS: Inscribed, in plate, lower left: *53*; lower center: *Esto es malo.*

148. *This is how it happened*
Plate: 154 x 206 mm.
Sheet: 245 x 326 mm.
PR.991.50.1.47

MARKS AND INSCRIPTIONS: Inscribed, in plate, lower left: *33*; lower center: *Asi sucedió.*

149. *Cruel pity*
Plate: 152 x 205 mm.
Sheet: 246 x 326 mm.
PR.991.50.1.48

MARKS AND INSCRIPTIONS: Inscribed, in plate, lower left: *47*; lower center: *Cruel lástima!*

150. *A woman's charity*
Plate: 153 x 206 mm.
Sheet: 243 x 325 mm.
PR.991.50.1.49

MARKS AND INSCRIPTIONS: Inscribed, in plate, lower left: *56*; lower center: *Caridad de una muger.*

151. *Unhappy mother!*
Plate: 155 x 205 mm.
Sheet: 243 x 326 mm.
PR.991.50.1.50

MARKS AND INSCRIPTIONS: Inscribed, in plate, lower center: *Madre infeliz!*

152. *Thanks to the grasspea*
Plate: 155 x 205 mm.
Sheet: 245 x 326 mm.
PR.991.50.1.51

MARKS AND INSCRIPTIONS: Inscribed, in plate, lower left: *46*; lower center: *Gracias á la almorta.*

153. *They do not arrive in time*
Plate: 155 x 206 mm.
Sheet: 244 x 324 mm.
PR.991.50.1.52

MARKS AND INSCRIPTIONS: Inscribed, in plate, lower center: *No llegan á tiempo.*

154. *There was nothing to be done and he died*
Plate: 154 x 204 mm.
Sheet: 243 x 324 mm.
PR.991.50.1.53

MARKS AND INSCRIPTIONS: Inscribed, in plate, lower left: *43*; lower center: *Espiró sin remedio.*

155. *Useless outcries*
Plate: 155 x 206 mm.
Sheet: 246 x 325 mm.
PR.991.50.1.54

MARKS AND INSCRIPTIONS: Inscribed, in plate, lower left: *45*; lower center: *Clamores en vano.*

156. *The worst is to beg*
Plate: 155 x 206 mm.
Sheet: 246 x 325 mm.
PR.991.50.1.55

MARKS AND INSCRIPTIONS: Inscribed, in plate, lower left: *Goya / 37*; lower center: *Lo peor es pedir*

157. *To the cemetery*
Plate: 155 x 205 mm.
Sheet: 247 x 326 mm.
PR.991.50.1.56

MARKS AND INSCRIPTIONS: Inscribed, in plate, lower left: *o*; lower center: *Al cementerio*

158. *The healthy and the sick*
Plate: 155 x 206 mm.
Sheet: 247 x 325 mm.
PR.991.50.1.57

MARKS AND INSCRIPTIONS: Inscribed, in plate, lower center: *Sanos y enfermos.*

159. *It is no use to cry out*
Plate: 155 x 208 mm.
Sheet: 247 x 325 mm.
PR.991.50.1.58

MARKS AND INSCRIPTIONS: Inscribed, in plate, lower left: *34*; lower center: *No hay que dar voces.*

160. *Of what use is a single cup?*
Plate: 153 x 205 mm.
Sheet: 246 x 327 mm.
PR.991.50.1.59

MARKS AND INSCRIPTIONS: Inscribed, in plate, lower center: *De qué sirve una taza?*

161. *There is no one to help them*
Plate: 153 x 206 mm.
Sheet: 246 x 327 mm.
PR.991.50.1.60

MARKS AND INSCRIPTIONS: Inscribed, in plate, lower left: *31*; lower center: *No hay quien los socorra.*

162. *If they are of a different lineage*
Plate: 155 x 206 mm.
Sheet: 244 x 326 mm.
PR.991.50.1.61

MARKS AND INSCRIPTIONS: Inscribed, in plate, lower left: *35*; lower center: *Si son de otro linage.*

163. *The deathbeds*
Plate: 175 x 220 mm.
Sheet: 247 x 327 mm.
PR.991.50.1.62

MARKS AND INSCRIPTIONS: Inscribed, in plate, lower center: *Las camas de la muerte.*

164. *Collection of dead men*
Plate: 153 x 205 mm.
Sheet: 245 x 327 mm.
PR.991.50.1.63

MARKS AND INSCRIPTIONS: Inscribed, in plate, lower left: *34*; lower center: *Muertos recogidos.*

165. *Cartloads to the cemetery*
Plate: 153 x 205 mm.
Sheet: 246 x 326 mm.
PR.991.50.1.64

MARKS AND INSCRIPTIONS: Inscribed, in plate, lower left: *38*; lower center: *Carretadas al cementerio.*

166. *What is this hubbub?*
Plate: 175 x 219 mm.
Sheet: 247 x 328 mm.
PR.991.50.1.65

MARKS AND INSCRIPTIONS: Inscribed, in plate, lower center: *Qué alboroto es este?*

167. *Strange devotion!*
Plate: 175 x 220 mm.
Sheet: 246 x 327 mm.
PR.991.50.1.66

MARKS AND INSCRIPTIONS: Inscribed, in plate, lower center: *Extraña devocion!*

168. *This is no less so*
Plate: 175 x 220 mm.
Sheet: 247 x 326 mm.
PR.991.50.1.67

MARKS AND INSCRIPTIONS: Inscribed, in plate, lower center: *Esta no lo es menos.*

169. *What madness!*
Plate: 160 x 220 mm.
Sheet: 246 x 327 mm.
PR.991.50.1.68

MARKS AND INSCRIPTIONS: Inscribed, in plate, lower center: *Que locura!*

170. *Nothing. We shall see*
Plate: 155 x 200 mm.
Sheet: 244 x 327 mm.
PR.991.50.1.69

MARKS AND INSCRIPTIONS: Inscribed, in pencil, upper right; *69*; inscribed, in plate, lower left: *96*; lower center: *Nada. Ello dirá.*

171. *They don't know the way*
Plate: 175 x 220 mm.
Sheet: 245 x 325 mm.
PR.991.50.1.70

MARKS AND INSCRIPTIONS: Inscribed, in plate, lower center: *No saben el camino.*

172. *Against the common good*
Plate: 175 x 218 mm.
Sheet: 247 x 324 mm.
PR.991.50.1.71

MARKS AND INSCRIPTIONS: Inscribed, in plate, lower center: *Contra el bien general.*

173. *The consequences*
Plate: 174 x 218 mm.
Sheet: 246 x 323 mm.
PR.991.50.1.72

MARKS AND INSCRIPTIONS: Inscribed, in plate, lower center: *Las resultas.*

174. *Feline pantomime*
Plate: 174 x 215 mm.
Sheet: 245 x 323 mm.
PR.991.50.1.73

MARKS AND INSCRIPTIONS: Inscribed, in plate, lower center: *Gatesca pantomima.*

175. *This is the worst!*
Plate: 177 x 218 mm.
Sheet: 245 x 325 mm.
PR.991.50.1.74

MARKS AND INSCRIPTIONS: Inscribed, in plate, lower center: *Esto es lo peor!*

176. *Troupe of charlatans*
Plate: 173 x 216 mm.
Sheet: 245 x 323 mm.
PR.991.50.1.75

MARKS AND INSCRIPTIONS: Inscribed, in plate, lower center: *Farándula de charlatanes.*

177. *The carnivorous vulture*
Plate: 174 x 218 mm.
Sheet: 247 x 327 mm.
PR.991.50.1.76

MARKS AND INSCRIPTIONS: Inscribed, in plate, lower center: *El buitre carnívoro.*

178. *The rope is breaking*
Plate: 174 x 219 mm.
Sheet: 247 x 325 mm.
PR.991.50.1.77

MARKS AND INSCRIPTIONS: Inscribed, in plate, lower center: *Que se rompe la cuerda.*

179. *He defends himself well*
Plate: 175 x 218 mm.
Sheet: 247 x 326 mm.
PR.991.50.1.78

MARKS AND INSCRIPTIONS: Inscribed, in plate, lower center: *Se defiende bien.*

180. *Truth has died*
Plate: 175 x 218 mm.
Sheet: 247 x 326 mm.
PR.991.50.1.79

MARKS AND INSCRIPTIONS: Inscribed, in pencil, upper right, *79*; inscribed, in plate, lower center: *Murió la Verdad.*

181. *Will she live again?*
Plate: 173 x 218 mm.
Sheet: 243 x 325 mm.
PR.991.50.1.80

MARKS AND INSCRIPTIONS: Inscribed, in plate, lower center: *Si resucitará?*

MARKS AND INSCRIPTIONS: All eighty plates are numbered sequentially, in plate, upper left, and in pencil, upper right (1–80),

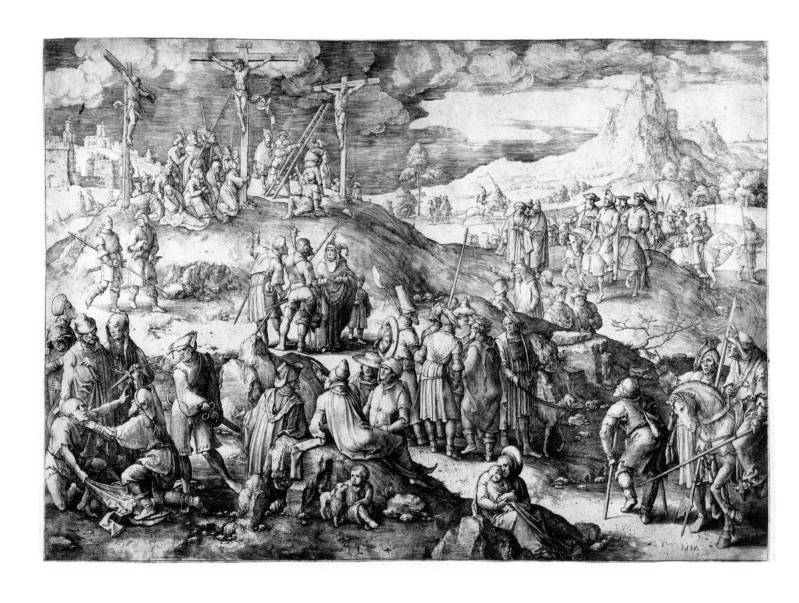

Lucas van Leyden, *Calvary (Golgotha)*, 1517, cat. no. 185

except cat. nos. 118 and 170; partial watermark in some sheets: J.O. with palmette/shell (?)

PROVENANCE: Felix Somary (1881–1956), Vienna and Zurich; sold Sotheby's, New York, May 3, 1978, lot 22.

LUCAS VAN LEYDEN
(Netherlandish, c. 1489 or 1494–1533)

182. *The Raising of Lazarus,* c. 1508
Engraving, state i/II
Sheet: 282 x 204 mm., trimmed to platemark
Bartsch, Hollstein 42
PR.997.5.68

MARKS AND INSCRIPTIONS: Inscribed, in plate, lower center: *L*; stamped, in black ink, on verso: collection mark of H. Weber (Lugt 1383); stamped, in blue ink, on verso: collection mark of D. G. de Arozarena (Lugt 109); watermark: Gothic P with Flower

PROVENANCE: Hermann Weber (1817–1854), Bonn (probably sold Rudolph Weigel, Leipzig, September 17, 1855); D. G. de Arozarena (around 1860), South America and Paris (probably sold Hôtel Drouot, Paris, March 11–16, 1861); acquired between July 1993 and February 1995.

183. *The Return of the Prodigal Son,* c. 1510
Engraving, state i/II
Sheet: 186 x 248 mm., trimmed to platemark or between platemark and borderline
Bartsch, Hollstein 78
PR.997.5.84

MARKS AND INSCRIPTIONS: Inscribed, in plate, lower right: *L*; stamped, in black ink, lower right: collection mark of Friedrich August II (Lugt 971); inscribed, in brown ink, on verso: *Pierre Mariette 1672* (Lugt 1789); stamped, in black ink, on verso: *K.B GRAPHISCHE SAMMLUNG* with pencil inscription *528 / 1928* (Lugt 1094a); deaccession stamp with pencil inscription *22.10.1976*; inscribed, in red pencil, on verso: *75*; watermark: Crowned Shield with Fleur-de-lys and Gothic R

PROVENANCE: Pierre Mariette II (1634–1716), Paris; Friedrich August II (1797–1854), King of Saxony, Dresden; Graphische Sammlung, Munich, 1928 until October 22, 1976, when deaccessioned; acquired from Linda M. Papaharis, Pittsburgh, on August 4, 1986.

184. *Potiphar's Wife Accusing Joseph,* from *The History of Joseph,* 1512
Engraving, state i/II
Plate: 126 x 165 mm., trimmed to platemark
Bartsch, Hollstein 21
PR.997.5.67

MARKS AND INSCRIPTIONS: Inscribed, in plate, upper center: *L / 1512*; stamped, in black ink, lower right: partial collection mark of A. Hunter (Lugt 2306); inscribed, in pencil, on verso: *AW*; watermark: Crowned Shield with Fleur-de-lys

PROVENANCE: Alexander Gibson Hunter, Ballskelly (19th century); acquired from Colnaghi & Co., London, on February 26, 1976.

185. *Calvary (Golgotha),* 1517
Engraving, state ii/IV
Sheet: 285 x 413 mm., trimmed between platemark and borderline
Bartsch, Hollstein 74
PR.997.5.83

MARKS AND INSCRIPTIONS: Inscribed, in plate, lower center: *L*; lower right: *1517*; watermark: Small Jug with Flowers

PROVENANCE: Acquired at Christie's, London, June 30, 1994, lot 102.

(186–199)
THE PASSION OF CHRIST, 1521
Fourteen engravings, state i/II
Bartsch, Hollstein 43–56

186. *The Last Supper*
Plate: 115 x 76 mm.
Sheet: 133 x 94 mm.
PR.997.5.69

187. *The Agony in the Garden*
Plate: 116 x 74 mm.
Sheet: 135 x 93 mm.
PR.997.5.70

188. *The Betrayal*
Plate: 116 x 75 mm.
Sheet: 136 x 94 mm.
PR.997.5.71

189. *Christ Before Annas*
Plate: 116 x 75 mm.
Sheet: 133 x 92 mm.
PR.997.5.72

MARKS AND INSCRIPTIONS: Inscribed, in plate, on wheelchair: *ANNS* [the "s" reversed]

190. *The Mocking of Christ*
Plate: 117 x 76 mm.
Sheet: 133 x 93 mm.
PR.997.5.73

191. *The Flagellation*
Plate: 116 x 76 mm.
Sheet: 135 x 95 mm.
PR.997.5.74

192. *Christ Crowned with Thorns*
Plate: 116 x 74 mm.
Sheet: 133 x 90 mm.
PR.997.5.75

193. *Ecce Homo*
Plate: 119 x 80 mm.
Sheet: 133 x 92 mm.
PR.997.5.76

194. *The Bearing of the Cross*
Plate: 116 x 75 mm.
Sheet: 133 x 91 mm.
PR.997.5.77

195. *The Crucifixion*
Plate: 114 x 75 mm.
Sheet: 133 x 92 mm.
PR.997.5.78

MARKS AND INSCRIPTIONS: Inscribed,
in plate, on cross: *INRI*

196. *The Descent from the Cross*
Plate: 116 x 76 mm.
Sheet: 133 x 93 mm.
PR.997.5.79

197. *The Entombment*
Plate: 116 x 75 mm.
Sheet: 136 x 93 mm.
PR.997.5.80

198. *Christ in Limbo*
Plate: 116 x 76 mm.
Sheet: 134 x 93 mm.
PR.997.5.81

199. *The Resurrection*
Plate: 116 x 75 mm.
Sheet: 132 x 93 mm.
PR.997.5.82

MARKS AND INSCRIPTIONS: Inscribed, in each
plate, in various locations: *L / 1521*; stamped,
in black ink, on verso of each: collection
mark of C. J. Rosenbloom (Lugt 633b)

PROVENANCE: Charles J. Rosenbloom
(1898–1973), Pittsburgh, PA; sold Christie's,
New York, November 16, 1982, lot 31.

DAVID LUCAS
(British, 1802–1881)
JOHN CONSTABLE
(British, 1776–1837)

(200–221)
ENGLISH LANDSCAPE, 1830–32, published 1833
Twenty–two mezzotints on chine collé,
bound in five portfolios
States listed below are from Osbert H. Barnard's
corrections of Shirley (see fn. 1, p. 77)

PORTFOLIO NUMBER 1

200. *Frontispiece: The Artist's Home at
East Bergholt*, 1831
State i/IV
Plate: 234 x 239 mm.
Sheet: 293 x 442 mm.
Shirley 27
PR.992.12.1

MARKS AND INSCRIPTIONS: Inscribed,
in plate, top center: *FRONTISPIECE.
/ To Mr. Constable's English Landscape.*;
lower right, beneath image: *Engraved by
David Lucas.*; lower left, beneath image:
Painted by John Constable, R.A.; bottom
center margin: *EAST BERGHOLT,
SUFFOLK. / "Hic locus ætatis nostrae
primordia novit / Annos felices lætitiæque
dies: / Hic locus ingenuis pueriles imbuit
annos /Artibus, et nostrae laudis origo
fuit."*; bottom center: *London. Published
by Mr. Constable 35 Charlotte St.⁺ Fitzroy
Square. 1831.*

201. *Spring*, 1830
State ii/V
Plate: 153 x 256 mm.
Sheet: 303 x 443 mm.
Shirley 7
PR.992.12.2

MARKS AND INSCRIPTIONS: Inscribed,
in plate, lower right, beneath image:
Engraved by David Lucas; lower left,
beneath image: *Painted by John
Constable, R.A.*; bottom center margin:
*SPRING / London Published by
Mr Constable 35 Charlotte St Fitzroy
Square 1830*

202. *Autumnal Sun Set*, 1831
State i/IV
Plate: 176 x 253 mm.
Sheet: 300 x 439 mm.
Shirley 14
PR.992.12.3

MARKS AND INSCRIPTIONS: Inscribed, in plate, lower right, beneath image: *Engraved by David Lucas.;* lower left, beneath image: *Painted by John Constable R.A.;* bottom center margin: *AUTUMNAL SUN SET. / London Pubd. by Mr. Constable 35, Charlotte St. Fitzroy Square 1831.*

203. *Noon, 1830*
State i/IV
Plate: 189 x 253 mm.
Sheet: 303 x 438 mm.
Shirley 16
PR.992.12.4

MARKS AND INSCRIPTIONS: Inscribed, in plate, lower left, beneath image: *Engraved by David Lucas.;* lower right, beneath image: *Painted by John Constable;* bottom center margin: *NOON. / London, Pubd. by Mr. Constable 35. Charlotte St. Fitzroy Square. 1830.*

204. *Yarmouth, Norfolk, 1832*
State iii/IV
Plate: 193 x 255 mm.
Sheet: 293 x 433 mm.
Shirley 18
PR.992.12.5

MARKS AND INSCRIPTIONS: Inscribed, in plate, lower right, beneath image: *Engraved by David Lucas.;* lower left, beneath image: *Painted by John Constable R.A.;* bottom center margin: *YARMOUTH, NORFOLK. / London. Published by Mr. Constable.35. Charlotte Street. Fitzroy Square. 1832.*

PORTFOLIO NUMBER 2

205. *Summer Morning, 1831*
State i/V
Plate: 175 x 253 mm.
Sheet: 438 x 298 mm.
Shirley 26
PR.992.12.6

MARKS AND INSCRIPTIONS: Inscribed, in plate, lower right beneath image: *Engraved by David Lucas.;* lower left, beneath image: *Painted by John Constable R.A;* bottom center margin: *SUMMER MORNING. / London Pubd. by Mr. Constable 35. Charlotte St. Fitzroy Square 1831.*

206. *Summer Evening, 1831*
State iii/IV
Plate: 176 x 254 mm.
Sheet: 293 x 430 mm.
Shirley 6
PR.992.12.7

MARKS AND INSCRIPTIONS: Inscribed, in plate, lower right, beneath image: *Engraved by David Lucas.;* lower left, beneath image: *Painted by John Constable, R.A.;* bottom center margin: *SUMMER EVENING. / London Pubd. by Mr. Constable. 35 Charlotte St. Fitzroy. Square. 1831.*

207. *A Dell, Helmington Park, Suffolk, 1830*
State ii/V
Plate: 177 x 224 mm.
Sheet: 302 x 440 mm.
Shirley 12
PR.992.12.8

MARKS AND INSCRIPTIONS: Inscribed, in plate, lower right, beneath image: *Engraved by David Lucas;* lower left, beneath image: *Painted by John Constable, R.A.;* bottom center margin: *A DELL, HELMINGHAM PARK, SUFFOLK / London Published by Mr. Constable 35 Charlotte St. Fitzroy Square 1830*

208. *A Heath, 1831*
State i/IV
Plate: 176 x 219 mm.
Sheet: 304 x 439 mm.
Shirley 23
PR.992.12.9

MARKS AND INSCRIPTIONS: Inscribed, in plate, lower right, beneath image: *Engraved by David Lucas.;* lower left, beneath image: *Painted by John Constable R.A.;* bottom center margin: *A HEATH. / London, Pubd. by Mr. Constable 35. Charlotte St. Fitzroy Square. 1831.*

PORTFOLIO NUMBER 3

209. *A Seabeach, 1830*
State i/V
Plate: 187 x 253 mm.
Sheet: 305 x 440 mm.
Shirley 17
PR.992.12.10

MARKS AND INSCRIPTIONS: Inscribed, in plate, lower right, beneath image: *Engraved by David Lucas;* lower left,

Painted by John Constable, R.A. Engraved by David Lucas

WEYMOUTH BAY. DORSETSHIRE.

London Published by M. Constable, 35. Charlotte St. Fitzroy Square 1830.

David Lucas and John Constable, *Weymouth Bay, Dorsetshire,* 1830, cat. no. 217

beneath image: *Painted by John Constable, R.A.;* bottom center margin: *A SEABEACH. / London Pubd. by Mr. Constable, 35. Charlotte St. Fitzroy Square. 1830.*

210. *Stoke by Neyland, Suffolk,* 1830
State i/IV
Plate: 175 x 251 mm.
Sheet: 306 x 440 mm.
Shirley 9
PR.992.12.11

MARKS AND INSCRIPTIONS: Inscribed, in plate, lower right, beneath image: *Engraved by David Lucas.;* lower left, beneath image: *Painted by John Constable, R.A.;* bottom center margin: *STOKE BY NEYLAND, SUFFOLK. / London Pubd. by Mr. Constable. 35. Charlotte St. Fitzroy Square. 1830.*

211. *Mill Stream,* 1831
State iv/V
Plate: 175 x 222 mm.
Sheet: 303 x 435 mm.
Shirley 25
PR.992.12.12

MARKS AND INSCRIPTIONS: Inscribed, in plate, lower right, beneath image: *Engraved by David Lucas.;* lower left, beneath image: *Painted by John Constable, R.A.;* bottom center margin: *MILL STREAM. / London Pubd. by Mr. Constable 35. Charlotte St. Fitzroy Square 1831.*

212. *A Lock on the Stour,* 1831
State iv/V
Plate: 176 x 215 mm.
Sheet: 293 x 435 mm.
Shirley 20
PR.992.12.13

MARKS AND INSCRIPTIONS: Inscribed, in plate, lower right, beneath image: *Engraved by David Lucas.;* lower left, beneath image: *Painted by John Constable, R.A.;* bottom center margin: *A LOCK ON THE STOUR, SUFFOLK. / London Pub. by Mr. Constable. 35. Charlotte St. Fitzroy Square. 1831.*

213. *A Summerland,* 1831
State iii/IV
Plate: 177 x 252 mm.
Sheet: 293 x 438 mm.
Shirley 10
PR.992.12.14

MARKS AND INSCRIPTIONS: Inscribed, in plate, lower right, beneath image: *Engraved by David Lucas.;* lower left, beneath image: *Painted by John Constable, R.A.;* bottom center margin: *A SUMMERLAND. / London Pubd. by Mr. Constable. 35. Charlotte St. Fitzroy Square. 1831.*

214. *River Stour, Suffolk,* 1831
State vi/VII
Plate: 177 x 252 mm.
Sheet: 293 x 436 mm.
Shirley 19
PR.992.12.15

MARKS AND INSCRIPTIONS: Inscribed, in plate, lower right, beneath image: *Engraved by David Lucas.;* lower left, beneath image: *Painted by John Constable. R.A.;* bottom center margin: *RIVER STOUR, SUFFOLK. / London. Pub. by Mr. Constable. 35. Charlotte St. Fitzroy Square. 1831.*

215. *Old Sarum* (second plate), 1832
State ii/III
Plate: 177 x 256 mm.
Sheet: 294 x 437 mm.
Shirley 32
PR.992.12.16

MARKS AND INSCRIPTIONS: Inscribed, in plate, lower right, beneath image: *Engraved by David Lucas.;* lower left, beneath image: *Painted by John Constable, R.A.;* bottom center margin: *OLD SARUM. / "HERE WE HAVE NO CONTINUING CITY." / ST PAUL. / London Pubd. by Mr. Constable. 35 Charlotte St. Fitzroy Square 1832*

216. *A Mill,* 1832
State iv/VI
Plate: 183 x 254 mm.
Sheet: 300 x 438 mm.
Shirley 5
PR.992.12.17

MARKS AND INSCRIPTIONS: Inscribed, in plate, lower right, beneath image: *Engraved by David Lucas;* lower left,

beneath image: *Painted by John Constable, R.A.*; bottom center margin: *A MILL. / London. Pub. by Mr. Constable. 35. Charlotte St. Fitzroy Square. 1832.*

PORTFOLIO NUMBER 5

217. *Weymouth Bay, Dorsetshire*, 1830
State iv/VI
Plate: 176 x 229 mm.
Sheet: 297 x 436 mm.
Shirley 13
PR.992.12.18

MARKS AND INSCRIPTIONS: Inscribed, in plate, lower right, beneath image: *Engraved by David Lucas*; lower left, beneath image: *Painted by John Constable, R.A.*; bottom center margin: *WEYMOUTH BAY, DORSETSHIRE. / London Published by Mr. Constable. 35. Charlotte St. Fitzroy Square. 1830.*

218. *Summer Afternoon—After a Shower*, 1831
State i/IV
Plate: 178 x 220 mm.
Sheet: 296 x 445 mm.
Shirley 28
PR.992.12.19

MARKS AND INSCRIPTIONS: Inscribed, in plate, lower right, beneath image: *Engraved by David Lucas.*; lower left, beneath image: *Painted by John Constable R.A.*; bottom center margin: *SUMMER, AFTERNOON—AFTER A SHOWER. / London Pub. by Mr. Constable, 35. Charlotte, St. Fitzroy Square, 1831.*

219. *The Glebe Farm*, 1832
State iii/IV
Plate: 175 x 252 mm.
Sheet: 292 x 436 mm.
Shirley 29
PR.992.12.20

MARKS AND INSCRIPTIONS: Inscribed, in plate, lower right, beneath image: *Engraved by David Lucas.*; lower left, beneath image: *Painted by John Constable, R.A.*; bottom center margin: *THE GLEBE FARM. / London Pub. by Mr. Constable. 35. Charlotte Street. Fitzroy Square. 1832.*

220. *Hadleigh Castle near the Nore*, 1832
State i/IV
Plate: 182 x 254 mm.
Sheet: 296 x 435 mm.
Shirley 34
PR.992.12.21

MARKS AND INSCRIPTIONS: Inscribed, in plate, lower right, beneath image: *Engraved by David Lucas.*; lower left, beneath image: *Painted by John Constable R.A.*; bottom center margin: *HADLEIGH CASTLE near the NORE. / London. Pubd. by Mr. Constable. 35. Charlotte St. Fitzroy Square. 1832.*

221. *Vignette, Hampstead Heath, Middlesex*, 1831
State i/II
Plate: 164 x 229 mm.
Sheet: 294 x 439 mm.
Shirley 3
PR.992.12.22

MARKS AND INSCRIPTIONS: Inscribed, in plate, top center, above image: *VIGNETTE. / To Mr. Constable's English Landscape.*; lower right, beneath image: *Engraved by David Lucas.*; lower left, beneath image: *Painted by John Constable, R.A.*; bottom center margin: *HAMPSTEAD HEATH, MIDDLESEX. / "Ut Umbra sic Vita." / London. Published by Mr. Constable. 35. Charlotte St. Fitzroy Square. 1831.*

MARKS AND INSCRIPTIONS: All five portfolios bear the inscription on upper left of pink wrapper: *Sir G. Beaumont.* Portfolio numbers 2 and 3 are bound with faded blue ribbon; the ribbon is missing on portfolio numbers 1, 4, and 5.

PROVENANCE: Sir George Howland Willoughby Beaumont (1799–1845), London, 1833; Sir Francis Beaumont, Baronet; sold Sotheby's, London, July 15, 1982, lot 176.

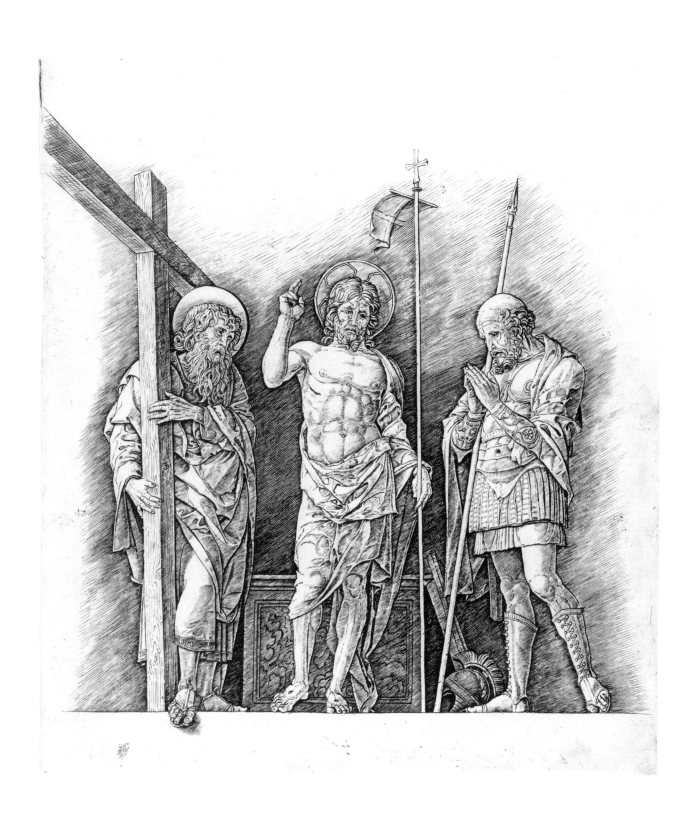

Andrea Mantegna, *The Risen Christ Between Saints Andrew and Longinus*, c. 1472, cat. no. 223

ANDREA MANTEGNA
(Italian, 1431–1506)

222. *Battle of the Sea Gods* (left half), 1470s
Engraving, only state
Sheet: 245 x 373 mm., trimmed considerably
at right and at bottom
Bartsch 18
PR.997.5.85

MARKS AND INSCRIPTIONS: Inscribed, in plate,
upper center: *INVID* / [undecipherable];
inscribed, in brown ink, on verso: *ai GA [?]*
/ A very Old Engraving by / Andrea
Mantegna—who was born 1451 and Died 1517 /
No 57 / J / 8 / 2.L.17; watermark: Scales in
Circle

PROVENANCE: Sold Karl & Faber, Munich,
June 2, 1972, lot 125.

223. *The Risen Christ Between Saints Andrew*
and Longinus, c. 1472
Engraving and drypoint, only state
Sheet: 377 x 333 mm.
Bartsch 6
PR.997.5.86

MARKS AND INSCRIPTIONS: Watermark: Shield
with PS

PROVENANCE: George Cumberland (1754–
1848), London; Royal Academy of Arts,
London, 1927 until 1965, when deaccessioned;
Kimbell Art Foundation, Fort Worth (sold
Sotheby's, New York, May 13, 1987, lot 37).

JOSÉ CLEMENTE OROZCO
(Mexican, 1883–1949)

224. *Serpents (The Prophecy of Quetzalcoatl),* 1935
Drypoint
Plate: 146 x 181 mm.
Sheet: 515 x 680 mm.
Orozco 33
PR.978.160

MARKS AND INSCRIPTIONS: Signed, in pencil,
lower right: *Clemente Orozco;* inscribed, in
pencil, lower left: *7/10*

PROVENANCE: Unknown.

CAMILLE PISSARRO
(French, 1830–1903)

225. *Landscape at the Hermitage, Pontoise,* 1880
Drypoint, state iii/III
Plate: 158 x 111 mm.
Sheet: 251 x 162 mm.
Delteil, Cailac 28
PR.991.50.6

MARKS AND INSCRIPTIONS: Signed, in pencil,
lower right: *C. Pissarro;* inscribed, in pencil,
lower left: *No. 15 Paysage à l'hermitage /*
Pontoise / manière grise; inscribed, on verso,
in red crayon: *P*

PROVENANCE: Sold Sotheby Parke Bernet,
New York, February 14, 1980, lot 448A.

226. *Peasant Woman Digging,* 1890
Etching, state vii/X
Plate: 109 x 125 mm.
Sheet: 215 x 300 mm.
Delteil 95
PR.991.50.5

MARKS AND INSCRIPTIONS: Inscribed, in
pencil, lower left: *7e–etat No 1 / Paysanne*
bêchant; lower right: *imp. par C. P.*

PROVENANCE: Rita Silver, New York (sold
Christie's, New York, May 13, 1986, lot 257).

JUSEPE DE RIBERA
(Spanish, 1591–1652)

227. *The Martyrdom of Saint Bartholomew,* 1624
Etching and engraving, state i/II
Sheet: 316 x 236 mm., trimmed to just
outside platemark
Bartsch 6; Brown 12
PR.997.5.116

MARKS AND INSCRIPTIONS: Inscribed, in plate,
lower center: *Dedico mis obras y esta estampa*
al Serenis^{mo} Principe Philiberto mi Señor / en
Napoles año 1624; lower right: *Iusepe de*
Riuera Spañol.; watermark: Small Latin Cross

PROVENANCE: The Dukes of Devonshire,
Chatsworth (sold Christie's, London,
December 5, 1985, lot 142).

REMBRANDT VAN RIJN
(Dutch, 1606–1669)

228. *Self Portrait in a Fur Cap: Bust,* 1630
Etching, state iv/IV (Hollstein); iii/V
(Usticke)
Sheet: 63 x 52 mm., trimmed to platemark
Bartsch, Hollstein 24; Hind 29
PR.997.5.87

MARKS AND INSCRIPTIONS: Inscribed, in plate,
upper left: *RHL* [monogram] *1630;*
inscribed, on verso, in black ink: *N. Mosoloff*
(Lugt 1802); Russian stamp, in blue ink, with
inventory number, in pencil: *19885*

PROVENANCE: Nicolas Mossoloff (1847–1914),
Moscow; James Kingon Callaghan (sold
Sotheby Parke Bernet, New York, November
14, 1981, lot 815).

229. *Adam and Eve,* 1638
Etching, state ii/II
Sheet: 163 x 118 mm., with narrow margins
Bartsch, Hollstein 28; Hind 159
PR.997.5.88

MARKS AND INSCRIPTIONS: Inscribed in plate,
lower center: *Rembrandt. f. 1638;* stamped, on
verso, in black ink: *SAMLUNG/HEBICH/
HAMBURG* (Lugt 1250); inscribed, on
verso, in black ink: *Hebich* (Lugt 1251);
watermark: Fleur-de-lys in Shield

PROVENANCE: Johann Carl Diedrich Hebich
(1818–1891), Hamburg (probably sold H. G.
Gutekunst, Stuttgart, November 15–16,
1880); acquired from David Tunick, Inc.,
on July 16, 1990.

230. *Abraham's Sacrifice,* 1655
Etching and drypoint, only state
Sheet: 158 x 133 mm., with narrow to
thread margins
Bartsch, Hollstein 35; Hind 283
PR.997.5.89

MARKS AND INSCRIPTIONS: Inscribed, in plate,
lower right: *Rembrandt f 1655* (the "d"
and the "6" reversed); inscribed, on verso,
in brown ink: *HG / No: 39* (not in Lugt)

PROVENANCE: Sold Sotheby Parke Bernet,
New York, February 15, 1980, lot 1028.

231. *The Triumph of Mordecai,* c. 1641
Etching and drypoint, only state
Sheet: 175 x 215 mm., with thread margins
or trimmed to platemark
Bartsch, Hollstein 40; Hind 172
PR.997.5.90

MARKS AND INSCRIPTIONS: Inscribed, in black
ink, on verso: *F. Rechberger 1803* (Lugt 2133);
inscribed, in pencil, on verso: *des collections
Fries et Verstolk / MEP;* stamped, on verso,
in black ink: collection mark of E. Smith
(Lugt 2897)

PROVENANCE: Comte Moriz von Fries
(1777–1826), Vienna (probably sold C. S.
Roos et. al., Amsterdam, June 21, 1824);
Baron Jan Gijsbert Verstolk van Soelen
(1776–1845), The Hague (probably sold J. de
Vries et. al., Amsterdam, October 26, 1847);
Edward Smith Junior, London (probably
sold Sotheby's, London, November 20, 1880);
Christie's, New York, May 2, 1980, lot 98
(bought in); private sale, Sotheby Parke
Bernet, New York, November 13, 1980.

232. *Christ Preaching (La Petite Tombe),* c. 1652
Etching and drypoint, only state
Sheet: 155 x 207 mm., trimmed to and just
within platemark
Bartsch, Hollstein 67; Hind 256
PR.997.5.91

MARKS AND INSCRIPTIONS: Inscribed,
in pencil, on mount: *good impression*
[indecipherable]

PROVENANCE: Sold Christie's, London, June
24, 1986, lot 269.

233. *Christ Presented to the People (Ecce Homo),*
1655
Drypoint, state v/VII
Sheet: 359 x 457 mm., with narrow to
thread margins
Bartsch, Hollstein 76; Hind 271
PR.997.5.92

MARKS AND INSCRIPTIONS: Stamped, in
brown ink, lower center: *BR* (Lugt 409);
deaccession stamp, in black ink, on verso:
E 3025

PROVENANCE: Duplicate deaccessioned from
the Bibliothèque Royale (later Nationale),
Paris; acquired from Artemis Fine Arts, Ltd.,
London, in 1994.

234. *Christ Crucified Between the Two Thieves:
The Three Crosses,* 1653–c. 1660
Drypoint, state iv/V
Sheet: 387 x 452 mm., trimmed to platemark
Bartsch, Hollstein 78; Hind 270
PR.997.5.93

MARKS AND INSCRIPTIONS: Inscribed, in
pencil, on verso: *lot 109 T H Robinson sale
1820;* inscribed, in brown ink, on verso:
No. 90 / Third impression (Lugt 439);

Rembrandt van Rijn, *Adam and Eve,* 1638, cat. no. 229

inscribed, in pencil, on verso: *W. S. 1772 / no. 20* (Lugt 2650b)

PROVENANCE: W. S., 1772; Jan Chalon (1738–1795), Amsterdam, Paris, and London; probably by descent to Christian Josi, Amsterdam and London (probably sold Amsterdam, 1797); Thomas H. Robinson, London (sold Winstanley, Manchester, May 19, 1820, lot 189); private collection, Europe (sold Christie's, London, June 30, 1994, lot 154).

235. *Christ at Emmaus: The Larger Plate,* 1654
Etching and drypoint, state ii/III
Sheet: 212 x 160 mm., trimmed on or just within platemark
Bartsch, Hollstein 87; Hind 282
PR.997.5.94

MARKS AND INSCRIPTIONS: Inscribed, in plate, lower right: *Rembrandt f. 1654*; inscribed, in brown ink, on verso: *90*

PROVENANCE: Sold Christie's, London, June 29, 1988, lot 276.

236. *Woman Sitting Half Dressed Beside a Stove,* 1658
Etching and drypoint, state iii/VII
Sheet: 230 x 190 mm., with narrow margins
Bartsch, Hollstein 197; Hind 296
PR.997.5.95

MARKS AND INSCRIPTIONS: Inscribed, in plate, upper right: *Rembrandt f. 1658*; inscribed, in black ink, on verso: *N. Mossoloff* (Lugt 1802); Russian stamp, in blue ink, with inventory number, in pencil: *40571*

PROVENANCE: Nicolas Mossoloff (1847–1914), Moscow; perhaps deaccessioned from the Roumiantzoff Museum, Moscow; sale, Sotheby Parke Bernet, London, December 6, 1983, lot 194 (bought in); acquired from William H. Schab Gallery, Inc., New York, on January 30, 1984.

237. *Woman Bathing Her Feet at a Brook,* 1658
Etching, only state
Plate: 161 x 80 mm.
Sheet: 169 x 88 mm.
Bartsch, Hollstein 200; Hind 298
PR.997.5.96

MARKS AND INSCRIPTIONS: Inscribed, in plate, upper left: *Rembrandt f. / 1658*; inscribed, in brown ink, lower right: *192*; stamped, on verso, collection marks of F. Quiring (Lugt Supp. 1041c), Viscount Downe (Lugt Supp. 719a) and L. Lancy (not in Lugt)

PROVENANCE: Friedrich Quiring (born 1886), Eberswalde (near Berlin), after 1921; Richard Dawnay (1903–1965), Tenth Viscount Downe and Baron Dawnay of Danby, Wykeham Abbey, Scarborough, Yorkshire, after 1942 (sold Sotheby's, London, December 7, 1972, lot 271); L. Lancy; acquired from C. G. Boerner, c. 1987.

238. *Jupiter and Antiope: Smaller Plate,* c. 1631
Etching, state ii/II
Sheet: 87 x 115 mm., with narrow margins
Bartsch, Hollstein 204; Hind 44
PR.997.5.97

MARKS AND INSCRIPTIONS: Inscribed, in plate, right center: *RHL* [monogram]; stamped, in black ink, collection mark of August Artaria (Lugt 33)

PROVENANCE: August Artaria (1807–1893), Vienna (probably sold Artaria & Co., Vienna, May 6–13, 1898); sold Sotheby's, London, November 19, 1982, lot 585.

239. *Negress Lying Down,* 1658
Etching and drypoint, state ii/III
Plate: 83 x 158 mm.
Sheet: 90 x 167 mm.
Bartsch, Hollstein 205; Hind 299
PR.997.5.98

MARKS AND INSCRIPTIONS: Inscribed, in plate, lower left: *Rembrandt f. 1658*; inscribed, in pencil, on verso: *RU* (similar to Lugt 2247)

PROVENANCE: Possibly owned by Richard Udny (1722–1802), London and Teddington; acquired from W. H. Schab Gallery, New York, on August 23, 1982.

240. *The Three Trees,* 1643
Etching, drypoint, and engraving, only state
Plate: 213 x 282 mm.
Sheet: 221 x 288 mm.
Bartsch, Hollstein 212; Hind 205
Promised gift of Jean K. Weil, in memory of Adolph Weil Jr., Class of 1935

MARKS AND INSCRIPTIONS: Inscribed, in plate, lower left: *Rembrandt f 1643*; collection mark of F. Locker Lampson (Lugt 1692)

PROVENANCE: Frederick Locker Lampson (1821–1895), Rowfant, Sussex (sold Christie's, London, December 20, 1918, among lots 136–43); Mr. and Mrs. W. Clifford Klenk (sold Sotheby Parke Bernet, New York, February 16, 1979, lot 694); private collection; private sale, Sotheby's, New York, July 3, 1986.

Rembrandt van Rijn, *The Triumph of Mordecai*, c.1641, cat. no. 231

241. *Landscape with a Milkman (Het Melkboertje),*
c. 1650
Etching and drypoint, state ii/II
Sheet: 67 x 178 mm., trimmed to platemark
Bartsch, Hollstein 213; Hind 242
PR.997.5.99

MARKS AND INSCRIPTIONS: Inscribed, in
brown ink, on verso: *Pierre Mariette 1672*
(Lugt 1790)

PROVENANCE: Pierre Mariette II (1634–1716),
Paris; sold Sotheby's, New York, November
20, 1986, lot 54.

242. *Landscape with Three Gabled Cottages Beside
a Road,* 1650
Etching and drypoint, state iii/III
Plate: 161 x 204 mm.
Sheet: 164 x 209 mm., partly remargined
Bartsch, Hollstein 217; Hind 246
PR.997.5.100

MARKS AND INSCRIPTIONS: Inscribed, in plate,
lower left: *Rembrandt F 1650*; stamped, in
blue ink, on verso: collection mark of G.
Rath (Lugt 1206); stamped, in black ink, on
verso: collection mark of N. D. Goldsmid
(Lugt 1962)

PROVENANCE: Georg (György) Ráth (1828–
1904), Budapest (sold Alexander Posonyi,
Vienna, January 11, 1869, lot 827); Neville
D. Goldsmid (1814–1875), The Hague (sold
Hôtel Drouot, Paris, April 25–27, 1876, lot
438); sold Christie's, London, June 24, 1986,
lot 302.

243. *Landscape with a Haybarn and a Flock of
Sheep,* 1652
Etching and drypoint, state ii/II
Sheet: 84 x 174 mm., trimmed to platemark
Bartsch, Hollstein 224; Hind 241
PR.997.5.101

MARKS AND INSCRIPTIONS: Inscribed, in plate,
lower left: *Rembrandt f. 1652*; inscribed,
in brown ink, on verso: *81*

PROVENANCE: Sold Sotheby's, New York,
November 20, 1986, lot 56.

244. *Landscape with a Cottage and Haybarn:
Oblong,* 1641
Etching, only state
Plate: 132 x 323 mm.
Sheet: 140 x 333 mm.
Bartsch, Hollstein 225; Hind 177
PR.997.5.102

MARKS AND INSCRIPTIONS: Inscribed, in plate,
lower right: *Rembrandt f / 1641*

PROVENANCE: Kimbell Art Foundation,
Fort Worth (sold Sotheby's, New York, May
13, 1987, lot 55).

245. *Landscape with an Obelisk,* c. 1650
Etching and drypoint, state ii/II
Sheet: 87 x 165 mm., with thread margins
Bartsch, Hollstein 227; Hind 243
PR.997.5.103

MARKS AND INSCRIPTIONS: Inscribed, in brown
ink, on verso: *JB* (Lugt 1419); stamped,
twice, in black ink, on verso: collection
mark of R. Gutekunst (Lugt 2213a)

PROVENANCE: John Barnard (died 1784),
London (sold Thomas Philipe, London, May
8, 1798, lot 267 or 268); Richard Gutekunst
(born 1870), Berne (sold Garland-Smith &
Co., London, December 2, 1920, lot 131);
Richard Dawnay (1903–1965), Tenth
Viscount Downe and Baron Dawnay of
Danby, Wykeham Abbey, Scarborough,
Yorkshire, after 1942 (sold Sotheby's,
London, December 7, 1972, lot 177);
acquired from Kennedy Galleries, New York,
September 16, 1980.

246. *The Boat House; Grotto with a Brook,* 1645
Etching, state iii/III
Sheet: 127 x 134 mm., trimmed to platemark
Bartsch, Hollstein 231; Hind 211
PR.997.5.104

MARKS AND INSCRIPTIONS: Inscribed, in plate,
lower right: *Rembrandt. 1645.*; stamped,
in blue ink, on verso: *M.J.M.* (Lugt 1879);
inscribed, in pencil, on verso: *EHose*

PROVENANCE: Mary Jane Morgan, New York
(sold American Art Association, New York,
March 15, 1886, lot 2100); Bromberg (?);
acquired between July 1993 and August 1994.

247. *The Windmill,* 1641
Etching and drypoint, only state
Sheet: 145 x 204 mm., trimmed to
platemark
Bartsch, Hollstein 233; Hind 211
PR.997.5.105

MARKS AND INSCRIPTIONS: Inscribed, in plate,
lower right: *Rembrandt f 1641*; stamped,
in blue ink, on verso: collection mark of the
Earl of Aylesford (Lugt 58)

PROVENANCE: Heneage Finch (1786–1859),
Fifth Earl of Aylesford, London and
Packington Hall, Warwickshire (probably
sold by him in 1846 to Samuel Woodburn,
London); acquired from William H. Schab
Gallery, Inc., New York, on August 23, 1982.

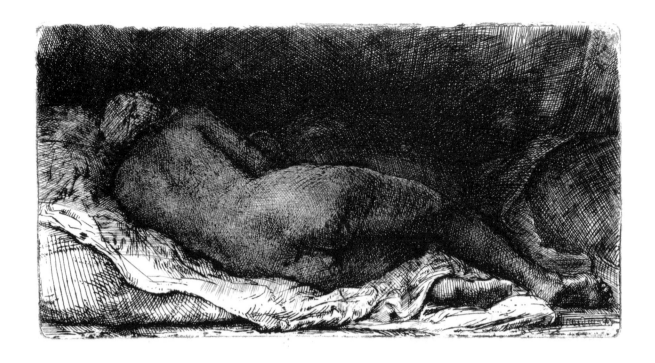

Rembrandt van Rijn, *Negress Lying Down,* 1658, cat. no. 239

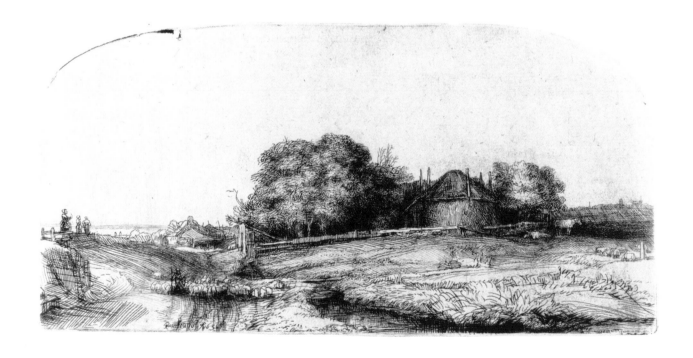

Rembrandt van Rijn, *Landscape with a Haybarn and a Flock of Sheep,* 1652, cat. no. 243

248. *The Goldweigher's Field,* 1651
Etching and drypoint, only state
Sheet: 121 x 317 mm., with thread margins
or trimmed to platemark
Bartsch, Hollstein 234; Hind 249
PR.997.5.106

MARKS AND INSCRIPTIONS: Inscribed, in plate,
lower left: *Rembrandt 1651*

PROVENANCE: Sold Christie's, New York, May
10, 1982, lot 86.

249. *Faust,* c. 1652
Etching and drypoint, state ii/III
Plate: 210 x 160 mm.
Sheet: 215 x 164 mm.
Bartsch, Hollstein 270; Hind 260
PR.997.5.107

MARKS AND INSCRIPTIONS: Stamped, in purple
ink, on verso: collection mark of F. Somary
(not in Lugt); watermark: CDG (Claude de
George)

PROVENANCE: Dr. Carlos Gaa (1871–c. 1925),
Mannheim (sold C. G. Boerner, Leipzig,
May 5–6, 1926, lot 836); Felix Somary
(1881–1956), Vienna and Zurich; acquired
from Artemis Fine Arts, Ltd., London, on
November 14, 1985.

250. *Clement de Jonghe, Printseller,* 1651
Etching and drypoint, state i/VI
Plate: 207 x 161 mm.
Sheet: 217 x 170 mm.
Bartsch, Hollstein 272; Hind 251
PR.997.5.108

MARKS AND INSCRIPTIONS: Inscribed, in plate,
lower right: *Rembrandt f. 1651*; inscribed, in
brown ink, on verso: *f / 14*

PROVENANCE: Sold Sotheby's, London,
February 4, 1982, lot 176.

251. *Jan Lutma, Goldsmith,* 1656
Etching and drypoint, state i/III
Plate: 198 x 149 mm.
Sheet: 203 x 154 mm.
Bartsch, Hollstein 276; Hind 290
PR.997.5.109

MARKS AND INSCRIPTIONS: Stamped, in blue
ink, on verso: collection mark of R. von
Seydlitz (Lugt 2283); stamped, in blue ink,
on verso: collection mark of G. Cognacq
(Lugt Supp. 538d); watermark: Arms-of-
Amsterdam (?)

PROVENANCE: Rudolph von Seydlitz (died
1870), Pilgramshain (probably sold C. G.
Boerner, Leipzig, May 20–24, 1912); Gabriel
Cognacq (1880–1951), Paris (sold Maurice
Rousseau, Paris, May 21, 1952); acquired
from R. E. Lewis, San Francisco, on January
25, 1983.

252. *Jan Lutma, Goldsmith,* 1656
Etching and drypoint, state ii/III
Plate: 199 x 149 mm.
Sheet: 202 x 152 mm.
Bartsch, Hollstein 276; Hind 290
PR.997.5.110

MARKS AND INSCRIPTIONS: Inscribed, in plate,
upper center: *Rembrandt / f 1656*; center
right: *Joannes Lutma Aurifecx / natus
Groningæ*; inscribed, in pencil, on verso:
CHWC

PROVENANCE: Acquired at Kennedy Galleries,
New York, on December 30, 1969.

253. *Jan Cornelis Sylvius, Preacher,* 1646
Etching and drypoint, state ii/II
Plate: 278 x 188 mm.
Sheet: 283 x 192 mm., trimmed just to
platemark at upper left
Bartsch, Hollstein 280; Hind 225
PR.997.5.111

MARKS AND INSCRIPTIONS: Inscribed, in plate,
upper center: *Rembrandt 1646*; extensive
inscription surrounding and below image;
inscribed, in black ink, on verso: *am* (Lugt
144); watermark: Strasburg Bend and Lily
with WK

PROVENANCE: Alfred Morrison (1821–1897),
London and Fonthill; by descent to his
widow, Mabel Chermside Morrison,
London; sold Christie's, New York,
November 16, 1982, lot 70.

254. *Bald Headed Man in Profile Right
(The Artist's Father?),* 1630
Etching, state iii/III
Sheet: 70 x 59 mm., trimmed to platemark
with thread margins
Bartsch, Hollstein 292; Hind 23
PR.997.5.112

MARKS AND INSCRIPTIONS: Inscribed, in plate,
lower right: *RHL* [monogram] / *1630*;
inscribed, in pencil, on verso: *F. F. Hansen*;
stamped, in purple ink, on verso: collection
mark of F. F. Hansen (Lugt 2813); inscribed,
in pencil, on verso: *V.S. 14757*

Rembrandt van Rijn, *Jan Lutma, Goldsmith,* 1656, cat. no. 252

PROVENANCE: Frederik Ferdinand Hansen (1823–1916), Copenhagen (sold C. G. Boerner, Leipzig, May 2–4, 1911, lot 533); Anderson Galleries, New York; Gordon W. Nowell-Usticke (sold Sotheby Parke Bernet, New York, October 31, 1967, lot 41); acquired from William H. Schab Gallery, Inc., New York, on December 6, 1984.

255. *Portrait of a Boy in Profile*, 1641
Etching, only state
Sheet: 95 x 68 mm., with thread margins
Bartsch, Hollstein 310; Hind 188
PR.997.5.113

MARKS AND INSCRIPTIONS: Inscribed, in plate, upper center: *Rembrandt f 164* [last digit missing]; stamped, on verso, in black ink: collection mark of the Earl of Aylesford (Lugt 58); in black ink: collection mark of H. S. Olivier (Lugt 1373); in red ink: collection mark of A. Hirsch (Lugt 133), and J. H. Wrenn (Lugt 1475)

PROVENANCE: Heneage Finch (1786–1859), Fifth Earl of Aylesford, London, and Packington Hall, Warwickshire (probably sold by him in 1846 to Samuel Woodburn); H. S. Olivier, Potterne Manor, Wiltshire; Alphonse Hirsch (1843–1884), Paris (possibly sold Sotheby's, London, July 29–30, 1875); John H. Wrenn (1841–1911), Chicago; by descent; sold Sotheby Parke Bernet, New York, November 14, 1981, lot 868.

256. *The Little Jewish Bride (Saskia as Saint Catherine)*, 1638
Etching and drypoint, only state
Plate: 110 x 78 mm.
Sheet: 114 x 84 mm.
Bartsch, Hollstein 342; Hind 154
PR.997.5.114

MARKS AND INSCRIPTIONS: Inscribed, in plate, upper right: *Rembrandt f. / 1638* [in reverse]; inscribed, in pencil, on verso: *very fine / W. Stewart's* (?) *Collection*; stamped, in purple ink, on verso: collection mark of F. Somary (not in Lugt)

PROVENANCE: W. Stewart (?); sold Gilhofer and Ranschburg, Lucerne, August 7, 1936; Felix Somary (1881–1956), Vienna and Zurich; acquired from Artemis Fine Arts, Ltd., London, on November 14, 1985.

257. *The Artist's Mother, Head and Bust: Three Quarters Right*, 1628
Etching and drypoint, state ii/II
Plate: 66 x 64 mm.
Sheet: 71 x 67 mm.
Bartsch, Hollstein 354; Hind 1
PR.997.5.115

MARKS AND INSCRIPTIONS: Inscribed, in plate, upper right: *RHL* [monogram] *1628* [the "2" reversed]; inscribed, in pencil, on verso: *C. 37748*

PROVENANCE: Acquired from Colnaghi & Co., London, on July 9, 1971.

All exhibitions were accompanied by a catalogue unless otherwise noted. Catalogue authors and curators are listed.

Diane J. Gingold, *Master Prints from the Fifteenth through the Eighteenth Centuries from the Collection of Mr. and Mrs. Adolph Weil, Jr.*, Montgomery Museum of Fine Arts, Montgomery, Alabama, September 11 – November 6, 1977; Museum of Fine Arts, St. Petersburg, Florida, July 2 – August 14, 1978.

Suzanne Folds McCullagh, *Italian Master Prints of the 18th Century: Selections from the Collection of Mr. and Mrs. Adolph Weil, Jr.*, Montgomery Museum of Fine Arts, Montgomery, Alabama, September 16 – November 4, 1984.

Hilliard T. Goldfarb and Barbara J. MacAdam, *From Titian to Sargent: Dartmouth Alumni and Friends Collect*, Hood Museum of Art, Dartmouth College, Hanover, New Hampshire, September 12 – November 1, 1987.

Hilliard T. Goldfarb, *A Humanist Vision: The Adolph Weil, Jr. Collection of Rembrandt Prints*, Hood Museum of Art, Dartmouth College, Hanover, New Hampshire, January 23 – March 20, 1988.

Hilliard T. Goldfarb and Reva Wolf, *Fatal Consequences: Callot, Goya, and the Horrors of War*, Hood Museum of Art, Dartmouth College, Hanover, New Hampshire, September 8 – December 9, 1990.

Ronni Baer, *Of an Uncommon Beauty: The Adolph Weil Collection of Rembrandt Prints*, High Museum, Atlanta, Georgia, November 23, 1991 – February 2, 1992 (no catalogue).

Stacey Sell, *Dürer, Rembrandt & Beyond: From the Collection of Mr. & Mrs. Adolph Weil, Jr.*, Montgomery Museum of Fine Arts, Montgomery, Alabama, July 1 – August 28, 1994.

Richard Rand and John Varriano, *Two Views of Italy: Master Prints by Canaletto and Piranesi,* Hood Museum of Art, Dartmouth College, Hanover, New Hampshire, June 10 – September 3, 1995.

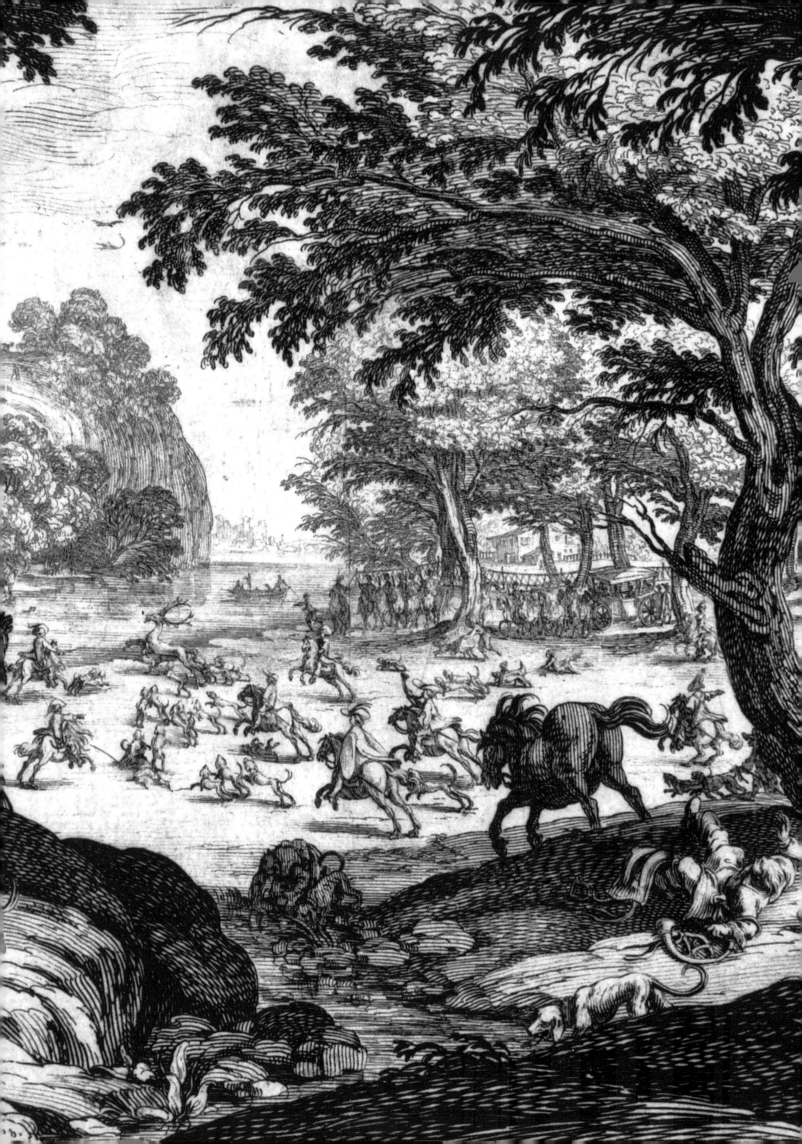